ANT:
THE JAVA BUILD TOOL
IN PRACTICE

ANT:
THE JAVA BUILD TOOL
IN PRACTICE

BERND MATZKE

CHARLES RIVER MEDIA, INC.
Hingham, Massachusetts

Acquisitions Editor: James Walsh
Production: Publishers' Design and Production Services, Inc.
Cover Design: The Printed Image

CHARLES RIVER MEDIA, INC.
10 Downer Avenue
Hingham, Massachusetts 02043
781-740-0400
781-740-8816 (FAX)
info@charlesriver.com
www.charlesriver.com

This book is printed on acid-free paper.

Bernd Matzke. *Ant: The Java Build Tool in Practice.*
ISBN: 1-58450-248-7

Library of Congress Cataloging-in-Publication Data
Matzke, Bernd.
 Ant : the Java build tool in practice / Bernd Matzke.
 p. cm.
 ISBN 1-58450-248-7 (Paperback with CD-ROM : alk. paper)
 1. Java (Computer program language) 2. Ant (Computer file) I. Title.

 QA76.73.J38M35258 2003
 005.13'3—dc22
 2003016405
Printed in the United States of America
03 7 6 5 4 3 2 First Edition

Contents

1 ▪ Introduction

Every new programming language and every new tool presents a number of new challenges to the programmer. First, of course, the command syntax must be learned. This is closely related to the understanding of various concepts and procedures, as well as the operation of the application. Many of these things are described in more or less detail in program documentation. Good tutorials are less common, and instructions that impart knowledge and interrelations among facts, as well as the pure facts, are quite rare. However, it is just such a grasp of the fundamental ideas behind a product, i.e., of the "unbroken thread," that will significantly ease the beginner's efforts at familiarization. And if, after some familiarization, a programmer is to master a tool such as Ant without problems, he must spend valuable time. Time that is scarce and valuable, and might be used for more important things than exploring a build tool.

Ant is being developed in a very pragmatic way. This means that new concepts are often not completely worked out, or that several methods exist for solving a given problem. Ant is no longer fully consistent and logical, so that more time must be spent to become familiar with it. A completely logically structured description, with no redundancies, cannot be provided for an application of this type.

This book is, therefore, not primarily intended as a reference. You can find a reference for the latest version on the Web (*http://jakarta.apache.org/ant/index.html*). I have, on the contrary, gathered the most important Ant commands in thematic groups and described them from the standpoint of their practical application. The individual chapters are thus oriented to specific functions or concepts, rather than primarily to separate commands. The examples serve to demonstrate the properties of the commands as clearly as possible. Occasionally, they have been devised specifically for this purpose and may not always represent productive applications. Some practical examples with extensive commentary are included in a special chapter devoted to examples.

ON THE CD Beyond this, you can find all the examples used in this book on the enclosed CD-ROM. Supplementary files that may be needed are also included there. The CD-ROM also contains the latest versions of Ant and Jakarta-Oro (a library for processing regular expressions).

2 | First Contact

This chapter begins by presenting you with the most important components of an Ant configuration file and demonstrating the call-up of this tool. The emphasis is not on describing the details of various commands; rather, you will become acquainted with the basic operating mode of Ant.

2.1 TASKS

The task of Ant is to specify groups of files and to apply specified commands to these files. These commands include calling various Java compilers and copier commands, as well as writing zip and other archives. Ant is, therefore, primarily intended for writing an independent, distributable, and installable application from Java source code, and even to undertake the deployment or installation of this application on its own. Beyond that, domains of application can be imagined which are not directly involved with programming in the narrow sense. Thus, files can be copied, substitutions located in property files, etc., very efficiently with Ant.

2.2 INSTALLATION

The build tool *Ant* is a pure Java application. There is no explicit installation tool. Before using it for the first time, however, some preliminaries should be considered.

A JDK must be installed on your computer in order to take advantage of all the possibilities of Ant. Version 1.1 of Java is certainly sufficient, but version 1.2 of Java or above is recommended. A simple Java runtime environment is quite adequate,

in principle, for starting Ant and processing Build files or, certainly, for using some of the Ant commands of the JDK, for example, the Java compiler. Without a complete JDK, however, Ant cannot fulfill its real tasks.

Ant can be employed with greatest convenience if a version 1.4 or higher JDK is used. This version contains some packages which have to be installed separately in the older versions, e.g., packages for interpretation of regular expressions.

Ant is customarily available as zip or tar archives. The specific archive you use depends essentially on the driver and on the available unpacker. With Windows, a zip archive is most often used, and with the various Unix derivatives, more likely a

ON THE CD

tar archive. On the CD-ROM accompanying this book, you will find the version that was available at the time the manuscript was submitted.

Unpack the appropriate archive into the desired directory. The archive contains all the files under a root address whose name consists of the string jakarta-ant- plus the version number of the tool. You can then simply unpack new versions into an existing directory and subsequently find a subdirectory that contains all the required files. You can rename this directory if you take the new name into account when modifying the environmental variables.

As no further actions are required beyond unpacking, an existing Ant directory

ON THE CD

can also be copied instead. You will find an already unpacked version on the enclosed CD-ROM alongside the archives.

To start Ant, one further environmental variable must be fixed besides the Java specific settings. It is up to you whether it is done in the course of basic system settings or by setting specific values on starting the command interpreter. In any case, you must set the environmental variables ANT_HOME in the root path of the Ant packet. Unless it is renamed, that is the "jakarta-ant-x.x.x" directory. Furthermore, it must be entered in the system path under the subdirectory bin in the Ant root-directory in order for the Ant start script to be found by the system.

When the setup is successful, you can make a simple functional test. Just call the command

```
ant
```

from an arbitrary directory outside the bin-directory of Ant. Insofar as Ant can be started by the system, the following error message should appear:

```
Buildfile: build.xml. does not exist!
Build failed
```

If this output appears, then Ant is correctly installed. Certainly, one file named `build.xml` should show up in the current directory, so Ant tries to execute this file. This, of course, also leads to control panel output that is indicative of a correct start for Ant.

2.3 ELEMENTS OF AN ANT FILE

The Ant commands will be collected in one or more XML files. The fact that Ant was originally developed for compiling Java applications has resulted in the colloquial term *Build file*. In this book, the term *Ant file* will also be used.

Every XML file requires exactly one `<project>` root-tag. Ant files are, therefore, also referred to as a *Project*. A project contains one or more *targets*, which can be compared remotely with a module or subprogram conventional programming language. A target will be introduced by the tag `<target>`.

Targets serve to structure Ant files. When programming a build file, you can stipulate the interrelationships of the targets with one another and thereby establish a definite order of processing. Simple run control can also be realized through conditional processing of the targets.

A target contains one or more proper Ant commands, which will be referred to as a *task*. You can modify the characteristics of the commands through attributes and embedded tags. Currently, more than 100 distinct commands exist. In fact, familiarity with about 15 commands and a few important principles will suffice for meaningful work with Ant.

Within a project you can have recourse to *properties*. These correspond roughly to the constants of other programming languages. Properties make it possible for an Ant application to adjust to the actual conditions on your computer without having to modify the application itself. Thus, you can put, e.g register paths, names of files, etc., in property files and dynamically link these to Ant files or transfer them as parameters when starting Ant. In addition, you can place properties in the build file itself and draw on them for conditional processing of targets. In this case, the properties serve as a flag.

There are other elements, besides the targets, for structuring the source text. Some of the tags which are normally embedded in single commands can first be noted separately and subsequently referenced through a unique identifier. In this

way, repeated application of the construct is possible, thereby reducing the effort of writing, and making maintenance easier.

The *data type definition* does not belong directly among the Ant commands, but it is inseparably linked to the topic of XML. Ant can generate a DTD file through a special command. This file can be embedded in the Ant files. This is trivial for Ant; certainly special XML editors can fully utilize the DTD and, right during editing, can perform a validation or provide appropriate input assistance.

2.3.1 A Practical Example

The following little example should place some of the elements just mentioned in an actual build file. This example is not meant to illustrate the commands in detail. That is deferred to the following chapters. Rather, it will be shown what tasks Ant can undertake and how slight the required programming effort is.

This example is operational. It is, of course, deliberately simple. A build file to be placed in a real environment would surely be somewhat more extensive. The script would be broken up into several sections in order to permit better description of the individual parts. You can find the complete source text on the accompanying CD-ROM.

ON THE CD

The task of this build file is to compile a Java application, make a Jar archive available from the class files, and subsequently, to test the application. Three separate directories should exist for the Ant-, source-, and class-files. All are to be found under a common root.

A build file will first be initiated through an XML-type statement, which primarily establishes the character encoding. This line must appear in all build files. It will not be printed out in any of the subsequent examples in this book.

The content, as such, will be introduced through the `<project>` tag. The attribute `default` defines the starting target (comparable to a subprogram). The `name` attribute is for information only and has no practical significance.

```
<?xml version="1.0" encoding="UTF-8"?>
<project name="bsp0201" default="main" basedir=".">
```

Definitions often appear at the beginning of a build file. Here, three properties will be set. They are most closely comparable to a declaration of constants in a conventional programming language. In this example, they serve as designators for directory names. Properties can also be read out from files and be defined on the command line when the build files are called up. Thus, it is possible to maintain

them independently of the application itself. Mostly, the properties contain simply structured values.

```
<property name="dir.src"   value="./source"/>
<property name="dir.build" value="./classes"/>
<property name="dir.lib"   value="./lib"/>
```

The next element defines a complex path listing. The class path will be defined specifically here. Of itself, this element engenders no action. Later it will be bundled from other commands. This approach makes later adaptation easier and saves writing time. In order for the path definition to be referenced later, a unique ID must be established by the attribute. Such a complex element has the advantage that different subtags can be used in order to include directories in the path definition. These make it possible, for instance, to select directories over search patterns. In this case, of course, only preset paths that have been allocated through properties will be used. Reference to a property occurs by enclosing the name in curly brackets and placing a $ sign before it. One of the two properties (dir.build) would be defined at the outset and the other (classpath) would be specified by Ant. It contains the class path which will be picked out by the system variables of the same name.

```
<path id = "cp">
  <pathelement path = "${classpath}" />
  <pathelement location = "${dir.build}" />
</path>
```

Now the first target will be constructed at once. It must be the main target. It contains the name main. Thus, it will be called during the start of the build file, since main will likewise be specified as a default target there. This first target contains no further commands. Here it serves only to execute the dependent targets specified in the attribute depends. The three targets prepare, compile, and run will be specified in exactly this sequence.

```
<target name    = "main"
        depends = "prepare, compile, run" />
```

The following target, prepare, is the first that actually contains any commands. It is also referred to as a *task* in Ant. This target only contains one task, delete. For that reason, it is appropriate to erase the content of the target directory of the

compiler. Which files and directories are to be deleted is specified here by a so-called *fileset*. A fileset often contains other subtags with which you can select files and directories in entirely different ways. A fileset can also be contained in many commands as a subtag. It is, perhaps, the most important and most used tag of all. In this case, of course, only the simplest variant of a fileset will be used. Moreover, a property that is defined at the beginning of the script is also used here.

In the current example, this target must demonstrate that preparatory work may be necessary before the actual compiling. That must involve more than the erasure of target directories. Presumably it includes the reading of source data from a source code-administrative system, changing the version of old source files, etc. In this example, a directory will first be constructed that will later serve as a target directory for the compiler. Subsequently, the content of this directory will be erased. This will seem surprising at first. In fact, the command becomes operative for construction of the directory only upon the very first call of the build file. Subsequent calls bring the delete command to bear, ensuring that all traces of the old build are erased. This is advisable from time to time in extensive projects, in order to avoid hard-to-locate errors owing to outmoded classes. There is little sense in testing which of the two commands is actually necessary before they are executed. Decisions of this sort are relatively difficult to program in Ant.

```
<target name = "prepare">
  <mkdir dir="${dir.build}"/>
  <delete>
    <fileset
        dir     = "${dir.build}"
        includes = "**/*.*"
    />
  </delete>
</target>
```

After the `prepare` target, the `compile` target is called. It contains three commands: calling the Java compiler, generating another directory, and making an archive available. A few instructions must be passed on to the Java compiler. These include the name of the source and destination directories, the class path, and the list of the files to be compiled. The path element generated at the outset is used for a class path. Access occurs through the ID which will have been chosen in the attribute `classpathref`. The source and target directories are specified through the property.

After compilation, a jar archive will be prepared. It must contain the name ae.jar and will be filed in a separate lib-directory. A fileset is used to record all the class files from the build directory.

Should the compiler generate an error, the build breaks off at once, the other targets will not be executed, and the jar file will not be prepared.

```
<target name = "compile">
  <javac classpathref = "cp"
         destdir       = "${dir.build}"
         srcdir        = "${dir.src}"
         includes      = "**/*.java"
  />
  <mkdir dir="${dir.lib}"/>
  <jar destfile = "${dir.lib}/ae.jar">
    <fileset dir       = "${dir.build}"
             includes = "**/*.class"
    />
  </jar>
</target>
```

After compilation and creation of the jar archive, the application must be tested. To avoid having this test run every time, Ant processes this target only if a certain property exists. This will be arrived at through the attribute if. It means that Ant should execute the target run only if the property test exists. You can define this property when calling the application in the command line and, in this way, flexibly decide whether a test should or should not occur in connection with compiling.

Calling the application with the Java command is relatively simple. Naturally, the name of the starting class must be specified. In this special case, the jar file is suitable as a class path. If these match a test class parameter in the command target, they will be transferred with a specially prepared subtag <arg>. The content of the property test is used as a transfer parameter for the sake of simplicity.

```
<target name = "run"
        if   = "test">
  <java classname = "AntExample"
        classpath = "${dir.lib}/ae.jar">
    <arg line = "${test}"/>
  </java>
</target>
```

Testing an application by a simple call is not sufficient in practice. But, complex test procedures can be started in a similar fashion.

This was the last tag for this example. Now the XML file only has to be closed correctly:

```
</project>
```

The Ant package contains start files for the most widespread operating systems. You can, therefore, start the script simply with

```
ant -f bsp0201.xml
```

The target run will not, of course, be executed here, since the property test does not exist. You can arrange this with

```
ant -f bsp0201.xml -Dtest=Hello
```

In this way, the compiler will certainly be called again. In order to prevent this, you can deliberately call another as the main-target. For that, you only have to specify the name of the target to be executed, e.g., run, after the name of the build file,

```
ant -f bsp0201.xml run -Dtest=Echo
```

This call will suppress the depends-chain of the main-target. Ant only executes the specified target and its subtargets, provided any exist. In this case, if only prepared applications are called, compiling will not take place.

After this brief "embarkation," you will find detailed explanations for the individual command groups in the following chapters.

3 The Ant File

All Ant statements must be entered in XML files. Both the call, by way of the command line, and the root tag of these files, must be independent of the specific format of this file. This chapter deals with the most general basics.

3.1 THE COMMAND LINE

Ant is a console program. It must, therefore, be started by way of a command line. The call, as such, has roughly the following (simplified) form:

```
java java_parameter org.apache.tools.ant.Main ant_parameter
```

So that the start of Ant can be simpler and diverse parameters can be transferred, there are two start scripts for Windows and Unix operating systems,

```
ant.bat or ant.
```

You can transfer two kinds of information to the start scripts. Accordingly, the exact syntax of the call looks like

```
ant [options]  [target]
```

Both pieces of information will be forwarded directly to Ant. They correspond to the placeholder ant_parameter of the initially introduced command line.

To begin with, Ant accepts a series of options. This script passes on all options to be made available at the call, without changes, to Ant. They then are available only within Ant and not in the corresponding Java Virtual Machine (JVM). The following Table 3.1 shows you the available options. Many of these options will be ex-

plained in more detail in later chapters. The table indicates the corresponding chapters. You can also get this list by entering:

```
ant -help
```

TABLE 3.1 Command Line Options in Ant

Option	Meaning	Described in Section
-buildfile <file> -file <file> -f <file>	Execute the specified file (build.xml is standard).	3.1 4.1.3
-D<property>=<value>	Set a given property to a definite value.	5.1.6
-propertyfile <file>	Read properties from a file.	5.1.6
-find [<file>]	Seek a build file going upwards in a listing tree and execute.	3.1
-projecthelp	Output information on the current build file.	
-help	Output help text on the command line options for Ant.	3.1
-version	Indicate the version of Ant.	
-diagnostics	Output diagnostic information (environment, hardware, JDK, ...).	
-quiet, -q	Output fewer log announcements than usual.	
-verbose, -v	Output more log announcements than usual.	
-debug	Output debugging information.	
-emacs	Log-outputs without prefix.	
-logfile <file> -1 <file>	Reroute log-outputs to file.	10.7.3
-logger <classname>	Send log-outputs to special logger class.	10.7.3
listener <classname>	Send log-outputs to special listener class.	10.7.2
-inputhandler <classname>	Make input available through input handler class.	10.8

The name of a so-called *target* can also be noted in the command line alongside the options. A target corresponds to a subprogram. When a build file is called, the target to be executed is normally stipulated in the build file. This specification can be overwritten by specifying the target during the call.

Ant processes the instructions in a build file. Without additional statements, Ant seeks to execute the file `build.xml` from the current directory. With the command line options `-f` (or `-file` or `-buildfile`), you can let another file be executed instead of the standard file.

`-find` is an unconventional, but certainly very useful option. It ensures that the build file will be sought in the current listing, but also that all higher order directories will be searched incrementally until a build file is found. If no file name is specified, the standard file `build.xml` is sought. On the other hand, another file name can be stipulated.

Now some examples of calls in Ant. The following statement starts Ant with the file `build.xml` from the current directory:

```
ant
```

Starting the target `compile` from the file `build.xml`:

```
ant compile
```

Starting the tag `getsources` from the file `sccstasks.xml`. Here, the property `mode` is created with the value `all`:

```
ant -f sccstasks.xml  getsources -Dmode=all
```

In order to prevent misunderstandings, here is a hint regarding the *properties*: Ant scripts can process so-called properties which you can define using the command line option `-D`. The Java environment additionally recognizes the concept of *system properties*, which will also be generated by option `-D` in the Java command line. The two types of properties are not identical. In particular, no properties will be defined with the `-D` option in Ant that can also be recognized by the Java running time system. Should this be desired, the options for the Java environment have to be put, instead, in the environmental variable `ANT_OPTS`. The content of these variables will be reset by the start script into the Java command. In the command line presented at the beginning of this chapter, the content of `ANT_OPTS` will be found once more in the placeholder `java_parameter`.

3.2 THE ANT PROJECT

Every XML file requires exactly one so-called root tag. This tag encompasses the rest of the files. In the case of the build files, the `<project>` tag forms the shell for all other Ant commands. Ant reads the attributes of this tag and then calls a target within the build file. This target must be specified in the attribute `default` of the `<project>` tag.

The attribute `name` within the `<project>` tag is optional. It merely facilitates better control.

Since file-specific operations will often be executed in Ant applications, the root list for the subsequent file operations can be set by the attribute `basedir`. This attribute is also optional. In most cases, it is safer to specify such statements in properties.

To conclude, Table 3.2 lists the syntax description of the `<project>` tag.

TABLE 3.2 Attributes of the `<project>` Tag

Attribute	Description	Required
default	Name of the default target to be executed if no target is specified when the file is called.	Yes
basedir	Root listing for all relevant path statements within the build file.	No
name	Name of the project.	No

4 Targets

A target is a block of statements containing one or more commands. The commands within a target are processed sequentially; there are no branches or loops there. The targets themselves are only shells or containers; the actual task will always be executed by the commands in the target.

Targets are identified by a name which must be unique within the build file. As a target can be utilized only in connection with a build file, the names of the targets can be repeated in different files without leading to ambiguity.

4.1 DETAILS

The targets available in an Ant file are not only processed sequentially. Ant can execute targets subject to definite branching conditions and states. The mechanisms for operational control allow you, for example,

- to modularize a build project,
- to execute targets conditionally, depending on the current state of different files,
- to take the specific system environment or operating system into account, as well as
- to choose between different branches of the build process.

Two different actions are necessary, in principle, for operational control. First, the syntax of Ant must generally be allowed to define multiple targets and call them when desired. Next, a flexible reaction to the current system state is required. This is followed by a call of the target partially depending on the existence of properties.

These, on the other hand, will also be influenced by, among other things, commands that evaluate various conditions. In this section, you will find a description of all the commands connected with calling a target. The evaluation of conditions will be described in more detail in Chapter 9.

Table 4.1 summarizes all attributes of the `<target>` tag. Some of them serve only for operational control.

TABLE 4.1 Attributes of the `<target>` Tag.

Attribute	Description	Required
name	Target name	Yes
depends	List with names of the targets which must be started by Ant prior to the execution of the current target.	No
if	If the property exists, the current target will be executed.	No
unless	The current target will be executed if the property does not exist.	No
description	Verbal description of the task. It will be given only if Ant is called with the command line option `-projecthelp`.	No

Targets can be called in different ways. These possibilities will be described more precisely below.

4.1.1 Default Target

You must use the `default` attribute in the `<project>` tag. You enter the name of a target that must be used as the value of this attribute, if no other target is addressed when starting a build file by one of the methods described below.

TIP

Define a target in productive Ant files that merely generates an informational task at the console. Use this target as a default target. All targets that carry out real tasks will be called explicitly by command line parameters. In this way, you prevent problems or undesired side effects when an Ant file is called by mistake.

4.1.2 Dependences

Within the <target> tag you define, through the value of the attribute depends, which other targets must be executed successfully before the current target can be processed. All subtargets are listed in the attribute depends. The names are separated from one another by commas. The targets are executed in the sequence in which they are listed in the depends attribute.

When a build file is called, Ant must first check whether all the actuated targets actually exist or appear in cycles. In addition, before processing, the dependence of the targets on one another must be known and remain static. The attribute depends can then only operate with explicitly itemized target names; transfer via property is not possible.

At this point the concept of "successful execution" must be explained more precisely. A target would always be successfully processed if no exception appeared during its execution. An exception occurs, for example, when an error appears during compiling; files to be copied are not found or cannot be written, etc.

Successful execution does not mean that the target actually has to have done anything. Thus, if the commands in a target are not executed at all, for example, when the currently available properties involved in a conditional execution of the target prevent this, Ant will treat this as a successful (since it is error free) execution.

Now here is an example:

```
<project name="bsp0401" default="t0">
  <target name="t0" depends="t1">
    <echo message="Top tag, but last processed"/>
  </target>

  <target name="t1" depends="t2, t3">
    <echo message="Condition for t0"/>
  </target>

  <target name="t2">
    <echo message="Condition for t1"/>
  </target>

  <target name="t3">
  </target>
</project>
```

This build file contains four targets, of which the first depends on the second, and this, in turn, depends on the other two. Before the target t0 is executed, Ant must process the target t1. As this itself depends on t2 and t3, Ant executes these two targets first. In this way, the targets will be executed in the order in which they appear in the depends attribute.

4.1.3 Command Line Option

The simplest possibility for addressing a target is calling through the command line. In calling Ant, you can specify the name of one or more targets as a parameter. Ant starts the targets in this sequence. The default target defined in the <project>-tag remains unnoticed. Thus, possible forms of the call include:

```
ant -f bsp0401.xml t1
ant -f bsp0401.xml t3 t2
```

In the first case, Ant tries to execute the target t1. On the other hand, it recognizes the dependence on t2 and t3, and processes these targets first. The target t0 remains unnoticed.

The second call starts targets t3 and t2 in exactly this sequence.

This variant of the call allows you to program several different partial tasks of a build process in a single build file and deliberately call one of the tasks.

In case you would like to prevent the calling of a target directly from the command line, here is a little trick. Let the target names begin with a hyphen. Names of this sort will be evaluated as correct inside a depends attribute. During a call through the command line, however, all character strings after a hyphen will be treated as names of a command line option rather than as target names. Thus, these targets cannot be started by the command line.

4.1.4 Conditional Processing

The two attributes if and unless are available in the <target> tag. They expect the name of a property as an attribute. In the case of if, the target will only be processed if the corresponding property exists. It does not matter whether it has a value or what that value is. The attribute unless works in the opposite way; the target will only be processed if the indicated property does not exist. Both attributes can be used simultaneously. In this case, the two conditions (one property exists, the other

does not) are AND-coupled. At any given time, only one property per attribute can be specified; complex conditions for linking multiple properties are not possible.

Here is an example:

```
<project name="bsp0402" default="main" basedir=".">
    <target name="main"  depends="t1, t2, t3"/>

    <target name="t1" if="p1">
      <echo message="p1 exists"/>
    </target>

    <target name="t2" unless="p1">
      <echo message="p1 does not exist"/>
    </target>

    <target name="t3" if="p1" unless="p2">
      <echo message="p1 exist and p2 does not"/>
    </target>
</project>
```

You process these files one after another through the following command line call:

```
ant -f bsp0402.xml
ant -f bsp0402.xml -Dp1=x
ant -f bsp0402.xml -Dp2=x
ant -f bsp0402.xml -Dp1=x -Dp2=x
```

Observe that the condition is noted and checked directly in the target, but not at the point from which it is called out of the target. This procedure deviates sharply from the procedure in conventional programming languages, and can, on occasion, lead to some confusion during layout of complex build files. In conventional programming languages, a subprogram can be called out of entirely different contexts, although the subprogram does not know which preconditions have led to its being called. Should an Ant subtarget be, incorrectly, treated as a kind of subprogram, the relationships will be entirely different. The called program section does not know whether the called subtarget will actually be executed, for different preconditions may be tested there. Under certain conditions, this means that for one and the same task, several subtargets must be defined, only because in this target different preconditions are to be tested.

A further characteristic which can certainly lead to misunderstanding, is the fact that conditional processing of a target has no influence on the execution of the dependent targets. Independently of the value of the attributes if and unless, all the dependent targets will be executed first. Then, a check will be made of whether the current target must be executed or not. From that point on, dependent targets can have an influence on the execution of higher order targets through the definition of properties.

The following example demonstrates this procedure:

```
<project name=" bsp0403" default="main" basedir=".">
  <target name="main" depends="sub" unless="p1">
    <echo message="Main-Target"/>
  </target>

  <target name="sub" >
    <echo message="Target sub"/>
    <property name="p1" value="true"/>
  </target>
</project>
```

The main-target depends on the target sub. Furthermore, it must only be executed if the property p1 does not exist. Regardless of whether you set the property p1 in the command line on calling the file, the target sub will be executed first. Since the property p1 will ultimately be generated there, the target main is never executed.

4.1.5 The Commands ANT and ANTCALL

From time to time subtargets must be called through another target, rather than through the dependence defined by depends. The following scenarios illustrate the need for this:

- The subtarget is located in another file.
- The subtarget must (only) be supplied with selected properties.
- Condition checking and functionality must be separated from one another.
- The subtarget serves as a subprogram and is repeatedly (with different properties) called.
- The name of the target to be called is specified through a property.

All of these tasks necessitate an explicit call for a target. Two very similar commands, <ant> and <antcall>, are available for doing this. The basic difference between the two commands, is that with <ant> you can start a target in another build file, while <antcall> permits calling a target only within its own file. The respective attributes of the two commands can also resolve properties, so that the name of the target to be started can also be transferred dynamically to a property.

An additional difference consists in the transfer of properties, more precisely into an embedded tag used for the purpose. In the case of <ant>, you can use the property tag that is to be more precisely described below, to pass properties on to the called target. This command cannot be used within the tag <antcall>, and the command <param> is available there for this purpose. You can find more detail on these two commands in Section 5.1.7.

Table 4.2 lists the attributes of the <antcall> command.

TABLE 4.2 Attributes of the <antcall> Command.

Attribute	Description	Required	Default
target	The target to be called.	Yes	
inheritall	Pass on properties.	No	true
inheritrefs	Pass on references.	No	false

It is natural to use the attribute target with which the called target will be named in the <antcall> command. The other two attributes, inheritall and inheritrefs, specify whether the current properties and references are to be extended to the new target.

Two embedded tags are available for the transfer of properties and references, independently of these two attributes. With <param> you can define name-value pairs which will be converted into properties by <antcall>. These are then available within the called target. The <param> tag possesses the attributes name and value. In this way, specified properties overwrite properties that might already exist with the same names. In addition, the transfer to the called target takes place independently of the value of the attribute inheritall.

A second tag, <reference>, makes it possible to transfer references. These references can be used to note complex structures—such as file search patterns—

separately and then insert them in other commands by chaining. They can be extended using the `<reference>` tag. For this purpose, the tag recognizes the attributes `refid` and `torefid`. Here, `refid` is a must attribute. With it, you establish the extended reference. You can use the optional attribute `torefid` to specify the name under which the reference in the called target should be available. If this attribute is not brought up, the reference is to be addressed with its original name.

You will find details on properties, on transfer to lower order targets, on ranges of validity, etc., in Chapter 5.

The `<ant>` command operates somewhat more conveniently than the command described above. It can be used to call targets in other files. For this purpose, it has a series of additional attributes. Table 4.3 summarizes all the attributes of this command.

TABLE 4.3 Attributes of the `<ant>` Command.

Attribute	Description	Required	Default
antfile	Name of the build file to be called.	No	build.xml
dir	Directory in which the build file will be sought.	No	Current working directory
target	The target to be called.	No	Default target of the called file
output	Write the output in this file.	No	
inheritall	Pass on properties.	No	true
inheritrefs	Pass on references.	No	false

The attributes `target`, `inheritall`, and `inheritrefs` correspond to those of the `<antcall>` command. The attribute `target` is, of course, optional. If no target is specified, Ant uses the `default` attribute of the `<project>` tag of the called file.

The attribute `output` can be used for writing the console output of the called build file to a file, in addition to outputting to the console.

The two attributes `antfile` and `dir` do influence the called build file. With `antfile` you set the name of the called build file. This attribute is also optional. If you don't use it, Ant automatically searches for the file `build.xml`.

Normally, the current build file will be searched for in the working directory. This directory can be established in the `<project>` tag with the attribute `basedir`. Without this attribute, the directory containing the build file will be the working directory. The working directory of the current file is, at the same time, the working directory of the called file, even if another working directory is established using the attribute `basedir`. Of course, insofar as the attribute

```
inheritall="false"
```

is set in the command, the working directory is not passed on. In this case, a `basedir` attribute of the called file is operative.

You can change the operation of the `basedir` attribute or the working directory by the attribute `dir` of the `<ant>` command. This attribute establishes where the called file will be searched for and specifies the current working directory for the called file. This procedure cannot be influenced by the attribute `inheritall`! As soon as the attribute `dir` is used, the working directory of the called file is settled.

Two embedded tags can be used in connection with the `<ant>` command. One of these, the `<reference>` tag, has already been described with the `<antcall>` command. It has exactly the same function with the `<ant>` command.

The second possible tag is the `<property>` tag. With this command, you define properties for the called target. Insofar as the function of `<property>` resembles the `<param>` tag, it can be used with the command `<antcall>`. Certainly, the `<property>` command has a significantly wider functional capacity than the `<param>` tag. It can be used as an independent command, as well. For this reason, it will be discussed in detail in the section on properties. (See Chapter 5.)

The two following build files demonstrate the application of the `<ant>` command, and illustrate the effect of the various attributes on the working directory. We begin with the file to be called. Here there is just one target in which only the content of the property `basedir` is output to the console. In the `<project>` tag, a higher order directory is defined as the working directory with the attribute `basedir`. This file must be accommodated in a subdirectory under the other example files (`bsp0404.xml`):

```
<project name=" bsp0404" default="main" basedir="../..">
  <target name="main">
    <echo message="${basedir}"/>
  </target>
</project>
```

The file that has just been introduced will be called repeatedly by the following build file. All four combinations of the `inheritall` attribute and the `dir` attribute will come into action thereby:

```
<project name="bsp0405" default="main" basedir=".">
  <target name="main">
    <ant antfile="Bsp04/bsp0404.xml" inheritall="false"/>
    <ant antfile="Bsp04/bsp0404.xml" inheritall="true"/>
    <ant antfile="bsp0404.xml" dir="Bsp04" inheritall="false"/>
    <ant antfile="bsp0404.xml" dir="Bsp04" inheritall="true"/>
  </target>
</project>
```

Executing the Ant file results in a display output similar to the following:

```
main:
        [echo]   D:\usr\AntBook\Examples
main:
        [echo]   D:\usr\AntBook\Examples\Chapter04
main:
        [echo]   D:\usr\AntBook\Examples\Chapter04\Bsp04
main:
        [echo]   D:\usr\AntBook\Examples\Chapter04\Bsp04
```

The first two tasks arise through calling the subordinate build file without the `dir` attribute. Depending on the value of the `inheritall` attribute, either the basis directory in the subordinate file, or the working directory of the called file, will be the currently applied working directory. In call variants with the `dir` attribute, its value is always the basis directory for the called file, independent of the state of the `inheritall` attribute.

4.2 EXECUTION OF COMMANDS IN THE TARGET

The commands (tasks) within a target are executed sequentially in the order in which they appear in the target. A command is first executed when its predecessor is finished.

In certain cases there can be deviations from this procedure. Ant offers the possibility of executing multiple commands in parallel. That is reasonable, for ex-

ample, when software tests must be started from Ant. One Ant task starts the software to be tested and another task starts the test program. Other procedures can be run in parallel on fast computers, e.g., compiling and generating Javadoc.

There are four special tasks for controlled execution of commands. Table 4.4 summarizes these commands.

TABLE 4.4 Commands for Modification of the Sequence of Work

Task name	Task function
<parallel>	All included commands to be started as parallel-running tasks.
<sequential>	All included commands to be executed one after another.
<waitfor>	Waits for the occurrence of a specified event.
<sleep>	Interrupts the program execution for a specified time.

The <parallel> command is the most interesting. It serves as a shell around other Ant commands, which are then executed in parallel. It is especially easy in this way to execute several other targets in parallel, which can be called using the <antcall> tag:

```
<parallel>
      <antcall target="comp"/>
      <antcall target="jdoc"/>
</parallel>
```

Whether such paralleling actually saves time is extremely dependent on the called commands and the hardware that is being used.

In complex jobs, such as automated tests, the parallel-executed program train often contains numerous commands which must be processed sequentially. The tag <sequential> is available for this, and its use makes sense only within the <parallel> tag.

The two other tags can be used to affect the operating time. The tag <sleep> interrupts the processing of the current program train for a specified time. This can be set at one or more of the attributes hours, minutes, seconds, or milliseconds. The total time is given by the sum of the set times, which can also be negative.

The `<waitfor>` tag is somewhat more complicated. This tag interrupts the execution of the current program branch and waits for the occurrence of one or more events. These events will be programmed in the form of embedded tags. They correspond to those which will also be used in the `<condition>` tag. In order to avoid excessive redundancy, one should refer to the possible subtags in the description of `<condition>` in Chapter 9. In anticipation, here we enumerate the conditions or events of significance for `<waitfor>`:

- existence of a file or class
- successful up-to-date checking of files
- existence of a specified property
- test of the content of a property for a true or false value

In connection with the parallel execution of multiple c ommands, `<waitfor>` is significant in synchronizing their processing.

Checking of the conditions takes place periodically in order to avoid unnecessary computational time. During standard operation, the conditions will be checked every 500 milliseconds. This interval can be changed by the attributes `checkevery` and `checkeveryunit`. Here `checkevery` contains a numerical value. The corresponding unit will be specified by the attribute `checkeveryunit`. The possible range of values for `checkeveryunit` includes the character strings "millisecond," "second," "minute," "hour," "day," and "week." That default values are set for both attributes (500 for `checkevery`, and "millisecond" for `checkeveryunit`) is sufficient only to set the attribute that is actually to be modified.

In order to avoid having the application wait forever for an event that will never happen, there is, naturally, also a maximum waiting time, 180 seconds. This can be modified by the two attributes `maxwait` and `maxwaitunit`. The default values are 180000 for `maxwait` and, again, "millisecond" for `maxwaitunit`.

In case the `<waitfor>` tag waits unsuccessfully for an event and then interrupts on reaching the maximum waiting time, a property will be generated whose name you define through the attribute `timeoutproperty`.

The following little example demonstrates the application of all four tags. It has no practical use beyond the purpose of illustration.

```
<project name="bsp0406" default="main" basedir=".">
 <target name="main" >
  <parallel>
```

```
<sequential>
  <echo message="Sleep-Task started" />
  <sleep minutes="1" seconds="-55" />
  <echo message="Sleep-Task awakened" />
  <property name="go" value="on" />
</sequential>

<sequential>
  <echo message="Waitfor-Task started" />
  <waitfor checkevery="1000" >
    <isset property="go" />
  </waitfor>
  <echo message="Waitfor-Task end" />
</sequential>

  </parallel>
 </target>
</project>
```

This example generates two program branches which will be executed in parallel. Each program branch contains several commands, which are executed one after the other, and therefore are collected respectively in a `<sequential>` tag. After the start of the application, each program branch generates a console output in order to demonstrate its existence. The first branch then inserts a pause of length one minute minus 55 seconds, or 5 seconds. Then a notice is again output to the console and the property go is generated.

The second program branch waits until the first console output regarding the availability of the property. Its existence is checked every 1000 ms. Once it is set up, it performs another console output. The sequence of outputs makes it possible to trace the running of the program.

SUMMARY

Targets are the smallest and, other than build files, the only modularization units. Ant commands can only be executed if they exist within a target. Different mechanisms make it possible to influence the sequence of processing and to carry out conditional execution.

5 ▪ Properties

Properties are placeholders for values which can be set dynamically as the application runs. To that extent, they are distantly related to the constant declarations of ordinary programming languages. An initially apparent comparison with variables is, however, not correct, since properties cannot be erased or overwritten again, once they have been defined and provided with a value. Because the concepts of Ant differ greatly from those of a conventional programming language, the use of properties differs somewhat from that of constants in Java. Properties are used primarily for the following purposes:

- Use as a flag in order to represent Yes/No states.
- Use as symbols (constants) in order, for example, to simplify the maintenance of information that is employed repeatedly.
- Making customizing values available through external property files.
- Return of values through Ant commands.

5.1 GENERATION

Widely differing mechanisms exist for the definition of properties in accordance with their various tasks. The following variants exist:

- Ant or the JVM define some generally valid properties.
- Direct provision through the `<property>` tag.
- Reading in a property file to memory.
- Reading in the environmental variables of the operating system.
- Definition by command line parameters on calling Ant.

■ Various tags generate properties as status information.

■ When lower order targets are called, properties can be defined for this call.

5.1.1 Predefined Properties

Ant or the Java Virtual Machine makes a series of predefined properties available.

You can get an overview of the predefined properties most simply with the aid of the following small build file:

```
<project name="bsp0501" default="main" basedir=".">
  <target name="main">
    <echoproperties />
  </target>
</project>
```

The command <echoproperties> lists the properties that have been defined up to the current point in time. Many of these are not necessary for the operation of Ant. Table 5.1 shows a selection of predefined properties which must be used on occasion in Ant files. Note that some of the properties provide values that depend on the operating system and will not be available on all platforms.

TABLE 5.1 Predefined Properties

Property	Description	Available with	Example
java.version	Current Java Version.	JVM	1.3.1
java.home	Installation directory for JVM.	JVM	c\:\\jdkl.3.1\\jre
java.class.path	Current class path.	JVM	c\:\\jdkl.3.1\\ lib\\tools.jar;c\ :\\program\\ant\\ lib\\xml-apis.jar; c\:\\program\\ant\\ lib\\xercesImpl. jar;c\:\\program\\ ant\\lib\\optional. jar;c\:\\program\\ ant\\lib\\ant.jar;

(continues)

TABLE 5.1 Predefined Properties (*continued*)

Property	Description	Available with	Example
os.name	Operating system name.	JVM	Windows NT
os.arch	Hardware basis.	JVM	x86
os.version	Operating system version.	JVM	4.0
file.separator	Separator for file and directory names.	JVM	\\
path.separator	Separator for listing of multiple directories.	JVM	;
line.separator	Line separator.	JVM	\r\n
user.name	User name.	JVM	bernd
user.home	Home directory of current user.	JVM	C\:\\WINNT\\ Profiles\|\|bernd
user.dir	Current directory.	JVM	D\:\\USR\\Ant book\examples
basedir	The absolute path of the directory set by the attribute basedir.	Ant	D\:\\USR\\ Ant book\\examples
ant.file	The complete name of the current build file.	Ant	D\:\\USR\\ Ant book\\examples \\ant070.xml
ant.version	Long form version designation of Ant.	Ant	Apache Ant version 1.5Beta2 compiled on May 31, 2002
ant.project. name	The name of the current project set by the attribute name.	Ant	ant070

5.1.2 **Explicit Definition by the** `<property>` **Command**

Properties can also be set manually in a build file by means of the `<property>` command. This command has a series of attributes which are somewhat mutually exclusive. Thus, you can use this command either to establish single, explicitly named properties, and assign them a value by various mechanisms, or to read in a complete record of properties from external sources (usually a file).

The `<property>` tag can also lie outside the `<target>` tag, or on a level directly under the `<project>` tag. This capability is used to define properties that are, in any case, necessary for execution of the build file, and whose existence should, therefore, not be dependent on the execution of a target.

The following listing primarily indicates the different variants of the `<property>` command for establishing individual properties. All of the variants of the command used here employ the attribute `name`.

```
<project name="bsp0502" default="main">

  <target name="main" depends="compile_dummy">
    <property name="path.abs.root"
              value="/forcont/factory"/>
    <property name="path.rel.source"
              value="src"/>
    <property name="path.rel.target"
              value="build"/>
    <property name="path.abs.source"
              value="${path.abs.root}/${path.rel.source}"/>
    <echo message="${path.abs.source}"/>

    <property name="path.this"
              location="bsp0502.xml"
              id="pt"/>
    <echo message="${path.this}"/>

    <property name="path.classpath"
              refid="cp"/>
    <echo message="${path.classpath}"/>

    <property name="prop"
              refid="pt"/>
    <echo message="${prop}"/>
  </target>
```

```
<target name="compile_dummy">
  <javac srcdir="."
         destdir="."
         includes="*.java">
    <classpath id="cp">
      <pathelement location="xyz.jar"/>
    </classpath>
  </javac>
</target>

</project>
```

The first four `<property>` tags define properties in the simplest manner by using the name- and value- attributes. In the fourth definition, the contents of two of the previously used properties are used as a value. The value generated in this manner will subsequently be used for control by an `<echo>` command output at the console.

The `location` attribute represents yet another possibility, that of assigning a value to an individual property. It expects a file name as a parameter in a case where this file does not exist. As a result, the file name will be restored with the current path and assigned to the property as a value.

Finally, a value can be assigned to a property by reference. The attribute `refid` then comes into action. This is meaningful, however, only if the reference points to another property or to a path statement. A demonstration of this variant requires the notation of a second target that contains the `<javac>` tag, which has not yet been described in detail. At this point, it is not the javac command, but only the embedded `<classpath>` tag that is significant. This tag involves a path specification, which can be read through a reference to a property. The last two `<property>` tags in the main target illustrate the relationship to other values via the reference.

At first, the referencing of another property seems identical to a direct specification of the property name. Certainly, Ant cannot execute any recursive substitutions. It is, therefore, impossible to specify the name of another property in a property and insert its value. If this is necessary, references offer a way out. The following Ant file makes this clear. In this file, the first `<property>` tag will be placed outside the target in order to illustrate this possibility in practice at the same time.

```
<project name="bsp0503" default="main">
  <property name="property" value="property value" id="ref"/>

  <target name="main">
```

```
<!-- does not work -->
<property name="pointer1" value="property"/>
<property name="target1" value="${pointer1}"/>
<echo message="${target1}"/>

<!-- works -->
<property name="pointer2" value="ref"/>
<property name="target2" refid="${pointer2}"/>
<echo message="${target2}"/>
</target>

</project>
```

First, a property is set in the target main and filled with a value. In addition, the property contains an identifier with which it can be referenced.

Now the property pointer1 will be set. It keeps the value of the name of the first property. The subsequent attempt to generate a property whose value is the content of the property and whose name appears in pointer1 is abortive. The following echo command shows that only the value of pointer1 will be allocated.

Things look different if the allocation occurs via a reference. The identifier will be placed in pointer2 in place of the property name. Subsequently the property target2 will be generated and its value set via reference. The name of the reference will then be taken from pointer2. Now the correct value will be transferred, as the second echo message shows. Here you can see the console output of the build file:

```
Buildfile:  bsp0503.xml
main:
     [echo] property
     [echo] property value
BUILD SUCCESSFUL
```

In the test of the last application, a little problem can arise if you embed the DTD generated by Ant and attempt to validate the file. The DTD provided by Ant is not flexible enough to be able to correctly evaluate the dynamic transfer of the reference in a property. It can only perform a static check of the character strings in the file for id and refid. Then the file will be critiqued as "not valid," although it could be correctly processed by Ant.

5.1.3 Reading-in Property Files

Besides generating individual properties, the `<property>` command can also set multiple properties all at once. These, however, will not be noted within the command, but read-in from an external file. The file must contain entries of the form

```
key=value
```

The following example uses two files that have identical contents. The content is:

```
date=06.06.2002
num=17
running=true
```

One of the files (`my0504.properties`) lies in the same directory as the build file. The other (`myres0504.properties`) appears in a separate directory `Resources` under the current working directory.

The mark for mass definition of properties is the `name` attribute, which is missing in the `<property>` command. Instead of this, you must indicate an alternative attribute. Two different attributes, `file` and `resource`, are available for reading-in external property files. The value for the two attributes is the name of the file to be read-in. The two attributes differ only in the directories at which the given files will be searched for. If an absolute path is used in the `file` attribute, Ant will naturally use this option.

Otherwise, it will be sought in the specified working directory. With the `resource` attribute, Ant first considers an optionally specified class path. This can be assigned either directly in the `classpath` attribute or, via a reference, in the `classpathref` attribute.

When embedding external property files, it is possible that properties may be multiply defined. In order to avoid such conflicts, you can have Ant provide individual properties with a prefix as it reads-in the files. You define this in the `<property>` command with the attribute `prefix`. The following example uses this attribute during reading of the first file.

```
<project name="bsp0504" default="main">
  <target name="main">
    <property file="my0504.properties"
              prefix="my"/>
```

```
      <echo message="${my.date}"/>
      <echo message="${my.num}"/>
      <echo message="${my.running}"/>
      <echo message="---------------------------------"/>

      <property resource="myres0504.properties"
                classpath="./resources"/>
      <echo message="${date}"/>
      <echo message="${num}"/>
      <echo message="${running}"/>
   </target>
</project>
```

A successful test of this example assumes that you have generated the two above-mentioned property files, with already-set contents, and distributed them in the specified paths. You can check the operation of the classpath and prefix attributes by making some changes in the file contents and in the build file.

Two other commands exist for reading-in a property file, and these provide additional convenience. The commands <loadproperties> and <xmlproperties> can certainly only exist within a target and, unlike the <property> command, cannot occur directly at that level under the <project> tag.

You read-in a conventional property file with the command <loadproperties>. As opposed to the <property> tag, here you can choose which properties are to be dealt with from among additional embedded tags. Under certain conditions, the properties to be read-in can be modified. The tag <filterchain>, in combination with so-called filters, is appropriate for this. How these tags can be brought into use in connection with other commands, will be discussed in detail in Section 8.9.

Without the embedded tags, the syntax of the <loadproperties> command is very simple. Only one attribute, srcfile, is available, and it must always be used. With this attribute, you set the property file that is to be read.

With the <xmlproperty> command, you read in properties from an XML file. The applicable attributes, however, differ substantially from those for the <loadproperties> command. In this regard, note Table 5.2.

The names of the properties originate from the arrayed names of the tags and attributes. In the normal case (collapseattributes not set or "false") the tag names will be separated by periods and the attribute names will be enclosed in parentheses. If collapseattributes is set to the value "true," the attribute names will be set without parentheses and taken into the property name, but also separated from the

TABLE 5.2 Attributes of the <xmlproperty> Command

Attribute	Description	Required	Default value
file	Name of the file to be read-in.	Yes	
prefix	Prefix to be added to each property name.	No	
keeproot	If "false," then the root tag of the XML file will not be retained in the property name.	No	true @$p>
validate	If "true," than the XML file will be validated.	No	false
collapse attributes	If "true," then the XML attributes will be treated as embedded tags.	No	false

other parts of the name by a preceding period. Here are some examples. The following XML property file prop.xml is assumed:

```
<xml-root>
    <path root="/usr/forcont/factory">
        <source>src</source>
        <build>build</build>
    </path>
</xml-root>
```

In the first example, the XML file is simply read-in without use of other attributes in the <xmlproperty> command. The command looks like this:

```
<xmlproperty file="prop.xml"/>
```

The following summary lists the resulting properties with their values:

```
xml-root.path.source=src
xml-root.path(root)=/usr/forcont/factory
xml-root.path.build=build
```

All properties will be preceded by the name of the root tag of the property file. The names of the inner tags are attached. The name of the attribute in the root tag is in parentheses in the property name. This somewhat unconventional notation can be transformed into a more easily read format using the `collapseattributes` attribute of the `<xmlproperty>` command. Next, we consider the command

```
<xmlproperty file="prop.xml" collapaseattributes="true"/>
```

The resulting properties resemble the preceding ones, up to the notation for the source attribute:

```
xml-root.path.source=src
xml-root.path.build=build
xml-root.path.root=/usr/forcont/factory
```

The root tag attached to the property name does lengthen the name. This may be undesirable. The attribute `keeproot` prevents the addition of this component of the name. The command

```
<xmlproperty file="prop.xml" keeproot="false"/>
```

thereby generates the following properties:

```
path(root)=/usr/forcont/factory
path.build=build
path.source=src
```

Naturally, the `collapseattributes` attribute could also be used along with the `keeproot` attribute, in order to handle the tags and attributes of the property file in identical fashion.

The automatically attached prefixes are quite necessary in some cases. Often it is possible to maintain unique property names only in this way. In large projects, there is often a danger that identical property names will be needed for logically distinct information, either in property files or in build files. In just this way, the `<loadproperties>` command provides the `<xmlproperty>` tag with the possibility of attaching a freely chosen prefix to the property name. The following example illustrates the application of this attribute. Note that in this example, despite the use of the `prefix` attribute, you have to keep the record of the root tag of the XML property file separate in the property names.

```
<xmlproperty file="prop.xml" prefix="pr" keeproot="false"/>
```

With the above-mentioned command, you generate the following properties:

```
pr.path(root)=/usr/forcont/factory
pr.path.build=build
pr.path.source=src
```

The following listing collects all the commands together in a functional build file. The `<xmlproperty>` calls have each been relocated in their own targets, which are called by `<antcall>`. This means that the properties only exist within the sub-targets, so that no side effects occur as a result of previously existing properties.

```
<project name="bsp0505" default="main">

  <target name="main">
    <antcall target="xmlprop1"
             inheritall="false"/>
    <antcall target="xmlprop2"
             inheritall="false"/>
    <antcall target="xmlprop3"
             inheritall="false"/>
    <antcall target="xmlprop4"
             inheritall="false"/>
  </target>

  <target name="xmlprop1">
    <xmlproperty file="prop0505.xml"/>
    <echoproperties prefix="xml"/>
  </target>

  <target name="xmlprop2">
    <xmlproperty file="prop0505.xml" collapseattributes="true"/>
    <echoproperties prefix="xml"/>
  </target>

  <target name="xmlprop3">
    <xmlproperty file="prop0505.xml"
                 keeproot="false"/>
    <echoproperties  prefix="path"/>
  </target>
```

```
<target name="xmlprop4">
  <xmlproperty file="prop0505.xml"
                prefix="pr"
                keeproot="false"/>
  <echoproperties  prefix="pr"/>
</target>
</project>
```

Besides the possibility of reading-in real property files, arbitrary files can also be read into an individual property. That is appropriate, e.g., for properties which must accept a list with file- or path-names. Another possible application is reading-in a message that has to be sent out using the `<mail>` command.

The command intended for this function is `<loadfile>`. It has the attributes listed in Table 5.3. The `<filterchain>` command already mentioned in connection with the `<loadproperties>` command is the only possible embedded tag.

TABLE 5.3 Attributes of the `<loadfile>` Tag

Attribute	Description	Default	Required
srcfile	File to be read-in.		Yes
property	Property to be generated.		Yes
encoding	Character coding.		No
failonerror	Interrupt build if read-in error occurs?	true	No

5.1.4 Reading-in Environmental Variables

In many applications, you have to take the specific system environment into account. Here you have the possibility of reading-in all the environmental variables of the operating system as properties. For this you use the attribute `environment`. This attribute retains a prefix as its value, which is placed in front of the name of the environmental variables. In that way, you can avoid the inadvertent overwriting of existing properties. The following example illustrates the application in a Windows NT system:

```
<project name="bsp0506" default="main">

  <target name="main">
```

```
        <property environment="env"/>
        <echo message="${env.USERNAME}"/>
        <echo message="${env.SystemDrive}"/>
        <echo message="${env.Path}"/>
    </target>

</project>
```

5.1.5 Properties as Status Information

A series of commands can generate properties themselves and fill them with values. In accordance with how they handle properties, these commands can be subdivided into two large groups.

In one case, the available property is used later as a flag. Depending on the parametrization of the command, either an empty flag is provided or just a default value (e.g., "true") allocated. Properties of this sort are often used to control the conditional execution of targets. Thus, it is often only the existence of a property, rather than its value, that is of interest.

The commands in the second group, on the other hand, could, in a further reference to real programming languages, be collected under the rubric of *functions*. They return a character string that represents the result of a complex process.

Table 5.4 summarizes the most important commands that can generate properties.

TABLE 5.4 Ant Commands that Generate Properties

Command	*Task*	*Generated property*
apply	Execute a system command.	Flag/Function value
available	Tests whether a resource (file, class, . . .) is available.	Flag
basename	Provides the latest constituent of a path statement.	Function value
checksum	Calculates a check sum.	Function value
condition	Tests a condition.	Flag

(continues)

TABLE 5.4 Ant Commands that Generate Properties (*continued*)

Command	Task	Generated property
`dirname`	Removes the latest constituent of a path statement and provides the remaining portion.	Function value
`exec`	Execute an operating system command.	Flag/Function value
`format`	Formatting of a time stamp.	Function value
`input`	Reads a user input.	Function value
`jarlib-available`	Tests whether a Java library (extension) is available in a jar file or not.	Flag
`jarlib-resolve`	Tests whether a Java library (extension) is available in a number of jar files or not.	Flag
`loadfile`	Loads a file in a property.	Function value
`pathconvert`	Generates a character string with a platform dependent list with file and path names.	Function value
`uptodate`	Checks the update status of a file.	Flag

Some of these commands will be described in more detail later. At this point, a brief example should give a sense of how these commands are used.

```
<project name="bsp0507" default="main">

    <target name="main" >
     <dirname property="file.dir" file="${ant.file}"/>
     <basename property="file.name" file="${ant.file}"/>
     <available property="flag1" file="${ant.file}"/>

     <echo message="${ant.file}"/>
     <echo message="${file.dir}"/>
     <echo message="${file.name}"/>
```

```
        <echo message="${flag1}"/>
    </target>

</project>
```

In the `main` target of the build file, two functionlike commands will be called first, to generate a property with which a return value is delivered to the rest of the application. The two commands use the predefined property `ant.file`, which contains the complete name of the just executed file. This name will be analyzed by the commands. One of these commands delivers the file name without a path and the other, only the path component.

The third command yields a property that will be used as a flag. It tests whether a specified file (the attribute `file`) is available or not. In this case, the existence of the file is verified, otherwise the name of the current build file will be used. The flag will contain the value `true` in this case. The subsequent console outputs show you the current state of the properties that are being used and generated.

5.1.6 Definition in the Command Line

The properties available in Ant are, technically speaking, Java properties. Besides a definition within the program, they can also be brought up by calling an Ant file from the command line. This is the result of the following option:

```
-Dproperty=value
```

In older versions of Ant, it was possible to generate properties without allocating a value. That was reasonable, since within Ant the mere existence of properties would be utilized without taking their value into account. In this case, the value would be left out of the command line; the equals sign had, nevertheless, to be written down:

```
-Dproperty=
```

Newer versions no longer accept this form of the property definition; a value must be assigned in every case. Otherwise, Ant ceases processing without further commentary. For defining multiple properties, correspondingly many D-options must be written down:

```
-Dprop_1=value_1  -Dprop_2=value_2 ... -Dprop_n=value_n
```

Besides setting individual properties, the command line option

```
-propertyfile <filename>
```

can be used to read-in a complete property file.

5.1.7 Property Definition by Calling of Subtargets

Two commands (<ant> and <antcall>) allow the calling of subtargets independently of the dependences defined by depends. You can find a detailed description of these commands in Section 4.1.5 on the operational control of targets.

Both commands make it possible to define properties using embedded tags and pass them on to the called target. For the <ant> command, the <property> command will be used as an embedded tag. It can be activated in all the variants that have been described. You can, accordingly, define single properties, or read-in complete property files and transfer them to the subtarget.

The <antcall> command, on the other hand, only accepts the <param> tag as an embedded target. This tag will also be used in many other commands as an embedded tag, in order to transfer additional, widely differing, types of information to them. Here, properties will not always be defined by <param>; this effect shows up first in connection with the <antcall> command.

When <antcall> is used, the <param> tag is used with the parameters name and value. Other attributes are not possible. Hence, you can generate properties only singly and directly in the source text.

The properties defined in this way are only valid in the called target and, if occasion arises, valid in its subtargets, but not within the called target.

Here is an example of this. The <antcall> command calls a target to which two properties are to be transferred:

```
<project name="bsp0508" default="main">

  <target name="main"  >
    <antcall target="sub">
      <param name="prop1" value="Property 1"/>
      <param name="prop2" value="${ant.file}"/>
    </antcall>
    <echo message="Main Property 1: ${prop1}"/>
    <echo message="Main Property 2: ${prop2}"/>
  </target>
```

```
<target name="sub">
  <echo message="Sub Property 1: ${prop1}"/>
  <echo message="Sub Property 2: ${prop2}"/>
</target>
</project>
```

5.2 ACCESS AND DOMAIN OF APPLICABILITY

The utilization of properties or, more precisely, access to their value, will now be demonstrated in more detail. The placeholder

```
${Property-Name}
```

is replaced by the value of the property during run time. If no such property exists, then the placeholder character string remains unchanged and processing of the build file proceeds. Only by using the `verbose-` command line option when Ant is called, can an informative output reach the console.

Properties should not be confused with the variables of conventional programming languages. They are more like constants. Once a property has been generated, it can neither be erased nor supplied with another value. These procedures have no effect on the continuation of the build; only when Ant is called with the `verbose-` option is an output delivered to the console.

The domain of applicability for a property is normally the current file. Regardless of where properties are placed in a file, they are normally valid globally in the entire file from the moment they are installed. All definitions outside a target, and not just those in properties, will be executed by Ant before a target is started. They are, therefore, available in all targets of the current file.

Command line properties are henceforth valid for the entire Ant call over all files. This holds for the properties generated by the `D`-option, as well as for those that can be read-in from a property file in the command line with the `-propertyfile` option. Properties defined by the command line options are made available by Ant prior to interpretation of the build file. Accordingly, in this way, you can define properties to be made available in the build file. Since definition by command line is more efficient than definition in the build files, the latter are ineffective. Thus, you can overwrite property definitions in a build file.

When a target is called by the <ant> and <antcall> commands, the current properties are normally transferred along with it. Certainly, there is no return of properties from the called file to the calling file! This method has not, in principle, been provided for. This also holds when the called target exists in the current file, for the two commands start a new process which will end on quitting the called target. Then all the values will be lost in this process. The following example shows the effect of different calling mechanisms on the domain of applicability of the properties:

```
<project name="bsp0509" default="main">
  <target name="main" depends="sub1">
    <antcall target="sub2"/>
    <echo>
      ${prop1}
      ${prop2}
    </echo>
  </target>

  <target name="sub1">
    <property name="prop1" value="Property 1"/>
  </target>

  <target name="sub2">
    <property name="prop2" value="Property 2"/>
  </target>

</project>
```

Whereas prop1 is defined in a target that will be called by the depends mechanism, the target <sub2> is called by the <antcall> command. The outputs in the main target illustrate the resulting differences in property handling.

In certain cases, it is possible to limit the validity of a property and to define it anew in subordinate targets. This, however, occurs only if the subordinate target is not called as a result of the dependences defined by the depends attribute, but by the <ant> or <antcall> commands. Both commands recognize the attribute inheritall, which can be used to control the transmission of properties. The default value of this attribute is true. Then all properties will be extended in the standard case. If this value is set to false, the properties will not be passed on. These can then be newly prepared in the called target. The two commands open up a new process, which will again be erased after processing of the target. In this way, all the

properties defined in the called target are also lost. Here is a simple example of this:

```
<project name="bsp0510" default="main">
  <property name="glob" value="Global property"/>

  <target name="main"  >
    <property name="prop" value="Main-Target"/>
    <echo message="prop: ${prop}"/>
    <antcall target="sub" />
    <antcall target="sub" inheritall="false"/>
  </target>

  <target name="sub">
    <property name="prop" value="Sub-Target"/>
    <echo message="prop: ${prop}"/>
    <echo message="glob: ${glob}"/>
  </target>

</project>
```

A property glob is first defined directly below the <project> tag; this property is globally valid from the start because of the above provision. Hence, its validity—at least within the current file—is not dependent on the transmission mechanisms for the individual targets. The main target subsequently generates the property prop. Then it starts the target sub twice with the <antcall> command. Here the default specification for inheritall will be used the first time; the second time, on the other hand, the return of the properties is cut off. The target sub also attempts to make a property prop available. The output to the console indicates the respective current content of the property. On the first call, the value of the property set in the target main is retained, and on the second, the <property> command is, on the other hand, operational in the target sub.

The global validity of the property glob is, of course, established only in the current file. Should a target in another file be called by the <ant> command, this property will naturally be transferred if the transmission of the property is not cut off.

Besides the undifferentiated transmission of all existing properties, the <ant> and <antcall> commands can be used to set specific properties for the called target. The embedded tags <property> or <param> serve this purpose. This possibility was mentioned in the previous section. If properties have been generated in this

fashion, there are two aspects of their domain of applicability which must be noted:

- The properties will be transferred to the subtarget in every case. Subsequent use of the `inheritall` attribute has no effect.
- Already existing properties can also be defined anew.

The following build file shows the preceding with an example employing the `<antcall>` command, which requires the `<param>` tag as an embedded tag:

```
<project name="bsp0511" default="main">
  <target name="main"  >
    <property name="prop" value="Main-Target, Property 1"/>
    <property name="prop2" value="Property 2 from the main target"/>
    <antcall target="sub">
      <param name="prop" value="Newly defined in the main target"/>
    </antcall>
    <echo message="Main-Target, prop: ${prop}"/>
  </target>

  <target name="sub">
    <echo message="Sub-Target, prop : ${prop}"/>
    <echo message="Sub-Target, prop2: ${prop2}"/>
  </target>
</project>
```

The target `main` first generates two properties. When the subtarget is called, the first property will be furnished with a new value. The outputs within the subtarget show that both properties are available, with the first containing the new value. Within the target `main`, the initially set value for the property `prop` is then again available.

The characteristics of properties require a certain amount of preliminary planning in their application, for inadvertent multiple provision of a property will, with a high probability, lead to undesired behavior of Ant. Here the provision of properties through reading-in of property files and the definition of properties in the command line are critical. It is, therefore, advisable always either to assign a prefix on reading-in property files or to define unique name spaces. The start scripts used for starting a build file should have the properties to be defined noted in the source text by command lines. The calling parameters of the start script will be converted

by the program into property definitions. Direct manual notation of property definitions on starting Ant is a possible source of error. Certainly, this possibility can also be deliberately employed in order to overwrite properties that are properly defined inside a build file.

TABLE 5.5 Domain of Applicability of Properties

Location of the property definition	*Command line*	*Global in files*	*Target*	*In* <ant> *or* <antcall> *command*
Domain of applicabiliby in current file	Yes	Yes	Yes, if the current target has been called by depends	No
Domain of applicability in subtargets for a depends call	Yes	Yes	Yes	No
Domain of applicability in subtargets for Ant/ Antcall call and inheritall=true	Yes	Yes	Yes	Yes
Domain of applicability in subtargets for Ant/ Antcall call and inheritall=false	Yes	No	No	Yes

5.3 DATES

Ant can furnish date data in properties and format these data. This involves two tasks, which will be described together here.

In an Ant script, three properties can be generated with the task <tstamp> and filled with time or date data. These are the properties DSTAMP, TSTAMP, and TODAY. Their content and default formats are listed in Table 5.6.

TABLE 5.6 Properties that Are Set by `<tstamp>`

Property	Description	Default format
DSTAMP	Current day's date.	yyyyMMdd
TSTAMP	Current time.	hhmm
TODAY	Alternative date.	MMMM dd yyyy

The following example illustrates the most important application:

```
<project name="bsp0512" default="main" basedir=".">
  <target name="main">
    <tstamp/>
    <echo message="DSTAMP    ">${DSTAMP}</echo>
    <echo message="TSTAMP    ">${TSTAMP}</echo>
    <echo message="TODAY     ">${TODAY}</echo>
  </target>
</project>
```

The tag recognizes only an optional attribute, `prefix`, with which a prefix for the three properties can be specified.

With the embedded tag `<format>`, you can freely format the current time output. The formatting possibilities correspond to those of the class `SimpleDateFormat`, which is contained in every JDK. The `<format>` tag provides some additional attributes, which you can take from Table 5.7.

TABLE 5.7 Attributes of the `<format>` Tag

Attribute	Description	Required
property	Property for the result.	Yes
pattern	Pattern for formatting.	Yes
timezone	Time zone.	No
offset	Difference from the current time.	No
unit	Unit for the offset value.	No
locale	Localization output.	No

The valid data ranges for the attributes timezone and locale are identical with those for the Java classes Timezone and Locale, which will be used in the background for formatting. The valid values for unit are millisecond, second, minute, hour, day, week, month, and year.

A brief example for the <format> tag follows:

```
<project name="bsp0513" default="main" basedir=".">
  <target name="main">
    <tstamp>
      <format property="d1"
              pattern="E, d.MMMM yyyy"
              locale="de"/>
      <format property="d2"
              pattern="HH:mm:ss"/>
      <format property="d3"
              pattern="HH:mm"
              offset="-123"
              unit="minute"/>
    </tstamp>
    <echo>${d1}</echo>
    <echo>${d2}</echo>
    <echo>${d3}</echo>
  </target>
</project>
```

6 File Selection and Name Handling

Many of the Ant commands perform operations with files or complete directory trees. This can involve quite general functions such as copying or erasing, while other commands are substantially more specialized. They compile Java sources or create archives. For their operation, all these commands require a list with the files to be processed. This can be done through attributes. For greater flexibility, however, file-oriented commands accept some embedded tags with which so-called *filesets* are defined. A fileset is a list with files which can be specified in various ways within the fileset.

This chapter is mainly intended to introduce the generally applicable tags for defining filesets. This includes explanations of the commands for general file operations.

This section ends with a description of other tags for the definition of file lists that, in fact, can only be used in selected Ant commands.

6.1 FILESETS

A fileset is a list containing one or more files. A fileset is generated by a special `<fileset>` tag. This tag is not a separately executable command, but will always be used by other commands as an embedded tag. Certainly, filesets can be defined right off as independent elements and linked by reference to other commands. In addition, there are executable commands which inherit all the characteristics of a fileset. Within these commands you can program file selection with the same subtags as in a proper fileset. The original documentation of Ant mentioned that these commands imitate an implicit fileset.

Within a fileset, several attributes and other embedded tags are available for file selection. The definition of a fileset can, therefore, be quite complex.

File selection is done by two different methods. First, files can be selected by patterns which are related to the path- and file-names. The pattern specifications form a so-called *patternset*. Another possibility is so-called *selectors*, which select files with the aid of supplementary characteristics such as length, creation date, containing a specified text in a file, etc.

Table 6.1 lists the attributes of the `<fileset>` tag.

TABLE 6.1 Attributes of the `<fileset>` Tag

Attribute	Description	Preset	Required
dir	Root directory for the following file specifications.		Yes
defaultexcludes	Establishes whether special files should be automatically excluded (see text).	true	No
includes	List of the included files (separated by commas or spaces). Pattern inputs are possible.	All files (corresponds to the pattern **)	No
includesfile	Name of a file containing the included file names. Pattern inputs are possible.		No
excludes	List of files which are excluded from the record (separated by commas or spaces). Pattern inputs are possible.		No
excludesfile	Name of a file containing the excluded files.		No
casesensitive	Allows for upper/lower case.	true	No
followsymlinks	Follow links.	true	No
id			No
refid			No

The basic operation of the `<fileset>` tag, as well as of some of its attributes, requires a detailed description.

In every case, you must use the attribute `dir`. With the value for this attribute, you establish the output directory for all subsequent file selections. Afterwards you can only select files which appear in this or in subordinate directories. If you later try to utilize path options which point to files outside this directory, these will not be allowed. This attribute is actually only intended for the acceptance of a single specific directory name. Pattern specifications lead to an error.

All path names provided by the fileset are relative to the output directory of the fileset. Afterwards, you must unconditionally ensure this, particularly in connection with mappers.

Without additional selection mechanisms, to be described in the next two sections, in fileset all files and directories are automatically contained under the root directory. The selection tags thereby always lead only to a narrowing of the file set.

6.1.1 Selection by Pattern

A first file selection is possible using the optional attributes `includes` and `excludes`. With `includes`, you set which files should be accepted and with `excludes`, you establish which files should not be included. Both attributes accept one or more patterns for file names. Here the individual elements are separated by a comma or a space. If the `includes` attribute is not used, the `<fileset>` tag automatically selects all files at the directory established by `dir`. Since spaces are used as separators, no file or directory names containing spaces can be used.

Patterns can include the standard pattern symbols "?" and "*" as search patterns for one or an arbitrary number of symbols. Beyond that, the combination "**" is available as a pattern symbol for arbitrarily deeply interlocked directories and, if necessary, all the files therein. Naturally, independent file names without pattern symbols and file names with specified path options can be used for both attributes. If a pattern specification ends in "/" or "\", then the pattern "**" will automatically be appended.

Fileset makes no distinction between files and directories when selecting files.

In all pattern specifications, the `<fileset>` tag accounts for uppercase and lowercase letters. If this is not desired, you can turn this procedure off using the attribute

```
casesensitive="false"
```

One peculiarity of the `<fileset>` tag is that certain files are automatically masked out in the basic setup for the tag. Here we are concerned primarily with files

installed from different source code control systems. They can be recognized using
the following patterns:

```
**/*~
**/#*#
**/.#*
**/%*%
**/._*
**/CVS
**/CVS/**
**/.cvsignore
**/SCCS
**/SCCS/**
**/vssver.scc
**/.svn
**/.svn/**
```

If you would like to include these files in the selection, you have to set the
defaultexcludes attribute to the value false.

As a demonstration of the application, the <copy> command is quite suitable.
For technical reasons, which will be described briefly, the <delete> command is also
necessary. You will find a detailed description of this command in the next section.
Here it should just be used without further explanation. Please note that the fol-
lowing examples are intended to illustrate file selection using the <fileset> tag. The
destination directory generated by the <copy> command, or its content, provide
the easiest way of checking which files are selected by fileset.

Here is the first example. It copies some files from the current work directory
into a directory with the name targetdir:

```
<project name="bsp0601" default="main" basedir=".">
  <target name="main" depends="prepare">
    <copy todir="targetdir">
      <fileset dir="." includes="*.xml" />
    </copy>
  </target>

  <target name="prepare">
    <delete dir="targetdir"/>
  </target>
</project>
```

The actual work is undertaken by the target main. This target is certainly dependent on the target prepare, in that the target directory, should it be on hand, will be erased. The only attribute in the <copy> tag yields the target directory for the copying procedure. Should this directory not exist, it will automatically be provided.

The fileset is defined in the simplest possible way. The dir attribute refers to the current work directory and the file pattern "*.xml" selects all XML files in the current directory.

Building on this example, you can try out the various attributes of the <fileset> tag. Consider the following examples as a stimulus for your own experiments.

ON THE CD

The CD-ROM has a build file for each of the following fileset definitions:

```
<fileset dir="." includes="*1*.xml" />
<fileset dir="." includes="*1*.xml, *3*.xml" />
<fileset dir="." includes="**.xml" excludes="*2*" />
```

The first fileset selects all XML files in the current work directory that contain the symbol "1" in their names. The second fileset involves the use of more patterns in the includes attribute. The patterns are separated by a space or a comma. All XML files containing one of the symbols "1" or "3" will be selected. The third example first selects all XML files, but excludes all files containing the symbol "2" using the excludes attribute.

The pattern ** ensures that not only files from the current directory, but also those from any subdirectories will be selected:

```
<fileset dir=".." includes="**/*.xml" />
```

If multiple directory levels exist, you can specify the directory depth using a single asterisk. The following pattern would select all XML files located in subdirectories at the first level. The XML files in the current directory are not included in this pattern!

```
<fileset dir="../chapter 4" includes="*/*.xml" />
```

To test the operation of the defaultexcludes attribute, you must first generate a file in the current work directory that corresponds to the excludes pattern, e.g., vssver.scc.

The file name patterns must appear unconditionally and directly in the build file. You can use the two attributes `includesfile` and `excludesfile` to read external files containing the pattern.

If very many patterns or file names must be included in a fileset, the notation in the attributes of the tag becomes obscure. Then embedded tags can also be used instead of the four attributes described above. We are concerned with the tags

```
<include>
<exclude>
<includesfile>
<excludesfile>
```

All the tags are equipped with the `name` attribute, in which either it or the pattern or name of the file to be read-in is noted. Naturally, the tags can only accept one name or one pattern each.

The aforementioned tags are evaluated in a prespecified order. First, files with the two `<include>` tags will be selected. Here Ant evaluates all the tags of this type, regardless of their order. Then Ant applies all the exclude patterns to this selection.

All four of the tags are processed in a more interesting way by the attributes `if` and `unless`. The attributes have the same effect as with the `<target>` tag. They contain the name of a property as a value. The tag will then be operative only if the tag exists (for `if`) or if it does not (in the case of `unless`).

Here is an example of this:

```
<project name="bsp0607" default="main" basedir=".">
  <target name="main" depends="prepare">
    <copy todir="targetdir">
      <fileset dir=".">
        <include name="*6*.xml" if="p1"/>
        <exclude name="*2*.xml" unless="p2"/>
      </fileset>
    </copy>
  </target>

  <target name="prepare">
    <delete dir="targetdir"/>
  </target>
</project>
```

Here the optional attribute of the `<fileset>` tag is dispensed with. Instead, two embedded tags come into action. Both define a pattern, but are also dependent on, respectively, the existence or nonexistence of a property. You call these build files in turn using the following commands:

```
ant -f bsp0607.xml -Dp1=x
ant -f bsp0607.xml -Dp1=x -Dp2=x
```

In the first case, all XML files with a "1" in their name will be copied. However, all files in whose name the symbol "0" appears will be masked out. Since the exclude pattern will be suppressed during the second call by the action of the property p2, more files should be copied.

The current implementation (version 1.5.1) has one characteristic that is regarded either as a bug or a feature by various users. If a directory that does not exist is called up in a `<fileset>` tag by the attribute `dir`, the build is interrupted with an error message. If the build file has a generic character and is to be employed, when necessary, in different environments, or varying directory structures have to be taken into account, this may require different filesets. For that purpose, distinct targets must be defined when necessary, and their execution will depend on the existence of various resources (files, directories, etc.). You can find more information on the evaluation of conditions in Chapter 9.

6.1.2 Patternset

The four tags mentioned above will be collected into a group by the `<patternset>` tag. Each patternset can be supplied with an ID and later referred to at other locations. This is, moreover, possible for the complete fileset. Not only the `<patternset>` tag, but the `<fileset>` tag as well, can be quoted outside the target. Patternsets can also be multiply interlocked with one another.

The following listing is an example of the application of a patternset:

```
<project name="bsp0608" default="main" basedir=".">
  <patternset id="ps">
    <include name="*6*.xml" if="p1"/>
    <exclude name="*2*.xml" unless="p2"/>
  </patternset>

  <target name="main" depends="prepare">
    <copy todir="targetdir">
```

```
        <fileset dir=".">
          <patternset refid="ps"/>
        </fileset>
      </copy>
    </target>

    <target name="prepare">
      <delete dir="targetdir"/>
    </target>
  </project>
```

The preceding examples make it clear that all pattern-based selections are OR-coupled. If two <include> tags exist, then not only those files matching the first and second patterns will be selected, but also all those which match at least one of the two patterns. Should multiple patternsets be contained in a fileset, these will likewise be coupled to one another.

6.1.3 Selection by File Characteristics

It was pointed out early that there are other possibilities for bringing files into a fileset besides pattern-based selection. Additional characteristics of the files will be evaluated by other tags. At present, the possibilities listed in Table 6.2 exist. The tags used for these selections will also be referred to as *selectors*.

TABLE 6.2 Tags for Selection by File Characteristics

Tag	Description
contains	selects files containing a specified character string.
date	Determines the last modification date for the file.
depends	Finds all the files in a target directory which are older than a file of the same name in the current working directory.
depth	Limits the file selection to a specified directory depth.
filename	Selection by name pattern (analog <include>).
present	Checks whether a file with the same name as in the working directory exists or not.
size	Determines the file size.
custom	Calling a particular Java class for carrying out the selection.

The individual selection tags employ widely different attributes with partially prespecified sets of values. Hence, the tags must now be described in more detail.

Unlike pattern-based selections, the tags for evaluating file characteristics are conventionally AND coupled. Furthermore, they are utilized only after evaluation of pattern-related selections. For a file set within a fileset to be evaluated jointly by pattern and file characteristics, two conditions are necessary:

- The pattern selection must be initiated by the `<filename>` selector.
- The individual selection tags must be connected by coupling operators.

You can find more details on this in Section 6.1.4., *Combination Operators*.

Contains

The `<contains>` tag selects all files containing a specified character string. Only two attributes are available for it. These are described in Table 6.3.

TABLE 6.3 Attributes of the `<contains>` Selection Tag

Attribute	Description	Default	Required
text	The character string to be searched for.	true	Yes
casesensitive	A flag indicating whether upper/lower case letters are to be distinguished.		No

The application is very simple, as the following example shows. In addition, the current file is excluded from the fileset by the `<exclude>` tag, as it is inevitably to be copied.

```
<project name="bsp0609" default="main" basedir=".">
  <target name="main" depends="prepare">
    <copy todir="targetdir">
      <fileset dir=".">
        <contains text="patternset" />
        <exclude name="${ant.project.name}.xml" />
      </fileset>
    </copy>
```

```
        </target>

        <target name="prepare">
          <delete dir="targetdir"/>
        </target>
      </project>
```

Date

The `<date>` tag selects files depending on a time statement. Table 6.4 lists the currently available attributes.

TABLE 6.4 Attributes of the `<date>` Selection Tag

Attribute	Description	Default	Required
`datetime`	Date in the form MM/DD/YYYY, HH:MM AM or PM.	`datetime` or `millis`	
`millis`	Number of milliseconds since January 1, 1970.	`datetime` or `millis`	
`granularity`	Tolerance for the time statements in milliseconds.	2000 ms for Windows systems; otherwise 0	No
`when`	Comparison criterion.	Possible values: `before equal` `after equal`	No

You specify the comparison date using the attributes `datetime` or `millis` and the comparison criterion with the optional attribute `when`. Depending on the comparison criterion, the `<date>` tag selects all the files whose time of last modification either is before or after the reference date, or corresponds exactly to that date. With the `granularity` attribute you can specify a tolerance which will be applied in the time comparisons.

The value for `datetime` must be given in the format "MM/DD/YYY HH:MM AM|PM". Otherwise, Ant interrupts with an error message.

A simple example can also be provided for this tag:

```
        <fileset dir="." includes="*.xml">
          <date datetime="07/26/2002 8:00 PM" when="before"/>
        </fileset>
```

The `includes` attribute in the `<fileset>` tag should prevent too many files and possible subdirectories from being copied. For the date, you set a value that makes sense with respect to the processing time on your system.

Size

With the `<size>` tag, you can use the size of a file as a selection criterion. The attributes of this selector are self-explanatory (see Table 6.5).

TABLE 6.5 Attributes of the `<size>` Selection Tag

Attribute	Description	Default	Required
value	Comparison value.		Yes
units	Units for this value.		No
when	Comparison criterion. Possible values: less, more, equal.	equal	No

One peculiar feature of the `units` attribute is noteworthy. With this attribute, you specify the units for the specified value. Without this attribute, the attribute will be taken to be the number of bytes. The unit prefixes k, M, G, etc., and, therefore, the customary single-place designator, change every 1000 units. The combination

```
<size value="10" units="K"/>
```

also means exactly 10,000 bytes. Double-place designators (ki, Mi, Gi), on the other hand, operate as multipliers of 1024. Thus, the actual selection size for the following tag is 10,240 bytes:

```
<size value="10" units="ki"/>
```

Depend

This command also evaluates the time of last modification of a file. Here, of course, the comparison is not with a rigidly specified time point. Rather, the `<depend>` tag compares the modification dates of two files with one another. The source file will be included in the fileset selection if it is more up-to-date than the comparison file.

As the tag recognizes only two attributes (see Table 6.6), its function is somewhat more complicated than the functional mode for the previous tags.

TABLE 6.6 Attributes of the `<depend>` Selection Tag

Attribute	Description	Default	Required
`targetdir`	Directory in which the comparison files are to be sought.		Yes
`granularity`	Tolerance limit for evaluation of time data in milliseconds.	2000 ms for Windows systems, otherwise 0.	No

Since two files will be used for the comparison, two file lists or directories must be specified within the overall fileset command. The fileset itself defines one of the two lists. To begin with, a fileset contains all the files and directories within the start directory. All further selection mechanisms (regardless of whether they are defined by attributes or embedded tags) work with this set of files that is implicitly contained in the fileset and ultimately only limit it. In the `<depend>` tag, you define a second directory using the `targetdir` attribute. For every file that is contained in the current data selection, a file with the same name will be sought in the target directory of the `<depend>` tag. If the file in the target directory is older than the one in the fileset, the file remains in the fileset selection; otherwise it is removed. This `targetdir` attribute is of significance only for file comparison; it is not the same as the target directory of the `<copy>` tag.

In the basic setup for this tag, files starting with the two root directories will be compared with identical file names (including the subdirectories). Deviations from this ordering can be arranged by employing so-called mappers. Because of their complexity, mappers are discussed in a separate section.

Testing this tag requires some preliminary work, which will customarily be attended to in the `prepare` target. On deletion of the target directory, two subdirectories—`dependssource` and `dependstarget`—will be generated. They are produced by twice copying another example-directory. In this way, all the files of concern initially have a consistent modification date. The following script makes

it possible, aside from the target prepare when it is first called, to avoid copying any files:

```
<project name="bsp0611" default="main" basedir=".">
  <fileset dir="../Chapter05" id="fs"/>

  <target name="main" depends="prepare">
    <copy todir="targetdir" >
      <fileset dir="dependssource">
        <depend targetdir="dependstarget" />
      </fileset>
    </copy>
  </target>

  <target name="prepare">
    <delete dir="targetdir" />
    <copy todir="dependssource" >
      <fileset refid="fs"/>
    </copy>
    <copy todir="dependstarget" >
      <fileset refid="fs"/>
    </copy>
  </target>
</project>
```

Now you change the modification date of some files in the directory dependssource, e.g., by editing the file or invoking a system command. These are the files which will be copied in a fresh execution of the build file, using the <copy> tag in the main target.

Present

The <present> tag resembles the <depend> selector. Here, however, no check will be done as to whether the file is more up-to-date than a comparison file, but only as to whether a file that matches the file in the working directory exists in the comparison directory. A comparison for exactly identical file names is also of little use in practice. However, the <present> tag can work together with the previously mentioned mappers. It is thereby possible to set the name of the comparison file dynamically.

The operation of the attributes of the <present> tag can be seen in Table 6.7.

TABLE 6.7 Attributes of the <present> Selection Tag

Attribute	Description	Default	Required
targetdir	Directory in which the comparison files will be sought.		Yes
present	Establishes whether files will be selected which exist in only the working directory (srconly) or in both directories (both).	both	No

Depth

The <depth> tag limits the selection to selected directory levels. Here the names of the subdirectories play no role, for only the depth of linkage is important. Accordingly, the attributes of the tag, which you will find in Table 6.8, are simple.

TABLE 6.8 Attributes of the <depth> Selection Tag.

Attribute	Description	Required
min	The minimum number of directory levels between the output directory and the file.	At least one of the two attributes
max	The maximum number of directory levels between the output directory and the file.	

At least one of the two attributes must be used. If one attribute is not used, Ant uses the value 0 for min, and also selects directly from the output directory, while taking an unrestricted depth of linkage for max.

Filename

In terms of its functionality, the <filename> selector corresponds approximately to the capabilities of the <include> and <exclude> tags. In the attribute name, you specify a file name or pattern. Unlike with the other two tags, you can only use one element here. Multiple file names or patterns cannot be listed. With the flag casesensitive, you establish whether upper and lower case should be distinguished

in the comparison of names. The third attribute, negate, allows you to reverse the selection. With the aid of this attribute, the <filename> tag can mask the functionality of the <include> and <exclude> tags.

Table 6.9 lists the attributes of the <filename> tag.

TABLE 6.9 Attributes of the <filename> Selection Tag

Attribute	*Description*	*Default*	*Required*
name	File name or pattern for the selection.		Yes
casesensitive	Upper/lower case sensitive.	true	No
negate	Negate the selection.	false	No

Custom

The <custom> selector permits integration of a self-programmed selector. Here, however, we shall not go into detail on the possibilities for extending the functionality of Ant by means of self programming.

6.1.4 Combination Operators

The selectors that are not based on patterns can be combined with logical expressions using additional tags. In this case, the Ant documentation refers to selector-containers. Table 6.10 lists the possible combination operators.

TABLE 6.10 Logical Combinations for Selectors

Tag	*Description*
and	All the included selection conditions must be satisfied for a file in order for it to be selected.
majority	The majority of the selection criteria must be met for a file.
none	None of the selection criteria can be met.
not	Negation of an individual selection condition.
or	Or-combination of the selections.

The logical combination operations can be demonstrated very easily. The following example performs numerous copying procedures into different target directories and, in each case, uses another form of combination for the selection patterns.

The <none> coupling requires multiple expressions in order to keep the number of copied files to a minimum.

```
<project name="bsp0612" default="main" basedir=".">
  <target name="main" depends="prepare">

  <copy todir="target_or">
    <fileset dir=".">
      <or>
        <filename name="*2*.xml"/>
        <filename name="*3*.xml"/>
      </or>
    </fileset>
  </copy>

  <copy todir="target_and">
    <fileset dir=".">
      <and>
        <filename name="*1*.xml"/>
        <filename name="*2*.xml"/>
      </and>
    </fileset>
  </copy>

  <copy todir="target_non" includeemptydirs="false">
    <fileset dir=".">
      <none>
        <filename name="*1*.xml"/>
        <filename name="*3*.xml"/>
        <filename name="*5*.xml"/>
        <filename name="t*/**/*"/>
        <filename name="d*/**/*"/>
      </none>
    </fileset>
  </copy>

  <copy todir="target_not">
    <fileset dir=".">
        <filename name="*2*.xml"/>
```

```
            <not>
              <filename name="*1*.xml"/>
            </not>
          </fileset>
        </copy>
      </target>

      <target name="prepare">
        <delete includeemptydirs="true">
          <fileset dir=".">
            <include name="target*"/>
            <include name="target*/**"/>
          </fileset>
        </delete>

      </target>
    </project>
```

The individual combination tags can be interlaced with one another when necessary.

Should pattern-based and characteristic-based selections be needed together in a fileset, the logical combinations and use of the `<filename>` selector offer a way out. The following segment of a listing provides a statement by which all files will be selected that either contain the character string "UnicastRemoteObject" or correspond to a special name pattern:

```
<or>
  <contains text="UnicastRemoteObject"/>
  <filename name="${path.rel.remove}/Remote*Impl.class"/>
</or>
```

6.1.5 Selectors

With pattern-oriented operating tags, reference is made to the patternset. In similar fashion, you can combine the selectors using the `<selector>` tag. All the previously described selectors, and the `<selector>` tag itself, can be contained within a `<selector>` tag. Likewise, as with a patternset, a selector can be defined outside a target as an independent element, and later be tied in by reference.

Independently of the place of definition, every `<selector>` tag, like every `<patternset>` tag, can be referenced in an arbitrarily deep sublevel by ID to other

locations in the build file. For reasons of clarity, it is better to dispense with this variant. Insofar as a reference should occur, the intelligibility of the build file is greatly improved if the objects to be referenced are generated as separate elements outside targets.

6.2 DIRSET

Besides fileset, there is a similar but rarely employed construct that only selects directories. Its mode of operation resembles that of fileset. The selection of directories proceeds via attributes or embedded tags. All of the pattern-based tags familiar from fileset are possible, as well as `<include>`, `<includesfile>`, `<exclude>`, `<excludesfile>`, and `<patternset>`.

Table 6.11 lists the attributes of this tag.

TABLE 6.11 Attributes of the `<dirset>` Tag.

Attribute	Description	Default	Required
dir	Root directory for the dirset.		Yes
includes	List of all the directories to be accepted. Pattern statements are possible. Separated by spaces or commas.	All subdirectories	No
includesfile	Name of a file containing the files to be included or the corresponding patterns.		No
excludes	List of all directories to be excluded. Pattern statements are possible. Separated by spaces or commas.		No
excludesfile	Name of a file containing the files to be excluded or the corresponding patterns.		No
casesensitive	Upper/lower case sensitive?	true	No
followsymlinks	Follow symbolic links?	true	No

6.3 FILE AND PATH LISTS

A fileset defines one or more search patterns, which will be used to find a number (usually) of files and directories. Depending on the higher tag, it serves both for the selection of files and for the selection of directories.

Occasionally it is also necessary to set up a list with exactly named files. In addition, some of the commands require a list with paths as a runtime environment. As an example, the <javac> command requires the class path in order to make precise use of the runtime system and external libraries.

Separate tags exist for these two purposes. First of all, the path lists must be examined intensely in more detail, as they are of more significance than the file lists. These lists are referred to as *pathlike structures* in Ant terminology. In terms of their purpose, path lists may contain file names as well as actual path statements. Finally, jar and zip archives occupy an important place in a Java classpath.

The basis for paths lists is the <path> tag. This tag can exist outside targets and be referenced later. It is provided with two attributes for path selection—location and path. The attribute location is intended for notation of a single path, while path can accept multiple paths separated by semicolons or colons. Often the path attribute will be filled by a property, e.g., one containing the class path taken over by the system.

Complex path lists can be provided by additional embedded tags. First, a <path> tag can contain other <path> tags. This is possible primarily in connection with the referencing of this tag. Beyond that, there is the <pathelement> tag, which possesses the same attributes as <path> tag, but cannot be referenced. This tag has no further embedded tags.

It is also possible to insert files and directories in a path list with the tags <fileset>, <dirset>, and <filelist>.

Special tags for path statements, e.g., <classpath>, exist in connection with some tags such as <javac>. These tags are syntactically identical with the <path> tag described here, but, despite their name, they occupy a special place within selected tags. Table 6.12 lists these tags along with the commands that can contain them.

These tags have the characteristic that they are, so to speak, compatible with the <path> tag in terms of allocation. Of all the pathlike tags, only the <path> tag can be defined outside the target. It is, however, possible to reference these tags in the tags of Table 6.12. In this regard, compare this with the (following) example.

TABLE 6.12 Tags for Pathlike Structures and Their Use

Tag	Contained in Commands (examples)
addfiles	Jlink
bootclasspath	Javadoc, javah, javac
classpath	java, javac, filterreader, mapper, javadoc, ...
coveragepath	jpcovreport
extdirs	rmic, javac
filepath	available
mergefiles	Jlink
rulespath	Maudit
searchpath	Maudit
sourcepath	javadoc, maudit, jpcovreport, mmetrics, ...
src	javac
wasclasspath	websphere
wlclasspath	wlrun, weblogictoplink

The following fragment of a practical build file illustrates the use of pathlike tags, using the example of a classpath definition for a `<javac>` command:

```
<property file="main.properties" prefix="pf"/>
<path id="classpath">
  <pathelement path="${java.class.path}" />
  <pathelement location="${pf.extClasses}/classes12.zip" />
  <pathelement location="${pf.extClasses}/JSQLConnect" />
...
</path>
...
<javac srcdir="${pf.path.abs.src}/ff"
       destdir="${pf.path.abs.build}/classes">
  <classpath refid="classpath"/>
</javac>
```

We conclude with some comments about `<filelist>`. This tag will be needed only in very rare cases. The attributes are given in Table 6.13.

TABLE 6.13 Attributes of the `<filelist>` Tag

Attribute	Description	Required
dir	Output directory for file statements.	Yes
files	List of files.	Yes

The root directory will again be set by the attribute `dir`; in `files` you enter the list of desired files. Pattern specifications are not possible; the file names are relative to the value of `dir`. Embedded tags are not recognized by this command.

6.4 MAPPERS

With the help of the filesets described in the preceding section, you can communicate to the various commands which files are to be processed. Usually, these commands generate additional files. Normally, the name of the generated file corresponds to the output file. Depending on the command, the file name parcel changes the most. From `*.java` files, for example, after execution of `<javac>` commands, `*.class` files result. In addition, the path structure in the target directory turns out to be analogous to the path structure of the output directory.

Occasionally it is desirable to be able to have some influence on name formation. *File mappers* or, in short, *mappers* exist for this purpose.

A mapper influences name formation for files generated as the result of a command. A mapper must, for this reason, be noted in the respective command. In each case, only one mapper can be used. Multiple mappers cannot be defined because of possible ambiguity.

Ant provides a few mappers as the norm. In addition, you can tie in a few implementations with the aid of a special variant of a command, as with the selectors. At this point only the mappers provided by Ant will be explained further.

A `<mapper>` tag has the attributes listed in Table 6.14.

TABLE 6.14 Attributes of the `<mapper>` Tag

Attribute	Description	Required
type	Type of mapper. The kind and mode of conversion are specified.	Yes
from	Starting pattern; dependent on type, if needed.	Depending on type
to	Output pattern; dependent on type, if needed.	Depending on type

Various types of mappers exist. The following sections discuss each type in detail. First, however, here is a sample file that illustrates the operation of a mapper:

```
<project name="bsp0613" default="main" basedir=".">
  <target name="main" depends="prepare">
   <copy todir="targetdir">
     <fileset dir="." includes="*.xml"/>
     <mapper type="glob" from="*.xml" to="*.bak"/>
   </copy>

  </target>

  <target name="prepare">
    <delete dir="targetdir"/>
  </target>
</project>
```

This example is based on a minimal extension of the fileset example. A simple mapper comes into action within the `<copy>` tag. Its task is to convert the file names of all the output files (also the copies). In this case, all `*.xml` files will be renamed as `*.bak` files.

A mapper does not search through the current file system for files as such. It only converts file names that have been transferred to it. It gets a list with file names from the higher order command. These consist of the relative path name, (with respect to the working directory of the command), and the proper file name. The mapper evaluates this name as a simple character string. All pattern operations will be carried out by the mapper as pure character string comparisons or string substitutions. That can be problematic if the path separator is to be used explicitly in the patterns, as it depends on the current operating system. In this case, you should use

the predefined property `file.separator`, in which Ant files the symbol that the current environment expects as a path separator symbol.

Now to the individual mapper types in detail.

6.4.1 Identity Mapper

The identity mapper should, strictly speaking, never actually be used, as it accepts no modification in the file name. Thus, it ignores the two attributes `from` and `to`.

6.4.2 Flatten Mapper

The flatten-type mapper leaves the actual file names unchanged, but removes the prefixed path. When used in a `<copy>` command, all the copied files will be copied into one and the same subdirectory. The attributes `from` and `to` are unnecessary for this function and are, therefore, ignored.

Through an omission in the directory structure, a target file name might be allotted several times. Should this occur, it can, for example, lead to overwriting of some files.

6.4.3 Merge Mapper

This mapper requires use of the `to` attribute; it, of course, ignores the `from` attribute. All source files will be transferred to the file name specified by the `to` attribute. Here it should be noted that the mapper merely delivers the assignment of the source-to-target file names to the higher order command. In the case of the example given above, therefore, all the files will be copied one after another and, because of the invariably identical name of the target file, it will be overwritten every time. The merge mapper, thus, makes no sense in this scenario. Other commands which can be used to chain files (e.g., `concat`) possess an attribute in which the target file name can be set. Here, as well, the merge mapper is not required.

This mapper can certainly be helpful in connection with the above-described selectors within a file set. Two of the selectors (`<depend>` and `<present>`) accept an embedded `<mapper>` tag. In this case, this specifies the name of the comparison file. In the case of the merge mapper, all the source files will be compared with a single target file. In this way, for example, it can be determined which source files have been repeatedly changed following the preparation of an archive. Here is an example:

```
<project name="bsp0614" default="main" basedir=".">
  <property name="name.zipfile" value="demo.zip"/>
```

```
<target name="main" depends="prepare">
  <touch file="${ant.file}"/>
  <copy todir="targetdir">
    <fileset dir="." includes="*.xml">
      <depend targetdir="." granularity="0">
        <mapper type="merge" to="${name.zipfile}"/>
      </depend>
    </fileset>
  </copy>
</target>

<target name="prepare">
  <delete dir="targetdir"/>
  <zip destfile="${name.zipfile}">
    <fileset dir="." includes="*.xml"/>
  </zip>
</target>
</project>
```

The structure of this example is similar to that of the previous examples. Here, however, in the preliminary target, not only will the target directory be deleted, but an archive will be prepared. The zip command used for this has not been discussed yet, but its function is easily understood. All the files contained in the embedded fileset will be taken into the archive.

In the main target, the modification date of the current build file will be fixed to the current time by the <touch> command. This file is then more up-to-date than the just-prepared zip archive. Within the copy command, files that are more up-to-date than the zip file are selected by the combined <depend> and <mapper> tags. Hence, only the current build file will be copied.

In this example, the <copy> tag serves only as a simple way of marking the files chosen by fileset.

A really practical application would be to compile just those Java files which have changed since the preparation of the archive. Selections of this type can save significant amounts of time in an actual build.

6.4.4 Glob Mapper

The glob mapper employed in an example at the beginning of this chapter performs an actual change in the file names. In the from and to attributes, you specify pat-

terns for file names. These names can also contain a path statement. The patterns can contain at most one pattern symbol "*". Other pattern symbols are not allowed. For all files corresponding to the `from` pattern, the name components selected according to the pattern symbol, are set in the location of the pattern symbol in the `to` attribute. In this way, components of the path statement can also be selected according to the pattern symbol, and not only components of the file name, as such.

Files that do not correspond to the `from` pattern are completely ignored. In this way the mapper acts simultaneously as a supplementary filter.

This mapper can, naturally, be better described using a few examples than through mere explanations. The following little directory tree, placed in the current work directory for the sake of simplicity, will serve as a basis for discussing several patterns.

```
MapperExampleDir
    Sub1
        File-a.text
        File-b.txt
    Sub2
        File-a.txt
        File-b.txt
```

ON THE CD

All pattern statements in the mapper are based on the fact that they will be accessed precisely from this work directory. You can try out the subsequent examples for mappers by modifying the following example. The CD-ROM contains a build file for functional mappers (`bsp0615.xml` to `bsp0617.xml`). The example directory is also there.

```xml
<project name="bsp0615" default="main" basedir=".">

  <target name="main" depends="prepare">
    <copy todir="targetdir">
      <fileset dir="."/>
      <mapper type="glob" from="M*.txt" to="M*.bak"/>
    </copy>
  </target>

  <target name="prepare">
    <delete dir="targetdir"/>
```

```
    </target>
  </project>
```

First, the fileset selects all files. The pattern in the mapper establishes that the file name (including the path name) begins with the letter M and ends with .txt. All four files fit this pattern. All symbols between the leading M and the file type, i.e., .txt, are masked out by the pattern symbol. As an example, for the first file this might be the character string apperExampleDir/subdir_1/file_a. The pattern symbol in the to attribute would be replaced by this character string, to yield the new file name MapperExampleDir/subdir_1/file_a.bak.

All components of the name that are not masked by the pattern symbol can be newly defined in the to attribute. This can also influence the path name. The following mapper will change both the file ending, and the name of the top directory.

```
<mapper type="glob"
from="MapperExampleDir${file.separator}*.txt"
to="backup${file.separator}*.bak"/>
```

This example also uses the path separator in order to actually limit the selection to the dir directory. The first mapper would, on the other hand, select all directories whose name begins with d.

The patterns can, naturally, also begin with the pattern symbol itself. The next mapper would then convert all files ending in txt into bak files. At the same time, however, all text files located in arbitrary directories in and below the current working directory will be processed. Certainly, the selection can also be limited by an additional fileset.

```
<mapper type="glob" from="*.txt" to="*.bak"/>
```

The following two mapper examples are not functional. Indeed, Ant does not even issue an error message and no output set results. The first example searches for files whose name begins with file_a. Such files do exist, but certainly not immediately in the current work directory. The from pattern, therefore, passes on no names that the mapper would have to process.

```
<mapper type="glob" from="file_a" to="file_c"/>
```

The next example employs two pattern symbols. This is not possible with a glob-type mapper. The second pattern symbol will no longer be recognized as a

pattern, rather the specific symbol will be searched for. None of the files corresponds to this pattern.

```
<mapper type="glob" from="*_*" to="*-*"/>
```

6.4.5 Package Mapper

The package mapper operates in a manner similar to that of the glob mapper. Indeed, in the part of the file name to be selected by the pattern symbol, it replaces all the path separators by a period. In this way, a character string is produced from a conventional path specification, of the sort that can be used in notation of the name of Java classes. Thus, this mapper can, in particular, be inserted in order to determine whether a class is still current within an archive.

6.4.6 Regexp Mapper

The mappers described up to here can contain at most one pattern symbol. They cannot be used for some tasks, e.g., replacing a hyphen by an underline. For this purpose, a mapper is available in which both the search pattern and the replacement string can be provided in the form of regular expressions.

A comment must be made in this regard. The JVM requires additional libraries for the processing of regular expressions in this case. You may have to install these in your JVM. You can find more details on this installation and on the elements of regular expressions in Chapter 17.

A regular expression defines multiple partial patterns which will be enclosed in parentheses. The overall expression found by this pattern can be inserted with the placeholder \0 in the results string, and the partial strings, with the placeholders \1 to \9.

The task mentioned at the beginning of this section, replacing an underline by a hyphen in the file names, can be carried out using the following file:

```
<project name="bsp0618" default="main" basedir=".">
  <target name="main" depends="prepare">
    <copy todir="targetdir">
      <mapper type="regexp" from="^(.*)\_(.*)" to="\1-\2"/>
      <fileset dir="." includes="MapperExampleDir/**/*.txt"/>
    </copy>
  </target>

  <target name="prepare">
```

```
        <delete dir="targetdir"/>
    </target>
</project>
```

SUMMARY

Mappers are used to change file names, with different mechanisms coming into action. Both source and target names can be defined by pattern statements.

Mappers are small, independent commands, but they are used only as embedded elements.

The higher-order command only processes files whose names are provided by the mappers. Thus, in addition to the other selection mechanisms, a mapper limits the set of files to be processed. This can lead to unwanted side effects.

7 ■ File Commands

Many actions during a build require various manipulations on or with files. Most often it is necessary to copy or move files, erase old files, and set up an appropriate directory structure. A series of commands are available for these tasks, and this chapter is devoted to them. Almost all the commands share the feature that the files to be processed have been selected using the mechanisms described in the preceding sections.

7.1 COPYING AND MOVING

A build does not just involve the compilation of the source files. In particular, in a Java ambience, certain pre- and post-processing is necessary. File copying is of central importance in this.

7.1.1 The Copy Command

The most important and most often used command among the range of file commands is the <copy> command. It is used for copying files and directories, while additional manipulations can be performed, e.g., on file names, file content, or directory structures, by means of various attributes, embedded tags, and other elements.

The <copy> command copies files and directories. It replaces the outdated commands <copyfile> and <copydir>. The file access privileges of the source file are not transferred during copying.

When copying, it is natural initially to specify source and target files or directories. Various methods come into action for this purpose. The target specification

depends on whether an individual, explicitly named file, or perhaps multiple files, and directories are to be copied.

A single file to be copied can be specified using the `file` attribute. This attribute does not perform a pattern search. Wild cards will not be interpreted, but will be treated as normal symbols. The specified file must exist, or else Ant will generate a build error. This can, of course, be prevented using the attribute

```
failonerror="false"
```

In this case, Ant will, indeed, generate a warning, but it will not interrupt the build. This attribute only works for the `file` attribute.

The attributes `tofile` or `todir` are available for specifying the target. One of the two attributes must be contained in the `<copy>` tag. With `tofile` you can specify a complete file name including the path, while the name of the target file can, naturally, differ from the name of the source file. With `todir` a target directory is specified into which the relevant files will be copied. In this way the real file name will not be changed, unless the `<copy>` tag contains a mapper. If the target file already exists, it depends on various boundary conditions whether it will be overwritten or not. More about this later. Here we first give two examples that illustrate the copying of a single file:

```
<copy file="init.properties"
      tofile="server/startup.properties"/>
<copy file="init.properties"
      tofile="server"/>
```

In order to copy numerous files or directories, the `<copy>` tag must be enhanced with one or more embedded `<fileset>` tags. In this case, both the `tofile` and the `todir` attributes can be used for target specification. Of course, Ant generates a build error when `tofile` is used if more than one file has been selected by the `<fileset>` tag. An error also occurs if the root directory introduced in the fileset tag does not exist. This error cannot, of course, be suppressed by the `failonerror` attribute. The filesets and all the possibilities for file selection have already been discussed in detail in Chapter 6. Here is a little example:

```
<copy todir="install"/>
  <fileset dir="build" includes="*.class"/>
  <fileset dir="etc"/>
    <include name="*.properties"/>
    <include name="*.resources"/>
```

```
</fileset>
</copy>
```

During copying of multilevel directories, the directory structure within the start directory will be copied as well. Empty subdirectories will also be copied if their names are acceptable to the selection pattern for the fileset. If empty directories should not be copied, then copying can be suppressed using:

```
includeemptydirs="false"
```

Subsequently, you can use

```
flatten="true"
```

to ensure that the files to be copied are set directly in the target directory without imitating the directory structure of the source. Should files with the same name exist, an already existing file will be overwritten.

During the copying procedure, so-called *filters* can be employed which modify the contents of the file to be copied. Usually we are concerned with the replacement of various tokens with other information, for example by a copyright notice or the build date. You can find more information on filters in Section 8.9. Filters can exist either outside <copy> commands, or in the form of embedded tags within the <copy> tag. In order for externally defined filters to work, they must be activated by the attribute

```
filtering="true"
```

inside a <copy> command. In this way, all global filters are operative; no selection is possible.

The <copy> command operates selectively. In the standard case, a file will be copied only when the target file does not exist or is older than the source file. Only through the attribute

```
overwrite="true"
```

can you force all files to be copied always, regardless of whether the target file is older than the source file or not.

With the Microsoft operating system, the case (Upper/lower) of a file name is preserved, even if the notation of the file to be copied is different.

Some other commands, e.g., the compiler command <javac>, also check the modification date of the files in order to avoid unnecessary work. During copying, the copied files keep the current system time as a modification date. Thus, they will be treated as new in every case, even when the original file has undergone little real change. You can use the attribute

```
preservelastmodified="true"
```

to make the target file take the same modification date as the source file.

Table 7.1 shows you the complete attributes of the <copy> command.

TABLE 7.1 Attributes of the <copy> Command

Attribute	Description	Required	Default
file	The file to be copied. No interpretation of pattern characters.	Either the attribute file or an embedded fileset.	
preservelastmodified	The copies contain the same modification date as the original.	No	false
tofile	Name of target file.		Either tofile or todir.
todir	Name of target directory.		Either tofile or todir.
overwrite	Existing files also over-written if they are newer than the source file.	No	false
filtering	Allow for global filters?	No	false
flatten	Ignore directory structure during filing in target directory.	No	false

(continues)

TABLE 7.1 Attributes of the <copy> Command (*continued*)

Attribute	Description	Required	Default
includeemptydirs	Copy empty directories.	No	true
failonerror	Generate a build error if a file to be copied does not exist.	No	true
verbose	List the names of the copied files at the console.	No	false

The <copy> command accepts a comprehensive set of embedded tags. <fileset> has already been mentioned. Another tag that is closely tied to the <copy> command is the <mapper> tag. It makes it possible to modify file names in accordance with a conversion prescription. This command is very helpful for automatically adapting file or directory names in the course of massive copying procedures. You can, for example, change the file name package. You will find descriptions of the various mappers in Section 6.4. The following should serve as an example in which all Java files are copied into a backup directory with the suffix ".bak".

```
<copy todir="backup"/>
<fileset dir="source" includes="*.java"/>
<mapper type="glob" from="*.java" to="*.java.bak"/>
</copy>
```

The two tags <filterchain> and <filterset> define so-called *filters*. These filters will be operative during copying. They modify the content of the files that are to be copied in accordance with different rules. Possible functions include the replacement of tokens, erasing comments, etc. Filters will be described in detail in Section 8.9.

Table 7.2 lists all the embedded tags accepted by <copy>.

TABLE 7.2 Embedded Tags for the <copy> Command

Embedded tag	Task	Detailed description in Section
filterchain	Group of filter definitions by which the contents of the files to be copied can be influenced.	8.9
fileset	Selection of files and directories to be copied.	6.1
filterset	Further filter definitions for processing of the file contents.	8.3
mapper	Element for conversion of file names.	6.4

7.1.2 The Move Command

The <move> command works in a way similar to the <copy> command. Although the official description states that fewer attributes can be executed than with the <copy> command, the <move> command does process all the attributes available to the <copy> command. A real difference occurs, however, in the default setup for the overwrite attribute. As opposed to the <copy> command, here the default value is true. Already-existing files will be overwritten immediately, even when they are more up-to-date than the file to be moved.

7.2 DELETE

You can erase files and directories with <delete>. The attributes file and dir are suitable for deliberate deletion of a file or directory. The two tasks are independent of one another. dir also does not stipulate in which directory file will be sought, but which directory should be deleted. The directory stipulated by dir will be completely deleted, with all subdirectories and files. In the attribute file, on the other hand, you can enter a file name, if necessary with a path statement. If an absolute path statement is lacking in file or in dir, the current working directory will be used as the starting point.

Besides the use of these two attributes, it is possible to define the files to be deleted by embedded <fileset> tags. In this case, usually only files will be erased, while the empty directory tree remains. In order to delete the empty directories as well, the attribute

```
includeemptydirs="true"
```

must be used in the <delete> tag. The two following commands are, accordingly, functionally identical:

```
<delete dir="build/classes" />

<delete includeemptydirs="true">
  <fileset dir="build/classes" />
</delete>
```

The <delete> command or the embedded filesets, as do some other commands, allows for a list with file name patterns that are not usually dealt with. These files are concerned with backup copies or help files for the various source code control systems. You can find more detailed information, and a list of the corresponding patterns, in the description of the <fileset> tag in Section 6.1.1.

While there is usually no problem with the exclusion of a help file from the copy command, unless otherwise desired, this behavior can be a nuisance during deletion. Undeleted files can prevent the removal of directories, as they are not empty. For this reason, the use of the defaultexcludes attribute is recommended. It is, of course, obsolete immediately within the <delete> tag, so it should be installed in the fileset. The attribute

```
defaultexcludes="false"
```

cancels the special role of the reserved file name pattern, and thereby permits deletion of the files without problems. Here is an illustrative fragment:

```
<delete includeemptydirs="true">
  <fileset dir="source" defaultexcludes="false" />
</delete>
```

The attributes of the <delete> command are listed in Table 7.3. Obsolete (deprecated) attributes are not included.

TABLE 7.3 Attributes of the `<delete>` Command

Attribute	Description	Default	Required
file	The file to be deleted.		Either file or dir or an embedded fileset
dir	The directory to be deleted.		Either file or dir or an embedded fileset
verbose	Output the names of deleted objects to the console?	false	No
quiet	Output error messages? If set to true, failonerror will automatically be set to false.	false	No
failonerror	Generate build error if an error occurs during deletion? This attribute will only be allowed if quit=false.	true	No
includeemptydirs	Delete empty directories if filesets are used for file selection?	true	No

7.3 SETTING UP DIRECTORIES

Although many commands set up directory structures independently, in many cases it is also necessary to be able to set up directories manually. The command `<mkdir>` is available for this purpose. It uses only the unconditionally applied attribute `dir`. This attribute accepts exactly one prescribed directory name. If a property substitution occurs, the name can be combined with the name of the property and a simple character string.

Relative path specifications always refer to the current working directory of the build file. Thus, it makes some sense to set up an absolute root in a property file, and complete this with the variable part of the path name in the `<mkdir>` tag:

```
<mkdir dir="build/classes"/>
<mkdir dir="${pf.path.abs.build}/classes"/>
```

7.4 DELETING DEPENDENT FILES

Certain files can be dependent on one another without always obeying a 1:1 relation. As an example, let just one archive be named whose up-to-dateness depends on the state of numerous files. Dependences of this kind will be evaluated by the `<dependset>` tag. Ultimately, the `<dependset>` command involves a delete command. Certainly, the deletion process depends on preconditions. Within the command, a list with source files and a list with destination files will be defined by embedded tags. The modification date of every target file will be compared with that of the source files. If one of the source files is more up-to-date than one of the target files, or if one of the source files is missing, then all the target files will be deleted.

It is especially appropriate to employ this command when a target file is made up of numerous source files. This can happen, e.g., when an HTML or JSP file is to be created by means of an XSL transformation from an XML file and a style sheet. This is also prescribed for the creation of a property file from multiple partial files.

The `<dependset>` command recognizes only four embedded tags. These are `<srcfileset>`, `<srcfilelist>`, `<targetfileset>`, and `<targetfilelist>`. These tags can occur repeatedly. With the two src-tags you define the list of source files and the two target-tags define the set of target files. The names of the four tags suggest that they actually are variants of `<fileset>` or `<filelist>`. They can possess precisely the same attributes and subtags as the two general file selection tags.

Files are compared and deleted in accordance with the basic characteristics of the file selection tag. This has several consequences. Thus, if a set of files is chosen as the target set by `<targetfileset>`, e.g., using a pattern statement, then all these files will be checked and, if necessary, deleted in accordance with the pattern statement.

If the source files are defined by `<srcfileset>`, then the number of source files is supplied dynamically. In this case Ant cannot check whether one of the source files is missing.

A few examples will clarify the command and its characteristics. The basis of the first example is the following scenario: properties for an application are kept in

an XML file. The file is tended by an XML editor, and the entries in the XML file will be validated with an appropriate DTD. This permits the preparation of correct XML files with complete contents, as well as automatic checking of these files. During the build process, an ordinary Java property file arises out of the XML file, e.g., via an XSL transformation. In order to prevent the occurrence of invalid property files, the <dependset> command checks whether the property file is definitely newer than any of the three output files. If this is not so, it will be deleted.

```
<dependset>
  <srcfilelist dir="src/properties" files="serverprop.xml"/>
  <srcfilelist dir="src/properties" files="serverprop.dtd"/>
  <srcfilelist dir="tools" files="transformprops.xsl"/>
  <targetfilelist dir="build/properties"
files="server.properties"/>
</dependset>
```

The set of shared files cannot always be specified explicitly. A second example deletes all class files in a target directory, when the source directory contains Java sources that are newer than one of the target files. This procedure is certainly a bit drastic, but in this way, you can indeed stimulate the complete translation of a project when the source condition has been changed. This is not necessarily required, but it does avoid problems with class files whose sources have long been eliminated from the project.

```
<dependset>
  <srcfilelist dir="soucre" includes="**/*.*"/>
  <targetfilelist dir="build/classes" includes="**/*.*"/>
</dependset>
```

7.5 TEMPORARY FILES

Occasionally, temporary files are needed in order to store intermediate results. During processing of text files, multiple operational steps are sometimes required (See Chapter 8). Thus, the command <tempfile> is available to provide unambiguous names for temporary files for these purposes. The name will be set down in a property. A file will not thereby be created!

The name generated by `<tempfile>` consists of the file name proper with a complete path statement. If only the file name itself is needed, this must be established using the `<basename>` command.

The `<tempfile>` tag recognizes the attributes listed in Table 7.4. There are no embedded tags.

TABLE 7.4 Attributes of the `<tempfile>` Command

Attribute	Description	Required
property	Name of the property to be set up and filled with the file name.	Yes
destdir	The directory to be placed in front of the name of the temporary file. The default is the current directory name.	No
prefix	A prefix for the file name.	No
suffix	A suffix for the file name.	No

7.6 CHECKSUMS

With the command `<checksum>`, Ant offers the prospect of generating checksums for files and of checking them later. This way changes in files can be recognized. This is relevant, for example, when source files or libraries are supplied by remote connections.

As with all other file-related commands, this command must communicate which files are to be processed. This happens either with the `file` attribute, which can accept exactly one file name, or through one or more embedded `<fileset>` tags. The resulting checksum can be set either in a property or in a file. A property can be used only when the checksum is calculated for a single file, and the `fileext` attribute will not be used. In all other cases, Ant provides a checksum file for every processed file. Its name is conventionally generated from the combined name of the original file and the algorithm designation. Instead of the algorithm name, you can define an alternative prefix using the `fileext` attribute. As most of the attributes are optional, a call of the `<checksum>` command is organized quite simply:

```
<checksum>
  <fileset dir="." includes="*.xml"/>
</checksum>
```

For verifying the correctness of a file, the `verifyproperty` attribute is noted in the `<checksum>` tag. This attribute contains the name of a property as a value. The command then calculates the checksum anew, compares this with the value in the checksum file, and sets the property to `true` or `false`, depending on the result of the test.

```
<checksum verifyproperty="isok" file="bsp0302.xml"/>
```

Table 7.5 lists all the attributes of this command.

TABLE 7.5 Attributes of the `<checksum>` Command

Attribute	Description	Default	Required
file	File for which the checksum is to be calculated.	Either file or embedded fileset	
algorithm	Algorithm for calculating a checksum (MD5 or SHA).	MD5	No
provider	Provider of the algorithm.		No
fileext	Name of a prefix for the checksum file.	Algorithm name	No
property	Name of a property for the checksum. See the text!		No
forceoverwrite	Overwrite existing files, even if they are up-to-date?	No	No
verifyproperty	Property for the result of the test.		No
readbuffersize	Buffer size for reading files.	8192	No

7.7 FILE CHARACTERISTICS

One characteristic of a file that is very important for Ant is the modification date. Many commands write a target file from a source file. This action will be carried out only if the source file is newer than the target file. In order to create definite states, it is often necessary to set the modification

date of files to a certain value. This is done with the `<touch>` command. This command can process a single file with the attribute `file` or a group of files and directories with an embedded fileset. Here are two examples:

```
<touch file="bsp0606.xml"/>
<touch>
  <fileset dir="Chapter06">
    <inculde name="bsp*.xml"/>
  </fileset>
</touch>
```

In the forms shown here, the files and directories contain the current system time as the modification time point. The two attributes `millis` and `datetime`, on the contrary, allow reference to another time point. Here `millis` denotes a time point given by the specified number of milliseconds after January 1, 1970. In the `datetime` attribute you can specify the desired time point in the form "`MM/DD/YYYY HH:MM [AM|$|PM]`". All components must be included. Other formats lead to a build error.

```
<touch file="bsp0606.xml" datetime="09/01/2002 4:10 PM"/>
```

The operation of the `<touch>` command can be seen from the following example. A single file is copied. If the `<touch>` command is commented, then a copy procedure takes place only on the first call. With all subsequent calls, Ant recognizes that the target file is more up-to-date than the source file and won't copy it again. If the modification date for the source file is brought up to date before every call of the `<copy>` command, then Ant copies the file with every call.

```
<project name="bsp0701" default="main" basedir=".">
  <target name="main">
    <!--touch file="bsp0701.xml"/-->
    <touch file="bsp0701.xml"/>
    <copy file="bsp0701.xml" tofile="bsp0701.bak"/>
  </target>
</project>
```

There are no other platform independent commands for manipulating further file properties. That is unfortunate, since, at the very least, the write privileges have to be modified relatively often. In Unix systems, however, you can employ the `<chmod>` tag to set Unix-type privileges. In Windows systems, the only way out is to start a system command (See Chapter 14.2).

As the bulk of Java development is done on Unix computers, the `<chmod>` tag will have to be discussed here, despite its platform dependence. This command implicitly creates a `<fileset>` again. This means that all the subtags that also occur in the `<fileset>` tag can be in it, along with an embedded `<fileset>` tag.

The list of attributes (Table 7.6) is relatively short. Some of the attributes originate from the `<fileset>` tag. The `perm` attribute, which accepts a character string with the privileges to be set, is genuinely new. Structurally, this resembles the attributes of the Unix `chmod` command. You can use the `type` attribute to set whether only files, or directories as well, should be affected by the changes.

TABLE 7.6 Attributes of the `<chmod>` Tag

Attribute	Description	Default	Required
file	Name of a file or of a single directory whose privileges are to be changed.	Either `file` or `dir` or embedded filesets	
dir	Name of a directory in which the privileges of all the contained files are to be changed.		Yes
perm	The new access privileges.		No
includes	The list of all files to be included.		No
excludes	The list of all files to be excluded.		No
defaultexcludes	List with default exclusion allowed.	yes	No
parallel	Execute all changes at the system level with a single `chmod` call.	true	No
type	Select whether only files, only directories, or both are to be modified. Value set: `file`, `dir`, `both`.	file	No

7.8 DOWNLOADING FILES BY URL

All the examples up to now have proceeded from the assumption that all the required files are always available locally. Since Ant is somewhat more than a simple build tool, however, it can also obtain files by HTTP transfer and use them in the build process. In this way, for example, remote source code control systems can be addressed or resources can be provided from other locations. This command should not be regarded as unconditionally associated with an actual build. Ant can also be used for other tasks. For example, you could use the command

```
<get
src="http://www.geocities.com/bernd_matzke/ant/antexamples.zip"
      dest="antexamples.zip"/>
```

to download a zip file with all the examples in this book from my home page. This works, of course, only if you have access to the internet without proxy, or start Java with the appropriate settings. More about this at the end of this chapter.

The command `<get>` requires the use of two attributes `src` and `dest`. With `src` you establish the URL of the file to be downloaded. In the attribute `dest` you enter the name under which the file will be locally filed. If bigger files are to be downloaded, it might be appropriate to use the `usetimestamp` attribute. If this attribute is set to `true`, Ant tries to obtain the modification date of the source file and compares this with the modification time point of the local file. A download follows only if the local file is out of date.

Any failures during a download cause a build error and, thereby, an interruption of the processing. This can be prevented by using

```
ignoreerrors="true"
```

Additional information on downloads is provided by the attribute

```
verbose="true"
```

If the file to be downloaded is protected by an (HTTP-) password, then correct notification must be provided on the Web site using the attributes `username` and `password`. The `<get>` command is not equipped with embedded tags. Table 7.7 summarizes the attributes.

TABLE 7.7 Attributes of the `<get>` Command

Attribute	Description	Default	Required
src	URL of the file to be obtained.		Yes
dest	Name of the local file for receipt of the obtained data.		Yes
verbose	Display detailed information?	false	No
ignoreerrors	If `true`, there is no interruption when errors occur.	false	No
usetimestamp	Compare times. Download only if the local file is out-of-date. Only for HTTP-access.	false	No
username	Username.		If "password" is set
password	Password.		If "username" is set

The `<get>` command is certainly easy to employ, but it is not entirely free of problems. For example, there is no checking of downloaded files. If the Web server delivers a page with an output error instead of the desired file, it will be written without comment in the desired target file by `<get>`; however, a majority of problems of this sort can be relatively easily identified by checking the MIME type of the returned file. If the nameserver or the addressed Web server performs a URL mapping, that can, likewise, cause problems.

7.8.1 Access via Proxy Server

Because of security concerns, direct access from company networks to the Internet is not allowed. The connection to the Internet is provided by a proxy server. All applications which are to be accessed on the Internet must apply to this server, which then passes on the request. The corresponding settings proceed independently of the URL itself. How, exactly, this takes place, depends on the current tool. In the case of a Java application, the access data for the proxy server must be on hand at the start of the Java Virtual Machine, as a system parameter to be passed on to it (and not to Ant). The two parameters are:

```
-Dhttp.proxyHost=<proxyname>
```

and

```
-Dhttp.proxyPort=<portnumber>
```

You can get both specifications from your system administrator.

The start files of Ant make these tasks easier using the system variables ANT_OPTS. These variables will be tied into the Java call. You must assign these variables a suitable value only before the call of the Ant start file. They can then modify the start file themselves or, in your personal environment, be appropriately readjusted. Definition in the command line is also available for test purposes. In a Windows NT system the call looks like this:

```
Set ANT_OPTS=%ANT_OPTS% -Dhttp.proxyHost=companyproxy -
Dhttp.proxyPort=4712
```

8 | Modifying Text Files

Some tasks can modify the content of files. The simplest variant involves chaining the contents of several files together. Other variants involve replacing tokens (placeholders) with values. Possible areas of application include mixing of language dependent text directly in source code, entering a build number in status statements, or modifying property files. Various methods exist for solving these problems.

8.1 COMBINING FILES

This command combines (concatenates) the content of multiple files and writes them into another file. The name of the target file is specified by the `destfile` attribute. The `append` attribute establishes whether it will be appended to the target file or if it will be set up anew. If the task lacks a target file, then the result is delivered to the console. You can find the possible attributes in Table 8.1.

TABLE 8.1 Attributes of the `<concat>` Command

Attribute	Description	Default	Required
destfile	Name of the target file.	Console	No
append	If a target file exists, append content to the end of the file?	no	No
encoding	Coding for the font.	Platform dependent	No

The files to be combined or output are specified by embedded `<fileset>` or `<filelist>` tags.

The <concat> command cannot process any other embedded tags. The quite reasonable provision of filters does not (yet) work here. If needed, the files can be summarized and the entries manipulated in succession using the <concat> and <copy> tags, possibly using temporary files.

8.2 PROPERTY FILES

Property files exist in order to support Java applications with easily modified initialization data. They contain tasks in the form

```
Key = Value
```

The Ant task <propertyfile> can provide or modify files with entries of this type. This task has the obligatory attribute file, which is used to establish the name of the file to be processed. The optional attribute comment can be used in order to provide comments at the beginning of the property file.

The element <entry> is appropriate for modifying an entry. Obligatory attributes of this element set the name of the entry to be processed as well as its value. In addition, the values of existing entries can be modified using optional attributes.

The attribute key is absolutely necessary. It contains the name of the entry to be processed. The value of the attribute is set by one of the two attributes value or default. With value, the current value of the property entry is set every time to the specified value. If the entry does not yet exist, it will be set and furnished with the specified value. The attribute default, on the other hand, only operates if the entry is newly set. Thus, the default attribute sets the initial value for an entry in a property file. Initialization is not automatic; at least one of the two attributes must be used. Using default is most appropriate in connection with the operation attribute, which will be described now.

The optional attribute type with possible values int, date, and string, specifies the data type of an entry in detail. This prescription is important for the operation and pattern tags. operation can be used to calculate the new value for an entry, e.g., by raising the value by 1 each time. The pattern attribute, on the other hand, takes care of formatting the value.

A little example now follows. It makes a file available with three properties, of which two will later be inserted in a string inside a Java program. This string can be

output into an about box. This permits the unambiguous identification of the software state, which is of great importance in processing errors.

```
<project name="bsp0801" default="main" basedir=".">
  <property name="build.status" value="false"/>
  <target name="main">
    <propertyfile
      file="my0801.properties"
      comment="Build Information File - DO NOT CHANGE" >

      <entry
        key="build.num"
        type="int"
        default="0"
        operation="+"
        pattern="0000"
      />
      <entry
        key="build.date"
        type="date"
        value="now"
        pattern="dd.MM.yyyy HH:mm"
      />
      <entry
        key="build.running"
        value="${build.status}"
      />
    </propertyfile>
  </target>
</project>
```

The two attributes of the `<propertyfile>` tag establish `my0801.properties` as the file name. The file may not exist yet, and can be newly created if needed. The `comment` attribute ensures that the line

```
#  Build Information File - DO NOT CHANGE
```

will be inserted in the file. In addition, this task generates a further comment line which contains the date of last modification.

This example listing contains three `<entry>` tags. The entry `build.num` will be generated by the first. This entry must be of the type `int` and have the initial value 0.

The value of this entry increases by 1 on each access. The value "+" of the `operation` attribute is responsible for this. It requires a four-place format with leading zeroes. Here the value "0000" ensures the `pattern` attribute.

The second `<entry>` tag provides an entry with the current date. Here the `value` attribute is occupied by the value `now`. This value is only possible for the `date` data type. The pattern specified by `pattern`, formats the date in accordance with the specified pattern symbol. In this special case, the day's date will be given in the form day, month, and year, along with the current clock time. The possible format specifications correspond to those of `java.text.SimpleDateFormat`.

The pattern will be used both with a statement in the property file, and with parsing of the value imparted by `value` or `default`. When errors occur during parsing of the date value, the current date will be used. The significance of the places in the individual date constituents will certainly not be evaluated. The standard output format corresponds to "yyyy/MM/dd HH:mm". If an assignment must take place without a format specification having been provided in the tag, then the date must be entered in this standard form.

The third `<entry>` tag provides a simple entry of the data type `string`. The value will certainly be read as an Ant property. This possibility exists in all Ant tasks, as well as with the `<entry>` tag.

Table 8.2 summarizes the attributes of the `<entry>` tag. The tag is not provided with embedded tags.

TABLE 8.2 Attributes of the `<entry>` Tag

Attribute	Contains	Required
key	Name of the property entry.	Yes
value	Value to be assigned.	At least one of the two attributes `default` or `value`
default	Initial value for setting the property entry.	At least one of the two attributes `default` or `value`
type	Data type: `int`, `date`, or `string` (default).	No
operation	The operation which depends on the property entry to be applied. Dependent on data type.	No
pattern	Format of the input and output.	No

In Table 8.3 you will find the possible ranges of values for the `value` attribute.

TABLE 8.3 Possible Values of the `<value>` Attribute Depending on the Data Type

Type	Value	Effect
string	Arbitrary string.	Allocation of the string
int	Number.	Allocation of the number
date	Date.	Allocation of the specified date. Statement is either in standard format (yyyy/MM/dd HH:mm) or in the format prescribed by `pattern`
date	now.	Allocation of the current date

For each data type only certain operators are permitted; their effect, therefore, depends on the data type. Table 8.4 lists the currently available operators.

TABLE 8.4 Possible Operators for the Different Data Types

Type	Operation	Function
string	+	Appends the content of `value` to the current value of the property entry
	=	Sets the value of the property entry to the content of `value` (default function)
int	=	Sets the value of the property entry (default function)
	+	Raises the property entry by the value of `value`
	-	Decreases the property entry by the value of `value`
date	=	Sets the value of the property entry (default function)

8.2.1 Examples of Date Formats

The following build file provides seven date fields in a property file. All the assignments are syntactically correct, and the example can be correctly processed by Ant.

```
<project name="bsp0802" default="main" basedir=".">
  <property name="build.status" value="false"/>
```

```
<target name="main">
  <propertyfile
    file="my0802.properties"
    comment="Build Information File - DO NOT CHANGE" >

    <entry key="date1" type="date"
           value="2002.04.03"  pattern="yyyy/MM/dd" />

    <entry key="date2" type="date"
           value="2002/04/03"  pattern="yyyy/MM/dd" />

    <entry key="date3" type="date"
           value="2002.04.03"  pattern="dd.MM.yyyy" />

    <entry key="date4" type="date"
           value="03.04.2002"  pattern="dd.MM.yyyy" />

    <entry key="date5" type="date"
           value="2002/04/03 11:11" />

    <entry key="date6" type="date"
           value="2002/04/03" />

    <entry key="date7" type="date"
           value="2002.04.03 11:11" />
  </propertyfile>
</target>
</project>
```

These settings provide seven entries in the property file. Here a value is set for all entries which are not consistent in every case with the expected result:

```
date1=2002/06/06
date2=2002/04/03
date3=22.09.0008
date4=03.04.2002
date5=2002/04/03  11\:11
date6=2002/06/06  14\:09
date7=2002/06/06  14\:09
```

With the property entry date1, the value of value is not suitable for the format string. Whereas a period is used here to separate the components of the date in the

value attribute, the format string stipulates slashes. The date cannot be correctly parsed. Hence, the current date is used as a default. This error would be rectified by the second entry, where the value statement matches the format string.

The third entry does use the correct separator in the date value and in the format string, but the ordering of the individual components is wrong. This would not be noticed by Ant. A value is calculated corresponding to 2002 days after April 1, 3. This error is corrected by the fourth entry.

The example in the fifth property entry dispenses with the format string. In this case, the date and clock time must be specified in standard format. As the entry in the next row shows, the time statement cannot be dispensed with; otherwise, an error will again occur in parsing. The separator must also be entered correctly: the last line also leads to an error because of the nonstandard space.

Summary

The `<propertyfile>` task is useful for modifying the entries in classical property files. The entries to be processed must have the form

```
key=value
```

Simple expressions can be used for integer and string values. Every property file and every entry must be treated separately.

8.3 REPLACING PLACEHOLDERS BY COPYING

A further possibility for modifying files relies on the replacement of placeholders (tokens). This procedure can occur during copying of files. That is appropriate when numerous different copies have to be generated from a template, or the original file must be preserved in every case.

When replacement by copying takes place, the process relies on the `<copy>` or `<move>` tag. Besides the conventional specifications, such as the target directory, or the set of files to be copied, so-called *filters* must be defined. A filter contains the token that is to be replaced, as well as the value with which it is to be replaced. In the text to be replaced, the token must be enclosed in @ symbols.

You can connect them or the filter in two different ways with the `<copy>` tag. First, the filter assignment can be noted as a separate tag within a target. From the

moment of definition, filters are globally valid within a project, as well as in the build file. You can then also operate in other targets besides the current one. As the filter now does not automatically influence all <copy> tags of the project, you must enable evaluation of the filter in the <copy> tag by setting the optional flag filtering.

It is possible to overwrite once-defined filters. With a new definition of a filter, you can assign a new set value to a token inside a project that will be used from then on.

Besides independent use of the <filter> tag, one or more filters can be combined in a group using the <filterset> tag. This has several advantages:

- A filterset can be embedded in a <copy> command. It is then valid only for this command and no longer within the project as a whole.
- A filterset can evaluate alternative separators. Then the token to be replaced does not necessarily have to be enclosed in @ symbols.
- A filterset can be equipped with an identifier (ID). It can be referred to later through this ID, thereby saving some effort in writing.

First, an example of the use of a simple filter. The basis will be the text file source1.txt with the following content:

```
This is @token1@ and that @token.two@
```

So that this file will not have to be created separately with a text editor, the following example consists of two targets. The filter target, as such, is also dependent on the target createFile, in which the required text is supplied using the <echo> tag. Frequent use will be made of this procedure in the future. In order to ensure that the source file is newer than the target file during repeated calling of the build file, the <touch> command also comes into use as the file is written. This sets the time stamp for the file at the current system time.

The following command replaces the contents of both placeholders:

```
<project name="bsp0803" default="main" basedir=".">
  <target name="main" depends="createFile">
    <filter token="token1"
            value="the first replaced token" />

    <filter token="token.two"
            value="the second" />
```

```
    <copy file="source1.txt"
          tofile="target1.txt"
          filtering="true" />
  </target>

  <target name="createFile">
    <echo file="source1.txt">
This is @token1@ and that @token.two@.
    </echo>
    <touch file="source1.txt"/>
  </target>

</project>
```

It is to be expected that the file target1.txt will result with the following listed content:

```
This is the first replaced token and that the second.
```

The second example illustrates the global effect of a filter definition. This requires a second source file, source2.txt, with content corresponding to source1.txt. Three targets must be called in the build file: one for providing the file, and two for filters. In order for this to happen in the right order, the target main, which must be first, is called. Through the value of the depends attribute, this takes care of calling the targets createFile, filter_1, and filter_2 (in this order).

```
<project name="bsp0804" default="main" basedir=".">

  <target name="main"
        depends="createFile, filter_1, filter_2" />

  <target name="filter_1">
    <filter token="token1"
            value="the first replaced token" />

    <copy file="source1.txt"
          tofile="target1.txt"
          filtering="true" />
  </target>
```

```
<target name="filter_2">
  <filter token="token.two"
          value="the second" />

    <copy file="source2.txt"
          tofile="target2.txt"
          filtering="true" />
</target>

<target name="createFile">
  <echo file="source1.txt">
This is @token1@ and that @token.two@.
  </echo>
  <touch file="source1.txt"/>
  <echo file="source2.txt">
This is @token1@ and that @token.two@.
  </echo>
  <touch file="source2.txt"/>
</target>

</project>
```

The target `filter_1` will be executed first by Ant. The filter in this target performs the substitution of the first token. After correct execution of this target, the target `filter_2` is started. This target defines another filter which influences the second token. Accordingly, the first token must be substituted in the first file, and the first two must be substituted in the second file. The content of `target1.txt` then looks like this:

```
This is the first replaced token and that @token.two@.
```

The content of the file `target2.txt`:

```
This is the first replaced token and that the second.
```

Overwriting of filters can be illustrated with a modification of the target `filter_1`. For this, the target will be extended with a second filter. The example is *ON THE CD* not reproduced entirely here. It is, however, to be found on the CD-ROM as `bsp0805.xml`.

```
<target name="filter_1">
    <filter token="token1"
            value="the first replaced token" />

    <filter token="token.two"
            value="token 2" />
. . .
```

The target `filter_1` now has two filters available from the start. Both tokens will be substituted in the target file `target1.txt`:

```
This is the first replaced token and that token 2.
```

The second target defines the filter for the second token anew. Accordingly, another substitution takes place in the `target2.txt` file:

```
This is the first replaced token and that the second.
```

Other substitutions can be made using the `<filter>` tag in a filterset. A revision of the already-employed target illustrates at once the principle of using it. You will find the complete example on the CD-ROM as `bsp0806.xml`.

```
. . .
<target name="filter_1">

    <copy file="source1.txt"
        tofile="target1.txt" >
      <filterset>
        <filter token="token1"
                value="the first replaced token" />
        <filter token="token.two"
                value="token 2" />
      </filterset>
    </copy>
</target>

<target name="filter_2">
    <copy file="source2.txt"
        tofile="target2.txt"
        filtering="true" />
  </target>
. . .
```

The two filters in the `filter_1` target wander in a `<filterset>` tag within the `<copy>` command. Direct notation of a filter without filterset within a `<copy>` command is not possible. As the filter conditions will be explicitly noted in the `<copy>` command, the filtering attribute is no longer necessary in the `<copy>` tag.

Processing the file and checking the two result files now shows that changes have been made only in the `target1.txt` file.

Filtersets can be resolved out of the target segments and directly entered under the `<project>` tag. But basically, as only target segments will be executed, filtersets placed in this fashion will not be effective. They must be provided with an identifier and referenced within the `<copy>` tag. You will find the complete example as file `bsp0807.xml` on the CD-ROM.

```
<filterset id="fs" >
  <filter token="token1"
          value="the first replaced token" />
  <filter token="token.two"
          value="token 2" />
</filterset>
  . . .

<target name="filter_1">
  <copy file="source1.txt"
        tofile="target1.txt" >
    <filterset refid="fs"/>
  </copy>
</target>
```

Filtersets referenced in this way are, again, only effective for the surrounding `<copy>` tag. A reference outside the `<copy>` tag, as shown in the following listing, is certainly syntactically possible, but ineffective:

```
<target name="filter_1">
<!-- does not work !!! -->
<filterset refid="fs"/>

<copy file="source1.txt"
tofile="target1.txt"
filtering="true" />
</target>
```

A further advantage of the filtersets, is the possibility of changing the separator required for delimiting the token. For this, you use the attributes begintoken and endtoken. A demonstration is afforded by a trivial revision of the filterset and the example files. In the example file created by the createFile target, a second line will be entered with another separator. The two attributes mentioned here are to be added to the build file:

```
<project name="bsp0808" default="main" basedir=".">

  <filterset id="fs" begintoken="%" endtoken="$">
    <filter token="token1" value="the first replaced token"/>
    <filter token="token.two" value="token 2"/>
  </filterset>

  <target name="main" depends="createFile, filter_1"/>

  <target name="filter_1">
    <copy file="source1.txt" tofile="target1.txt">
      <filterset refid="fs"/>
    </copy>
  </target>

  <target name="createFile">
    <echo file="source1.txt">
This is @token1@ and that @token.two@.
Alternative separators %token1$ and %token.two$.
    </echo>
    <touch file="source1.txt"/>
  </target>
</project>
```

After the file is executed, the two placeholders in the second line will be replaced in accordance with the filter setting. The first line remains unchanged, as the separators no longer match the filter prescription.

The <filterset> tag within the <copy> tag can otherwise be equipped with the begintoken and endtoken attributes, in so far as effectively subordinate filters also exist in the <filterset> tag. In connection with the refid attribute, the two token attributes cannot be used. Supplementary parametrizing of a filterset by means of different separators is, therefore, not possible.

Besides direct specification of the filter criteria in the source text, you can, instead, also use a file and employ it in a filter command. A file of this sort can be used in numerous places. If the `<filter>` tag is used outside a filterset, you can replace the `token` and `value` attributes using the `filtersfile` attribute. This is not possible within a filterset. There you have to define the filter file, either using the `filters-file` attribute in the `<filterset>` tag, or using an independent `<filtersfile>` tag within the filterset.

All the possibilities for definition of filters can be combined inside a filterset. Should multiple filter conditions depend on one and the same token, the latest definition will always be operative.

The format of the filter file corresponds to the format of conventional property files. The token to be replaced serves as a property name, the content to be assigned as a value. In the following, you can see the listing of the filter file which, of course, is made available by a separate target:

```
token1=token 1
token.two=the second token
```

First, an example in which the filter file will be used in a simple filter command:

```
<project name="bsp0809" default="main" basedir=".">
  <target name="main" depends="createFile, filter_1"/>

  <target name="filter_1">
    <filter filtersfile="filter1.txt" />
    <copy file="source1.txt"
          tofile="target1.txt"
          filtering="true" />
  </target>

  <target name="createFile">
    <echo file="source1.txt">
This is @token1@ and that @token.two@.
    </echo>
    <touch file="source1.txt"/>

    <echo file="filter1.txt">
token1=token 1
token.two=the second token
    </echo>
```

```
        </target>

    </project>
```

A filterset now follows, which will be described by means of a filter file. In order for you to execute this example correctly, the filter file must first be created by processing the preceding example:

```
<project name="bsp0810" default="main" basedir=".">

  <filterset id="fs" filtersfile="filter1.txt" />

  <target name="main" >
    <touch file="source1.txt" />

    <copy file="source1.txt"
          tofile="target1.txt">
      <filterset refid="fs"/>
    </copy>

  </target>

</project>
```

Finally, you can see yet another example that combines multiple distinct commands for the filter definition:

```
<project name="bsp0811" default="main" basedir=".">
  <target name="main" depends="createFile, filter_1"/>

  <filterset id="fs">
    <filtersfile file="filter1.txt" />
    <filter token="token.two"
            value="write over the value from the filter file" />
  </filterset>

  <target name="filter_1">
    <filter token="3.token" value="token three."/>
    <copy file="source1.txt"
          tofile="target1.txt"
          filtering="true">
```

```
                <filterset refid="fs"/>
        </copy>
    </target>

    <target name="createFile">
        <echo file="source1.txt">
This is @token1@ and that @token.two@.
New line with @3.token@
        </echo>
        <touch file="source1.txt"/>

        <echo file="filter1.txt">
token1=the first token
 token.two=the 2nd token
        </echo>
    </target>

</project>
```

Should independent filters also exist besides the filterset in the current project, these will also be evaluated by the <copy> command, provided the `filtering` attribute is set to `true`. It is difficult to maintain perspective with filter combinations of this sort. Thus, to the extent possible, only one variant should come into action within a project.

For the sake of completeness, the `<filterchain>` tag should also be mentioned. Within this tag, multiple predefined or even self-programmed filters may be used, with one of the filters also executing the replacement of a token. The filters that can be used within a filter chain offer somewhat less functionality than the filterset described here, but they can be combined freely. Thus, the possibilities extend well beyond the replacement of tokens. You'll find more detail in Section 8.9.

The attributes of the three commands for filter definition can be summarized as follows. Table 8.5 summarizes the attributes of the `<filter>` tag.

TABLE 8.5 Attributes of the `<filter>` Tag

Attribute	Contains	Required
token	Name of a placeholder (token).	Together with `value`
value	Value to be assigned.	Together with `token`
filtersfile	File with filter definitions.	Alternative to `token` and `value`

The `<filterset>` command recognizes the `<filter>` and `<filtersfile>` tags as subordinate. The attributes are listed in Table 8.6.

TABLE 8.6 Attributes of the `<filterset>` Command

Attribute	Contains	Default	Required
begintoken	Name of a placeholder (token).	@	No
endtoken	Value to be assigned.	@	No
filtersfile	File with filter definitions.		No
id	Identifier.		No
refid	Reference to another filterset definition.		No

The attribute of the `<filtersfile>` command is given in Table 8.7.

TABLE 8.7 The Attribute of the `<filtersfile>` Command

Attribute	Contains	Required
file	Name of a file with filter definitions.	Yes

Summary

Filters in combination with the `<copy>` command allow for large scale changes in placeholders during copying or moving of files. Only substitutions with prescribed values are possible, but no calculations.

- The placeholders in the template text must be indicated with separators.
- The values to be substituted can be hard coded or taken from property files.

8.4 THE REPLACE COMMAND

With this command, it is possible to substitute placeholders (tokens) in one or more files. At the same time, it will not be copied; the changes occur directly in the specified files. The command executes the substitution in write-protected files, in the course of which it eliminates the write protect.

In the simplest form of the `<replace>` command, file names, tokens, and values to be written are specified by attributes of the `<replace>` tag. These attributes are `file`, `token`, and `value`. Unlike with the `<filter>` command, the tokens to be substituted in the `<replace>` command must not be marked by separators. That means that separators, if they should be contained in the file to be modified, must be itemized in the value of the `token` attribute. The abandonment of separators makes it possible, in principle, to replace any string in a file. Under certain circumstances, this can lead to unwanted results. Thus, if possible, the separators should not be abandoned without compelling reasons.

The following command replaces the placeholder `@build.number@` in the file `replace.txt` with the value `123`. The required text file will be again placed inside the file and, thereafter, the `depends` attribute in the `<replace>` command.

```
<project name="bsp0812" default="main" basedir=".">
  <target name="main" depends="createFile">
    <replace file="replace.txt"
             token="@build.number@"
             value="123" />
  </target>

  <target name="createFile">
    <echo file="replace.txt">
Row 1 with build number @build.number@
Row 2 with build date @build.date@
    </echo>
  </target>

</project>
```

In this simple form the command must be entered several times when it is necessary either to process multiple files or to make multiple substitutions. More comfortable solutions are available for these two tasks.

You can define multiple substitutions within the `<replace>` command, using the embedded tag `<replacefilter>`:

```
<project name="bsp0813" default="main" basedir=".">
  <target name="main" depends="createFile">
    <replace file="replace.txt">
      <replacefilter token="@build.number@"
                     value="7"/>
      <replacefilter token="@build.date@"
                     value="2002/11/11"/>
    </replace>
  </target>

  <target name="createFile">
    <echo file="replace.txt">
Row 1 with build number @build.number@
Row 2 with build date @build.date@
    </echo>
  </target>

</project>
```

The `<replacefilter>` tag is provided with the attributes `token` and `value`. A further possible attribute, `property`, will be encountered below.

Should multiple substitutions for a single token be required, the last definition comes into play.

One further characteristic of the `<replace>` tag is the "bequeathing" of a default substitute value to the subordinate filter. In the following example, the `<replace>` tag has, indeed, got a `value` attribute, but not an accompanying `token` attribute. A substitution cannot occur this way. The second `<replacefilter>` tag, on the other hand, does define a token to be substituted, but not a substitution value. In this case, the `value` attribute of the `<replace>` tag is "passed on" to the `<replacefilter>` tag. You can find the complete source text as `bsp0814.xml` on the CD-ROM.

ON THE CD

```
<target name="main" depends="createFile">
  <replace file="replace.txt"
           value="default">
    <replacefilter token="@build.number@" value="123"/>
    <replacefilter token="@build.date@"/>
  </replace>
</target>
```

In some special cases, strings containing a line feed, or other symbol with a special meaning for an XML parser, are to be processed. This sort of substitution cannot be entered in an attribute value, but only within an independent tag. There the values can, or must, sometimes even be stored in a CDATA segment in order to ensure reliable interpretation by the parser. For this purpose, there are two tags, `<replacetoken>` and `<replacevalue>`, which can be entered within a `<replace>` command. They replace the attributes `token` or `value`. The following example illustrates both tags:

```
<project name="bsp0815" default="main" basedir=".">
  <target name="main" depends="createFile">
    <replace file="replace.txt">
      <replacetoken>@token@</replacetoken>
      <replacevalue><![CDATA[End of the old line
Continuation in a new line]]></replacevalue>
    </replace>
  </target>

  <target name="createFile">
    <echo file="replace.txt">
Line with @token@
    </echo>
  </target>

</project>
```

In formatting the source text, it should be noted that the parser interprets all symbols inside the two related tags as a value. Thus, the source text can no longer be formatted freely: spaces or line feeds must then be included in the search pattern.

Since the two tags for the `<replace>` command merely represent another notation for the `token` or `value` attributes, it is not necessary to use both tags together. It is equally possible to define one value using an attribute, and to define the other using the separate tag. The following example (`bsp0816.xml`) is, therefore, equivalent to the preceding:

```
<target name="main" depends="createFile">
    <replace file="replace.txt" token="@token@">
      <replacevalue><![CDATA[End of the old line
Continuation in a new line]]></replacevalue>
    </replace>
  </target>
```

The two tags permit no multiple definition of substitution patterns. They can also not occur inside a `<replacefilter>` tag. In addition, when the tags inside a replace instruction are repeatedly executed, only one token and one substitution value exist. If a tag is used repeatedly, Ant simply appends the new value right onto the already available value for `token` or `value`. The `<replace>` instruction will thereby certainly not work as expected. But an error message does not result. The same effect occurs if a tag is used together with the corresponding attribute (`value` and `<replacevalue>` or `token` and `<replacetoken>`).

The following example will make this effect clear:

```
<project name="bsp0817" default="main" basedir=".">
  <target name="main" depends="createFile">
    <replace file="replace.txt"
             token="@tok"
             value="Replace ">
      <replacetoken>1@</replacetoken>
      <replacevalue>token 1</replacevalue>
    </replace>
  </target>

  <target name="createFile">
    <echo file="replace.txt">@tok1@</echo>
  </target>

</project>
```

The parameters for the `<replace>` tag or the embedded command must not be entered unconditionally and directly in the source text. The command supports two distinct procedures for entering the values to be substituted and, if need be, the tokens in an external file.

You define a file using the attribute `propertyfile` in the `<replace>` tag, from which the `<replacefilter>` tag can read substitution values. For this purpose, the `value` attribute in the `<replacefilter>` will be replaced by the `property` attribute. The value of this attribute serves as a key for access to the property file. The substitution value is, in this way, indirectly made available for reference.

The following example provides a property file `replace.properties` with two entries. The names of these entries must have no connection with the token that they are to replace. This connection will be first established by the `<replacefilter>` tag.

```
<project name="bsp0818" default="main" basedir=".">
  <target name="main" depends="createFile">
    <replace file="replace.txt"
             propertyfile="replace.properties">
      <replacefilter token="@build.number@" property="key.1"/>
      <replacefilter token="@build.date@" property="key.2"/>
    </replace>
  </target>

  <target name="createFile">
    <echo file="replace.txt">
Line 1 with build number @build.number@
Line 2 with build date @build.date@
    </echo>
    <echo file="replace.properties">
key.1=333
key.2=11.6.2002
    </echo>
  </target>

</project>
```

Another variant for storing substitution patterns is the filter file. The actual filter criteria are entered in these files. A direct assignment of the token to the substitution value then occurs in the file. This file contains one or more lines of the form:

```
token=replace
```

The effort expended in writing is significantly reduced when only the `replacefilterfile` attribute is needed in the `<replace>` tag, in order to combine all filter functions. Here it should be noted that the token must appear in the filter file with the correct separator symbol.

```
<project name="bsp0819" default="main" basedir=".">
  <target name="main" depends="createFile">
    <replace file="replace.txt"
             replacefilterfile="replacefilter.txt"/>
  </target>

  <target name="createFile">
    <echo file="replace.txt">
Line 1 with build number @build.number@
```

```
Line 2 with build date @build.date@
    </echo>
    <echo file="replacefilter.txt">
@build.number@=222
@build.date@=11.11.1999
    </echo>
  </target>

</project>
```

At first, the use of the commands `<propertyfile>` and `<replacefilterfile>` seems redundant. However, there are some differences:

- The entries in a replace filter file are fully processed; the values from the property file have to be addressed explicitly by a `<replacefilter>` tag in order for them to be effective.
- In the replace filter file, the tokens to be substituted must be included with the separator, which may be required, while the property file can contain arbitrary keys, since the assignment of key to token first occurs in the `<replacefilter>` tag.

In defining replacement filters, several of the mechanisms described above can be employed simultaneously. The following example offers a glimpse into the possibilities:

```
<project name="bsp0820" default="main" basedir=".">
  <target name="main" depends="createFile">
    <replace file="replace.txt"
             token="@tok1@"
             value="default"
             propertyfile="replace.properties"
             replacefilterfile="replacefilter.txt">
      <replacefilter token="@tok4@" property="key.tok4"/>
      <replacefilter token="@tok3@"
                      value="token 3, direct value"/>
      <replacefilter token="@tok2@" />
    </replace>
  </target>

  <target name="createFile">
    <echo file="replace.txt">
```

```
Line 1 @tok1@
Line 2 @tok2@
Line 3 @tok3@
Line 4 @tok4@
Line 5 @tok5@
    </echo>
    <echo file="replace.properties">
key.tok4=token 4 from property file
    </echo>
    <echo file="replacefilter.txt">
@tok5@=token 5 from replacefilter file
    </echo>
  </target>

</project>
```

After execution of this build file, the file `replace.txt` contains the following:

```
Line 1 default
Line 2 default
Line 3  token 3, direct value
Line 4  token 4 from property file
Line 5  token 5 from replacefilter file
```

There are two different possibilities for processing multiple files. First, the `<replace>` command accepts the embedded `<fileset>` tag and its subtags. In this way, for example, in the `<copy>` command, a group of files can be specified, if necessary, from multiple, different directories. This variant will not be discussed here in more detail, since the `<fileset>` tag has been explained extensively elsewhere. (See Section 6.1.) At this point, some additional attributes of the `<replace>` command, which can also perform a file selection, are more important. Similar attributes can, for example, also be used in other file-oriented tags such as `<javac>`. You will find a detailed description in Chapter 6 on file handling. At this point, however, a few examples should illustrate the principle.

A directory can also be defined in the `<replace>` tag by the `dir` attribute instead of the `file` attribute; this serves as a start directory for the substitution process. Without further setup, the `<replace>` command treats all subdirectories, and all files in these directories, recursively. The optional attributes, `includes` and `excludes`, establish patterns of files and directories which are to be dealt with or ex-

cluded. In these examples, all XML files are to be excluded in every case, as otherwise the source text for the Ant files would be changed:

```xml
<project name="bsp0821" default="main" basedir=".">
 <target name="main" depends="createFile">
   <replace dir="."
             includes="*.txt"
             excludes="*.xml"
             token="@tok1@"
             value="That was a token">
   </replace>
 </target>

 <target name="createFile">
   <mkdir dir="subdir"/>
   <echo file="./subdir/replace.txt">
@tok1@
   </echo>
   <echo file="replace.txt">
@tok1@
   </echo>
   <echo file="./subdir/file.doc">
@tok1@
   </echo>
 </target>

</project>
```

In the example depicted above, all files with the ending .txt will be accepted for replacement with the value of the includes attribute. If the attribute does not contain any pattern for directories, then the substitution takes place only in the start directory, and not in the subdirectories.

Should subdirectories be involved, this will be done by the pattern "**". The two asterisks represent an arbitrary number of subdirectories:

```xml
<replace dir="."
         includes="**/*.txt"
         excludes="*.xml"
         token="@tok1@"
         value="That was a token"/>
```

Multiple patterns, separated by commas, can also be introduced in the `includes` and `excludes` attributes. In the above example, all `txt` files in the current directory, and all `doc` files from any of the subdirectories, will be processed.

```
<replace dir="."
        includes="*.txt, **/*.doc"
        excludes="*.xml"
        token="@tok1@"
        value="That was a token"/>
```

Here also, the patterns for the files to be included and excluded can be entered in a corresponding external file. This file contains a pattern in each line. They will be accepted in the `<replace>` command through the attributes `includesfile` and `excludesfile`. You will find the complete source text for the above two examples on the CD-ROM, in the files `bsp0822.xml` and `bsp0823.xml`.

```
<project name="bsp0824" default="main" basedir=".">
  <target name="main" depends="createFile">
    <replace dir="."
            excludesfile="no_replace_for.txt"
            token="@tok1@"
            value="That was a token">
    </replace>

  </target>

  <target name="createFile">
    <mkdir dir="subdir"/>
    <echo file="./subdir/replace.txt">
@tok1@
    </echo>
    <echo file="replace2.txt">
@tok1@
    </echo>
    <echo file="./subdir/file.doc">
@tok1@
    </echo>

    <echo file="no_replace_for.txt">
*.xml
**/*.doc
    </echo>
```

```
          </target>

          </project>
```

Summary

You can replace patterns in arbitrary text files using the `<replace>` command. The files will not be copied, and the substitutions take place directly in the source file.

The pattern and the substitution value can exist immediately in the build file as well as in external property files. They can extend over several lines and contain arbitrary symbols.

8.5 USING RESOURCE FILES

Java makes so-called *resources* available for controlling language dependent files (localization). In principle, this involves property files. They, too, contain entries of the form:

```
Key=value
```

Normally, multiple files form a resource bundle. The names of these files will be built following a special scheme. Besides a name stem common to all files, shorthand will be used for the current language and, if need be, other specifications for the country and subversions. When the name stem and the root directory for a Java application are known, it can then use the appropriate resource files, depending on the desired language, in order to read resources such as strings, names of pictures, symbols, etc., in the appropriate language. Sometimes, however, mainly for reasons of performance, it makes sense to do away with resource files and, instead, to generate applications in which the language dependent elements are contained immediately in the program code. The `<translate>` command can be used for these purposes.

The function of the `<translate>` command corresponds somewhat to that of the `<copy>` command with a filter file. Indeed, `<translate>` can combine the names of filter files from multiple components. Beyond that, you can execute the changes directly in existing files with `<translate>` (somewhat as with `<replace>`) or store the results in another directory.

The components of the names of filter files are set in the `<translate>` tag using the attributes `bundle`, `bundlelanguage`, `bundlecountry`, and `bundlevariant`. At the

same time, all the attributes except `bundle` are optional. The `bundle` attribute accepts the necessary required name stem.

The other attributes set the language, country name, and version. From these components, the `<translate>` command forms the final name according to the following pattern:

```
bundle +
  [ "_" + bundlelanguage +
    [ "_" + bundlecountry1 +
     [ "_" + variant1 ]
    ]
  ].properties
```

Additional attributes define the start directory for the files to be processed, the separator for the tokens, and the coding of the shared files. In addition, the `todir` attribute can be used to specify in which directory the processed files are to be put. If it does not already exist, the directory will automatically be set up . If the source and target directories are identical, the source files are overwritten.

The choice of files to be processed by the `<translate>` command is made by an embedded `<fileset>` tag.

The following example replaces all tokens in the `translate.txt` file which are contained in the `resources_de.properties` and `resources_en.properties` property files. The resultant files will, likewise, be placed under the name `translate.txt` in two separate subdirectories. At the same time, this example illustrates the use of the `<antcall>` tag. It is used here since a command will have to be executed repeatedly with easily changed parameters.

```
<project name="bsp0825" default="main" basedir=".">

  <target name="main" depends="createFiles">
    <antcall target="translate">
      <param name="language" value="de"/>
    </antcall>
    <antcall target="translate">
      <param name="language" value="en"/>
    </antcall>

  </target>

  <target name="translate">
```

```
    <translate bundle="./ressources"
               bundlelanguage="${language}"
               todir="./output_${language}"
               starttoken="@"
               endtoken="@">
      <fileset dir=".">
         <include name="translate.txt"/>
      </fileset>
    </translate>
  </target>

  <target name="createFiles">
    <delete includeemptydirs="true">
      <fileset dir=".">
        <include name="output*"/>
        <include name="output*/**/*"/>
      </fileset>
    </delete>
    <echo file="./ressources_de.properties">
tok1=Das ist Token1
tok3=Token 3
    </echo>
    <echo file="./ressources_en.properties">
tok1=That is token 1
tok2=second token
tok3=token three
    </echo>
    <echo file="translate.txt">@tok1@
@tok2@
@tok3@
    </echo>
    <touch file="translate.txt"/>
  </target>

</project>
```

Summary

The <translate> command uses items from a resource file in order to replace place-holders arbitrarily in many text files. In this way, a copy process takes place implic-itly. Since resource files are used, this command is best employed primarily for generating language dependent files.

8.6 GENERATING BUILD NUMBERS

The `<buildnumber>` tag produces a subset of the `<propertyfile>` command. Its only function is to raise the value of the `build.number` entry in a property file by 1. Its only, optional attribute is `file`. With this attribute, you establish the file name within which this entry is to be sought. If you do not define any file name, then the command employs the string `build.number` as a file name.

The following example produces two files with build numbers. Execute the example several times and compare the results.

```
<project name="bsp0826" default="main" basedir=".">

  <target name="main">
    <buildnumber file="buildinfo.txt"/>
    <buildnumber/>
  </target>

</project>
```

Summary

You use the `<buildnumber>` tag to increase the `build.number` attribute in a property file by 1.

8.7 HANDLING LINE END SYMBOLS

Java programs run in overlapping platforms. Often text files (property and resource files) are used to provide default values for applications outside the source text. Unfortunately, the different operating systems use different line end symbols. This raises some text editing problems. In Microsoft operating systems, two symbols (CR and LF) are appended at the end of each line. Many Unix editors only consider the linefeed (LF) symbol, and treat the carriage return (CR) as a text sign ("^M"). Windows editors, on the other hand, often cannot correctly evaluate a simple Unix linefeed. The `<fixcrlf>` tag exists in order to be able to equip text files with the correct line end symbol for each case. Besides handling the line end symbol, this command can also replace tabs within the source text by spaces.

The files to be handled by the `<fixcrlf>` tag can, on the other hand, also be pre-set by attributes or an embedded `<fileset>` tag. Here we omit a description of these tags, as they have already been discussed in detail in Section 6.1.

The command can also put the modified files in a directory other than the source directory. For this, the target, or destination directory, is specified with the `destdir` attribute. This directory must already exist, otherwise the command fails. If a target directory is not set, the changes will be carried out directly in the specified files. Renaming the files as they are being modified, e.g., using a mapper, is not possible.

The following example shows a segment from a real build file. It provides platform dependent versions from property files, which differ only in the line end symbols:

```
<target name="createPlattformFiles">
    <fixcrlf eol="lf"
            srcdir="${templateDir}/properties"
            destdir="${installDir}/unix"
                includes="**/*.properties "/>
        <fixcrlf eol="crlf"
            srcdir="${templateDir}/properties"
            destdir="${installDir}/win"
                includes="**/*.properties "/>

</target>
```

Another use of the `<fixcrlf>` tag is the substitution of tab symbols. With the `tab` attribute, you set how tabulators, or a series of spaces, are to be treated. The value `asis` ("as is") cuts off any manipulations. With `add`, on the other hand, you can cause a sufficiently long series of spaces to be replaced by a tab. If, on the other hand, you use the value `remove`, tabs will be replaced by correspondingly many spaces. You set the number of spaces per tab with the `tablength` attribute.

At certain points, a replacement is not at all desirable, in principle, e.g., in string constants within a source text. The attribute `javafiles`, which is only used in combination with the `tab` attribute, can cut off changes in strings. For this, you have to set it to `true`.

In the following example, the fragment of a Java file is made available by the `createFile` target. The indentations at the beginning, as well as the space within the string, were created by tabs.

Upon execution of the target, the tabs outside the quotation marks were replaced by spaces. Within the string, the tab remains unchanged.

```
<project name="bsp0827" default="main" basedir=".">
  <target name="main" depends="createFile">
    <fixcrlf  srcdir="."
              includes="bsp.java"
              javafiles="true"
              tab="remove"
              tablength="8"/>
  </target>

  <target name="createFile">
    <echo file="bsp.java">
public static void main(String[] args) {
    Frame frame1 = new Frame("Window1");
    frame1.setSize(200,100);
    frame1.show();
}
    </echo>
  </target>

</project>
```

Summary

The <fixcrlf> tag modifies the line end symbol and tabulators in text file, in order to achieve conformity of files with the operating system or the source text editor.

8.8 REGULAR EXPRESSIONS

The tags described up to now can mostly only be used if the later modifications in the files to be processed are already taken into account. The tokens to be substituted must be unambiguously labeled in order to avoid undesired side effects. Much more flexibility can be attained by specifying search patterns and replacement values by means of regular expressions.

In order to avoid problems, first a preliminary comment: the evaluation of regular expressions requires the installation of additional packages in certain cases.

Furthermore, regular expressions can be relatively complex: relevant details will be assumed here. In Chapter 17, you can find some information on installation, as well as a brief introduction to the ambiguities of regular expressions.

The `<replaceregexp>` tag is available for modification of text files by means of regular expressions. The command performs the modifications directly in the original file. Table 8.8 lists the attributes of this command.

TABLE 8.8 Attributes of the `<replaceregexp>` Command

Attribute	Description	Default	Required
file	File whose content is to be processed.		Yes, if no `<fileset>` tag is used
match	Search pattern.		Yes, if no `<regexp>` tag is used
replace	Substitution.		Yes, if no `<substitution>` tag is used
flags	Flags for evaluating expressions.		No
byline	Force line by line processing of the input file.	false	No

The tag requires at least three declarations to work: the name of the file to be processed, the search pattern, and the expression to be substituted. All three declarations can be provided either by attributes or by embedded tags.

The name of the file to be processed can be specified by the `file` attribute. This attribute accepts exactly one specified file name. Pattern declarations are, therefore, impossible. If multiple files have to be processed, or the choice must be by patterns, then an embedded `<fileset>` tag can be used.

The match attribute is available for the search pattern. Alternatively, it can be made available through the embedded `<regexp>` tag. In this tag, the search pattern is specified by the pattern attribute. The `<regexp>` tag offers the advantage of being defined outside targets, and can be tied in later by reference. In this way, multiple use of the occasionally very complex expression becomes possible.

Multiple partial patterns can appear enclosed in parentheses in the search pattern; the latter can be accessed in the substitution string with the placeholders \1 to \9.

The substitution string will be defined in a similar way. You use either the re-place attribute or the embedded <substitution> tag with the expression attribute. Referencing is also possible for this tag.

The properties described thus far permit an initial demonstration:

```
<project name="bsp0828" default="main" basedir=".">
  <property name="file.name" value="regexp1.txt"/>

  <target name="main" depends="prepare">
    <replaceregexp file="${file.name}">
      <regexp pattern="line"/>
      <substitution expression="row"/>
    </replaceregexp>
    <fixcrlf includes="${file.name}"
             eol="crlf"
             srcdir="."/>
  </target>

  <target name="prepare">
<echo file="${file.name}">>line 1, still line 1
line 2
line 3
</echo>
    <touch file="${file.name}"/>
  </target>
</project>
```

The working file is made available in the already known way by the <echo> tag. The <fixcrlf> tag sets correct line end characters in Windows environments and thereby ensures better readability of the file. This is not necessary for reasons of functionality. The two regular expressions ensure that the word "line" is replaced by "row." Because in the standard evaluation of regular expressions, only the first encounter with this pattern will be processed, only one substitution takes place. The result is the following file:

```
row 1, still line 1
line 2
line 3
```

The command reads in the entire file and treats it as a whole. Hence, only on the first encounter is "Line" replaced. This setup can be varied using the `byline` attribute. If this attribute is set to the value `true`, the `<replaceregexp>` command processes each line separately. The following segment from the listing illustrates the supplementing of the tag by means of the extra attribute (complete source text in `bsp0829.xml` on the CD-ROM):

ON THE CD

```
<replaceregexp file="${file.name}"
                  byline="true">
```

These changes make it so that a substitution is now made in every line, since every line, as such, will be searched. Still, in each case, only the first encounter with the pattern will be handled in each searched segment. The following listing shows the content of the processed files:

```
row 1, still line 1
row 2
row 3
```

The operation of this command can be modified further through the content of the `flags` attribute. This attribute can accept one or more of the flags listed in Table 8.9.

TABLE 8.9 Possible Flags

Flag	Description
g	Perform all possible substitutions.
i	Ignore upper/lower case.
m	Allow for line end symbols.
s	Ignore line end symbols.

The flag g is of primary interest. With this flag, you can ensure that substitutions will be carried out in the entire file, and that not just the first encounter of the pattern will be noticed. When this flag is used, the value of the `byline` attribute is meaningless. In the following, you can again see the modified segment of the build file:

```
<replaceregexp file = "${file.name}"
                flags="g">
```

Now all the strings that match the pattern are replaced in the processed file:

```
row 1, still row 1
row 2
row 3
```

Another interesting approach involves using the alternative flags s and m. With the value m in the flag, you obtain standard treatment of line end symbols. That means the evaluation of regular expressions ends at the line end. You can additionally use the pattern symbol $ to select the end of every line, even when the <replaceregexp> command processes the entire file at once. The flag s, on the other hand, causes the line end symbols in the text to be ignored. The pattern symbol $ is ineffective in this case, or just comes up with the end of the file. Regular expressions, whose operation normally extends only to a single line, now work beyond the line boundaries, as the following example shows:

```
<project name="bsp0831" default="main" basedir=".">
  <property name="file.name" value="regexp1.txt"/>

  <target name="main" depends="prepare">
    <replaceregexp file="${file.name}"
                    flags="s">

      <regexp pattern="(.*)($)"/>
      <substitution expression="-:\1:-\2"/>
    </replaceregexp>

    <fixcrlf includes= "${file.name}"
             eol     = "crlf"
             srcdir  = "."/>
  </target>

    <target name="prepare">
<echo file="${file.name}">line 1, still line 1
line 2
line 3</echo>
        <touch file="${file.name}"/>
    </target>
</project>
```

The easily changed regular expressions ensure that the operating range of the pattern is set off by a few additional symbols. With the file given above, you obtain the following result:

```
-:line 1, still line 1
line 2
line 3:-
```

If you change the flag to the value m, then the regular expression will automatically end at the end of the first line. In this case, only the first line will be indicated. This is correct, since only the first of the patterns matching the regular expression is processed.

```
-:line 1, still line 1:-
line 2
line 3
```

The use of the byline="true" attribute makes no sense in connection with these two flags. Of course, you can combine the flags g and m. In that way, all the substitutions have been carried out, with all lines separately labeled.

Summary

With regular expressions you can undertake manifold modifications of files. Many of the commands already described can be replaced by the <replaceregexp> command. Certainly, the use of this tag offers the possibility of installing additional libraries. In addition, regular expressions can be very complex, so some experience in their use is required.

8.9 FILTER CHAINS AND FILTER READERS

A filter reader offers a further possibility for modifying the content of a text file. Although it has certain functional similarities to the other commands in this section, filter readers rely on a somewhat different basic concept.

Filters, more precisely *filter readers*, provide various predefined search and processing functions. Many of these readers can or must be combined into a *filter chain*. A <filterchain> tag, on the other hand, can only be contained in the four commands:

- `<copy>`
- `<move>`
- `<loadfile>`
- `<loadproperties>`

The `<copy>` and `<move>` commands are useful for copying or moving files. If filters are defined in these commands, then they are activated in the course of copying. In this case, the changes are to be found only in the target file. Note that the filters do not operate on a file-to-file basis, but on a line-to-line basis. If you copy or move a file, the target file will only contain the lines that get through the filter. Some examples at the end of this section illustrate this behavior in detail.

The `<loadfile>` and `<loadproperties>` commands read in the content of a file and make one or more properties available from it. In the process, the content of the file is modified by the specified filters during reading. The properties are made available only after the filtering.

First, a small example as a starter:

```
<loadfile property="list.developer" srcfile="developer.txt">
<filterchain>
<headfilter lines="3"/>
</filterchain>
</loadfile>
```

This command would read in the first three lines of the `developer.txt` file and enter these three lines into the `list.developer` property.

Ant offers a series of predefined filters. You can also write and tie in your own filters. The filters contained in the current version 1.5.1 and their functions are listed in Table 8.10. Note that, indeed, each filter can be used in both of the command groups mentioned above, but it will not necessarily always provide useful results.

TABLE 8.10 Predefined Filter Readers

Name	Function
filterreader	Calling filters by their complete class names. Serves predominantly for calling self-programmed filters.

(continues)

TABLE 8.10 Predefined Filter Readers (*continued*)

Name	Function
expandproperties	Replaces property placeholders with their current values.
headfilter	Reads the first *n* lines of a text file.
linecontains	Reads lines containing a search string. No pattern searches.
linecontainsregexp	Reads lines containing the regular expression.
prefixlines	Supplements each line with a prefix.
replacetokens	Replaces tokens enclosed within limiting characters.
stripjavacomments	Removes all comments from Java sources.
striplinebreaks	Removes arbitrary symbols. Usually line breaks will be removed.
striplinecomments	Removes lines that begin with a specified string.
tabstospaces	Converts tabs to spaces.
tailfilter	Reads the last *n* lines of a file.

Each of the predefined filters can be called by its own tag. It is also possible to make use of the filters predefined by Ant by means of the generic `<filterreader>` filter. This tag expects the complete class name of a filter as attribute. Thus, it is primarily used for calling self-programmed filters.

Some of these filters require additional parameters. Unfortunately, the syntax of the different filters is not unified in this regard. Some of the filters expect their parameters exclusively in the form of attributes, while others only accept embedded tags. Thus, a comprehensive review of their use is not possible. The following sections, however, present each of the predefined filters (except `<filterreader>`) separately, and illustrate their use in an example. For this purpose, the property related commands will mainly be used, since the result can be output to the console in the simplest fashion. Some tips for their practical use conclude these explanatory comments.

8.9.1 **Head Filters and Tail Filters**

Both filters read a specified number of lines at the beginning (<headfilter>) or end (<tailfilter>) of a data stream. The number of symbols to be read will, in each case, be set by the optional lines attribute. If this attribute is lacking, a default value of 10 lines is used.

The example for these two tags simultaneously illustrates the chaining of more than one filter:

```
<project name="bsp0832" default="main" basedir=".">
  <target name="main" depends="createFile">

    <loadfile srcfile="lines.txt" property="p1" >
      <filterchain>
        <headfilter lines="5"/>
      </filterchain>
    </loadfile>

    <echo>
Head 5 lines
${p1}
    </echo>

    <loadfile srcfile="lines.txt" property="p2">
      <filterchain>
        <tailfilter lines="3"/>
      </filterchain>
    </loadfile>

    <echo>
Tail 3 lines
${p2}
    </echo>

    <loadfile srcfile="lines.txt" property="p3">
      <filterchain>
        <headfilter lines="6"/>
        <tailfilter lines="3"/>
      </filterchain>
    </loadfile>

    <echo>
```

```
Head 6 lines, then tail 3 lines
${p3}
    </echo>
  </target>

  <target name="createFile">
    <echo file="lines.txt">Line 1
Line 2
Line 3
Line 4
Line 5
Line 6
Line 7
Line 8
Line 9
Line 10</echo>
  </target>
</project>
```

First, a dependent tag creates a file consisting of ten lines. Output of the first line should be noted immediately after the opening <echo> tag, since otherwise there is a space at the beginning of the file. The main tag contains three <loadfile> commands, each of which has an embedded <filterchain> tag. The filters ensure that at any given time, only one part of the file will be read into the property.

The last command is of some interest. There you will find two filters. The first reads the first six lines of the file, while the second ensures that, of the set of the first six lines, the last three will be filtered out. The property p3 should, therefore, contain lines four to six of the output file. Evidently, the current Ant version 1.5.1 does not work entirely correctly. Line feed characters at the end of a file (or of the relevant section) will apparently be interpreted as new lines (only tested for Windows). The last <filterchain> tag, therefore, yields only two lines instead of the expected three. For just this reason, the end tag of the <echo> command follows right on the last string. If "Line 10" were followed by a line feed, then the second <filterchain> tag would also only yield two output lines.

8.9.2 Filters with Simple Strings

The <linecontains> filter considers only lines containing a specified string, and no pattern symbols are permitted. This filter can be employed very well when, upon

reading-in a property file, only those entries that begin with a prescribed prefix are to be considered.

The `<linecontains>` tag accepts for parameter transfer only the embedded `<contains>` tag, which contains the search string in the `value` attribute. The syntax of the command allows it to employ several `<contains>` tags. In this case, the search strings are AND coupled. The command then selects only those lines containing all the search strings.

The following example is oriented to the difficulties with reading-in properties mentioned at the beginning:

```
<project name="bsp0833" default="main" basedir=".">
  <target name="main" depends="prepare">
    <loadproperties srcfile="pathes.properties">
      <filterchain>
        <linecontains>
          <contains value="dir." />
        </linecontains>
      </filterchain>
    </loadproperties>
    <echoproperties prefix="dir"/>
    <echoproperties prefix="filename"/>
  </target>

  <target name="prepare">
    <echo file="pathes.properties">
      dir.source=/src
      dir.build=/build
      filename.localization.de=/src/etc/local/de.ressource
      filename.localization.en=/src/etc/local/en.ressource
      dir.properties=/src/etc/properties
      filename.buildinfo=buildinfo.txt
    </echo>
  </target>
</project>
```

In this example, a property file is first created that contains six separate properties, with two different prefixes coming into action. The `<loadproperties>` command in the `main` target reads this file, in the course of which an installed filter allows only those properties with the prefix `dir`. The final two `<echoproperties>`

commands list all the properties with the two prefixes, in order to permit monitoring the operation of the filter.

8.9.3 Filters with Regular Expressions

If the filtering is to be guided by a pattern, the <linecontainsregexp> filter is required. This filter carries out a search by means of regular expressions. This, of course, requires that an appropriate library be installed, depending on the JDK being used. You can find information on the installation of supplementary libraries and regular expressions in the Appendix.

The tag must be supplied with a regular expression as a parameter. The embedded <regexp> tag with the attribute pattern, exists for this purpose. Several of these tags can occur in a <linecontainsregexp> filter; the patterns will be AND coupled.

The following example presents a modification of the preceding example. It replaces the main target, so as to demonstrate the application of regular expressions.

```
<project name="bsp0834" default="main" basedir=".">
  <target name="main" depends="prepare">
    <loadfile srcfile="pathes.properties" property="prop">
      <filterchain>
        <linecontainsregexp>
          <regexp pattern="src/(.*)res(.*)"/>
        </linecontainsregexp>
      </filterchain>
    </loadfile>
    <echo>${prop}</echo>
  </target>

  <target name="prepare">
    <echo file="pathes.properties">
      dir.source=/src
      dir.build=/build
      filename.localization.de=/src/etc/local/de.ressource
      filename.localization.en=/src/etc/local/en.ressource
      dir.properties=/src/etc/properties
      filename.buildinfo=buildinfo.txt
    </echo>
  </target>
</project>
```

8.9.4 Insertion of Prefixes

The `<prefixlines>` command adds a prefix, defined in the `prefix` attribute, to each read-in line. As no operations with expressions are possible, it is of limited use. The command is most appropriate for reading-in properties from a file. The `<property>` command, which is likewise provided for this task, allows it to be used to attach a prefix to the read-in properties, using the `prefix` attribute, in order to ensure the uniqueness of the property name. The `<loadproperties>` command does not recognize an attribute of this sort, but a remedy is available through the `<prefixlines>` filter.

The following segment of a build file shows the syntax of the command:

```
<filterchain>
  <prefixlines prefix="extprop."/>
</filterchain>
```

8.9.5 Removal of Comments and Line Feeds

Many Java source files contain information that is no longer needed during or after compiling. Three filters can be used to remove extra symbols from a Java file. You can remove all comments from a Java file using `<stripjavacomments>`. This command recognizes no attributes or embedded tags, so its function cannot be modified.

The `<striplinebreaks>` command, on the other hand, removes individual symbols. Normally, this means the line feed symbol. Arbitrary symbols can, of course, be specified using the `linebreaks` attribute. This attribute can accept multiple symbols. Each symbol is treated separately and erased from the source file. The attribute is interpreted as a set of values, and not as a string that belongs together.

The `<striplinecomments>` command operates in similar fashion. It removes all lines that begin with a specified string. The string is defined using the embedded `<comment>` tag or the `value` attribute.

The following example illustrates the above-mentioned tags, with the aid of the `<loadfile>` command, with which the result can be output to the console in a simple manner. In practice, these tags would be employed within the `<copy>` or `<move>` commands.

```
<project name="bsp0835" default="main" basedir=".">

  <target name="main" depends="createFile">
    <loadfile srcfile="example.java" property="p0"/>
```

```
      <echo>
Original
${p0}
      </echo>

      <loadfile srcfile="example.java" property="p1">
        <filterchain>
          <stripjavacomments/>
        </filterchain>
      </loadfile>
      <echo>
remove comments
${p1}
      </echo>

      <loadfile srcfile="example.java" property="p2">
        <filterchain>
          <striplinebreaks/>
        </filterchain>
      </loadfile>
      <echo>
erase line breaks
${p2}
      </echo>

      <loadfile srcfile="example.java" property="p3">
        <filterchain>
          <striplinebreaks linebreaks="emarfF"/>
        </filterchain>
      </loadfile>
      <echo>
erase arbitrary symbols
${p3}
      </echo>

      <loadfile srcfile="example.java" property="p4">
        <filterchain>
          <striplinecomments>
            <comment value="//"/>
          </striplinecomments>
        </filterchain>
      </loadfile>
      <echo>
```

```
erase individual comment lines
${p4}
      </echo>

  </target>

  <target name="createFile">
    <echo file="example.java">
/**
 * java doc
 *
 **/
public static void main(String[] args) {
/* comment 1 */
    Frame frame1 = new Frame("Window 1");
//comment 2
    frame1.setSize(200,100);
    frame1.show();   //comment 3
}
    </echo>
  </target>

</project>
```

8.9.6 Replacing Tabs

Java source code is structured with indentations. Hence, many editors use tabs. For widely varying reasons, these must later be replaced with spaces. This task is handled by the <tabstospaces> command. With the tablength attribute, you set how many spaces are to replace a tab. This filter also is most appropriate in combination with the <copy> or <move> commands.

8.9.7 Expanding Properties

The <expandproperties> tag causes all property placeholders in a data stream to be replaced by the current value of the corresponding property, provided one exists. This tag recognizes no attributes or embedded tags.

The following example shows one possible application. We set out with a property file in which some path statements exist that are required for the current build. These path statements must be relative to a root directory, whereby the root directory itself must be specified dynamically by a property. In this way, for example,

simple adaptation of the build file to different computer configurations would be possible.

In the example, a dependent target first ensures that a short property file will be created. This file contains the placeholder ${root}. This property will be created in the target main. If the <loadproperties> command reads in the properties, the placeholder is replaced by the value of root because of the embedded filter. The <echoproperties> command shows the three resulting properties and their current values:

```
<project name="bsp0836" default="main" basedir=".">
  <target name="main" depends="prepare">
    <property name="root" value="/projects/factory" />
    <loadproperties srcfile="pathes.properties">
      <filterchain>
        <expandproperties/>
      </filterchain>
    </loadproperties>
    <echoproperties prefix="dir"/>
  </target>

  <target name="prepare">
    <echo file="pathes.properties">
      dir.source=${root}/src
      dir.build=${root}/build
      dir.properties=${root}/src/etc/properties
    </echo>
  </target>
</project>
```

8.9.8 Replacing Tokens

With the <replacetokens> filter, you can replace tokens enclosed in predefined limiters by arbitrary strings. The token will be replaced, along with the limiter symbols. During file copying, you can use this function to simultaneously perform a massive update of various housekeeping information. The example alludes to this possibility. There, some placeholders will be replaced by a build number, the current date, and the name of the person executing the build.

The <replacetoken> tag recognizes two optional attributes, begintoken and endtoken. With these attributes, you can prescribe the limiter symbols at the begin-

ning and end of the tokens that are to be replaced. The "@" sign serves as a default. The token to be replaced and the replacement string, are set by the embedded `<token>` tag, which again recognizes the key attribute for the token to be replaced, and the `value` attribute for the new string. More than one token for replacement can be defined in a `<replacetoken>` tag. These will then have identical limiters.

The example is quite simple, and needs no further explanation:

```
<project name="bsp0837" default="main" basedir=".">
  <target name="main" depends="createFile">
    <loadfile srcfile="reptokenfilter.txt" property="p1">
      <filterchain>
        <replacetokens>
          <token key="build.num" value="7"/>
        </replacetokens>
        <replacetokens endtoken="#">
          <token key="build.date" value="${TODAY}"/>
          <token key="build.name" value="${user.name}"/>
        </replacetokens>
      </filterchain>
    </loadfile>
    <echo>${p1}</echo>
  </target>

  <target name="createFile">
    <echo file="reptokenfilter.txt">
Build @build.num@ of @build.date#; Owner @build.name#
    </echo>
    <tstamp/>
  </target>
</project>
```

Note at this point that, besides filter chains or filter readers, the `<copy>` and `<move>` commands also support so-called *filtersets*, which offer similar possibilities for replacing tokens. The filter chains are somewhat more universally applicable, as they can also be used in connection with the `<loadfile>` and `<loadproperties>` commands. In addition, multiple distinct filters can be operated one after the other. Filtersets, on the other hand, offer a somewhat wider functional range. For example, there the tokens can be read together with the replacement patterns out of an external file.

8.9.9 Generic Filters

Besides the predefined filters, you can use some filters in the form of a Java class. This class must be called via the `<filterreader>` tag. This tag recognizes only the `classname` attribute, which accepts the complete name of the class to be used. A detailed description cannot be given here. Extending Ant by self-programming is beyond the scope of this book.

9 ▪ Evaluating Conditions

The `if` and `unless` attributes in the `<target>` tag are the only possibilities for conditional processing of targets and, thereby, for implementing run control in Ant files. A few tags permit the setting of properties depending on various conditions, so that, at least to a modest extent, the execution of a build file can be influenced by the current status of the application and the environment.

Besides a few special tags, which always test only an elementary condition, there is a generally-supported `<condition>` tag, which evaluates multiple conditions whose results can be logically coupled. Since the independent tags can also be used within the `<condition>` tag for testing conditions, all the commands will be described together.

The `<condition>` tag only provides the outer shell for later tags, which are appropriate for the actual definition of the conditions. There is exactly one embedded tag within the `<condition>` tag that performs a test. This tag, however, can contain other tags that permit the construction of complex tests.

In the `<condition>` tag, the `property` attribute will establish which property is to be created, if the evaluation of the embedded conditions yields the value `true`. The second, optional, `value` attribute makes it possible to overwrite the default value for the property to be constructed. It is, of course, impossible to create the property and to set it to another value (e.g., to `false`) if the condition is not fulfilled. Table 9.1 summarizes the syntax for the `<condition>` tag.

TABLE 9.1 Attributes of the `<condition>` Tag

Attribute	Description	Default	Required
property	The name of the property to be provided.		Yes
value	The value to which the property is to be set.	true	No

Within the <condition> tag, the individual tests will be executed by embedded tags. Each of these tags exhibits another syntax, so that a separate description is required for each tag. Table 9.2 summarizes the available tests.

Some of the tests cited here can also be executed by independent tags.

TABLE 9.2 Test Tags Available for <condition>

Tag	Description
available	Tests the availability of a resource (file, directory, class, . . .).
checksum	Tests the correctness of a file by means of a check sum.
contains	Ascertains whether a string is contained in another.
equals	Checks whether two strings are identical.
filesmatch	Compares two files byte-by-byte.
http	Determines the availability of a resource which must be accessed through an HTTP link.
isfalse	Determines whether a string corresponds to the value for false.
isset	Establishes whether a property exists or not.
istrue	Determines whether a string corresponds to the value for true.
os	Tests whether the current operating system corresponds to a prespecified type.
socket	Tests whether a prespecified server port has a TCP/IP listener.
uptodate	Establishes whether one or more files have become obsolete.

9.1 CHECKING THE AVAILABILITY OF RESOURCES

The <available> tag checks whether selected resources (files, classes, or resources) are available. This tag exists in two variants, first as an independent tag, and then as an embedded tag within the <condition> tag. The syntactic and functional differences between the two variants are merely that, within the independent tag, two attributes, property and value, exist, within which a property can be set after a

successful test. The embedded variant does not recognize these two attributes, as these are already employed in the `<condition>` tag.

Depending on whether files, classes, or resources are sought, different attributes must be applied in special combinations. In searching for a class, the tag naturally first requires the name of the class being sought. This will open up in the `classname` attribute. You have to use the complete class name, including the package name. Normally it will be sought in the current class path. Both class files, which exist as independent files in the file system, and those in archives (e.g., zip- or jar- files) will be found. If it must be sought in additional paths, the class path to be used can be set with the aid of the `classpath` or `classpathref` attributes. An embedded `<classpath>` tag within the `<available>` tag can also be employed. You can ensure selection of the current class path, which was set immediately upon calling Ant, by use of:

```
ignoresystemclasses="true"
```

A Java application consists of other resources besides classes. All files whose names do not end in "class" can be regarded as resources, in the sense of the `<available>` tag. These include property files, graphics, and the like. Since these files can exist in an archive, a simple file search does not always find them. Accordingly, resources can be searched for using a mechanism similar to classes. As opposed to a class search, the name of the resource to be sought will open up in the `resource` attribute. If the resource is in a subdirectory, the complete path must be specified. For this, the ordinary path description is used. The directories and archives specified in the class path will be sought, as in a class search.

Last but not least, a search for simple files or directories is possible. Here the `file` and `filepath` attributes come into use. With `file` you set the name of the file or directory to be sought, while `filepath` specifies the directories in which the search takes place. Instead of the `filepath` attribute, the embedded `<filepath>` tag can also be used. This tag permits the unhampered definition of the path including an entry for search patterns. The `<filepath>` tag is described in more detail in Section 6.3 on file and path lists.

During a search for files, with the optional `type` attribute, you can establish whether only files or only directories are to be searched. Without this attribute, `<available>` accepts both.

Table 9.3 summarizes the attributes of the `<available>` tag. As noted above, it accepts the `<classpath>` and `<filepath>` tags as embedded tags.

TABLE 9.3 Attributes of the `<available>` Subtag

Attribute	Description	Default	Required
classname	The class whose existence is to be checked.		classname, file, or resource
file	The file whose existence is to be checked.		No
resource	The JVM resource whose availability is to be checked.		No
classpath	The class path in which the classname or resource is to be sought.		No
classpathref	Reference to a class path.		No
filepath	The path in which a file is to be sought.		No
type	Type for file search (dir or file). If not specified, both will be sought.		
ignoresystemclasses	Ignore Ant runtime classes. Only operative in combination with classname.	false	No

The following example illustrates the use of the `<available>` tag within the `<condition>` tag. You can retrace this example on your computer, if you set up a subdirectory, ExtClasses, in your example directory, and copy the file xercesImpl.jar into this directory. You can also use another file, but then the search term must be appropriate. This file is to be found in the Lib-directory of the Ant installation. The subdirectory with the corresponding file also exists in the example directory on the CD-ROM.

```
<project name="bsp0901" default="main" basedir=".">
  <path id="cp">
    <pathelement location="./ExtClasses/xercesImpl.jar"/>
  </path>

  <target name="main">
```

```
      <condition property="a">
        <available file="xercesImpl.jar"
                    filepath="./ExtClasses"/>
      </condition>
      <echo message="File: ${a}"/>

      <condition property="b">
        <available file="xercesImpl.jar">
          <filepath>
            <fileset dir="."
                     includes="**"/>
          </filepath>
        </available>
      </condition>
      <echo message="File with path pattern: ${b}"/>

      <condition property="c">
        <available classname="org.w3c.dom.ls.ParseErrorEvent"
                   ignoresystemclasses="true"
                   classpathref="cp" />
      </condition>
      <echo message="Class: ${c}"/>

      <condition property="d">
        <available ignoresystemclasses="true"
    resource="org/apache/html/dom/CollectionIndex.class" >
          <classpath>
            <pathelement
               location="./ExtClasses/xercesImpl.jar"/>
          </classpath>
        </available>
      </condition>
      <echo message="Ressource: ${d}"/>
    </target>
</project>
```

The example file contains four `<condition>` tags, each of which contains an `<available>` tag. The properties generated by the `<condition>` tag will be output to the console, supplemented by a short piece of information.

The first tag checks the existence of a file. This brings the simplest form of the `<available>` tag into action. The name of the file to be sought is in the `file` attribute, and the `filepath` attribute accepts the path specification.

The next tag searches for the same file, but uses an embedded `<filepath>` tag. This makes it possible to set a search pattern for the path name with a further sub-tag (`<fileset>`). Now all subdirectories of the current directory will be searched.

The other two tags search for a class or a resource in the previously used file. This will, therefore, be picked up in the class path. As a demonstration, this is set once by reference and, with the other tag, by the embedded `<classpath>` tag. Note the different way of writing down the objects to be sought in the last two `<condition>` tags. The components of class names will be separated from one another by periods, and those of resources, by the customary directory separator.

9.2 TESTING CHECKSUMS

The `<checksum>` tag can also be used either as an independent tag or as a subtag within the test of conditions. Its operation as a separate tag has already been discussed in Section 7.6. If this tag is used as a subtag, it only executes the test of a file, but generates no new checksum files. Also, during use as a subtag, all the attributes will be employed, provided a syntax error does not occur. Of course, they will be virtually ignored. This naturally concerns the `verifyproperty` attribute, in particular.

9.3 FINDING STRINGS

With the `<contains>` tag, you can check whether a string is contained in another. For that purpose, this tag has available two mandatory attributes, `string` and `substring`, in which the string and the part of the string to be sought are provided. The optional `casesensitive` attribute controls the comparison with regard to upper/lower case letters. You'll find an example in the next section. Table 9.4 summarizes the attributes.

TABLE 9.4 Attributes of the `<contains>` Tag

Attribute	Description	Default	Required
string	The string to be sought.		Yes
substring	The (sub)string to be sought.		Yes
casesensitive	Account for upper/lower case.	true	No

9.4 COMPARING STRINGS

The <equals> tag compares two strings with one another. It yields the result true only if the two strings are identical. This tag can optionally distinguish or ignore upper/lower case, as well as remove spaces at the beginning and end of the strings to be compared. Table 9.5 lists the available attributes.

TABLE 9.5 Attributes of the <equals> Tag

Attribute	Description	Default	Required
arg1	The first string.		Yes
arg2	The second string.		Yes
casesensitive	Distinguish Upper/lower case?	true	No
trim	Ignore spaces at beginning and end?	false	No

The following build file, which will not be described in detail, presents some examples using the <contains> and <equals> tags. At the same time, this example offers the possibility of filling the properties with a specific value, independent of the specific outcome of the condition test. This procedure, of course, only works if the tags involved are linked via the depends attribute and are not called by <ant> or <antcall>.

```
<project name="bsp0902" default="main" basedir=".">
  <target name="main" depends="check">
    <echo message="File: ${a}"/>
    <echo message="File: ${b}"/>
    <echo message="File: ${c}"/>
    <echo message="File: ${d}"/>
    <echo message="File: ${e}"/>
    <echo message="File: ${f}"/>
  </target>

  <target name="check">
    <condition property="a" value="'abc123' contains 'c1'">
      <contains string="abc123" substring="c1"/>
    </condition>

    <condition property="b" value="'abc123' contains 'BC'">
```

```
            <contains string="abc123" substring="BC"/>
        </condition>

        <condition property="c"
          value="'abc123' contains 'BC', if casesensitive = false">
            <contains string="abc123" substring="BC"
                    casesensitive="false"/>
        </condition>

        <condition property="d"
          value="'abc123' = 'ABC123', if casesensitive = false">
            <equals arg1="abc123" arg2="ABC123"
                    casesensitive="false" />
        </condition>

        <condition property="e"
          value="'abc123' = ' abc123 '">
            <equals arg1="abc123" arg2=" abc123 "/>
        </condition>

        <condition property="f"
          value="'abc123' = ' abc123 ' for trim = true">
            <equals arg1="abc123" arg2="  abc123 "
                    trim="true"/>
        </condition>

        <property name="a" value="'abc123' does not contain 'c1'"/>
        <property name="b" value="'abc123' does not contain 'BC'"/>
        <property name="c" value="'abc123' does not contain 'BC'"/>
        <property name="d" value="'abc123' unequal to 'ABC123'"/>
        <property name="e" value="'abc123' unequal to ' abc123 '"/>
        <property name="f" value="'abc123' unequal to ' abc123 '"/>
    </target>
</project>
```

9.5 COMPARISON OF FILE CONTENTS

The `<filesmatch>` tag is used to compare two files. These will be compared byte-by-byte, so that the test takes longer for large files in some cases. The command rec-

ognizes only the two required attributes, `file1` and `file2`, in which the names of the two files to be compared are noted.

9.6 CHECKING THE AVAILABILITY OF HTTP RESOURCES

With the test command `<http>` you can check the availability of an HTTP resource. The get command lets you read a file via an HTTP link. If errors are encountered, this will probably lead to a build error. With the `<http>` tag, you can first check whether the URL to be used provides correct access and, if not, branch out to alternatives.

The `<http>` tag recognizes only the two attributes given in Table 9.6.

TABLE 9.6 Attributes for the `<http>` Tag

Attribute	Description	Default	Required
url	The URL to be checked.		Yes
errorsbeginat	The lowest status code of the Web server that should be recognized as an error.	400	No

A Web server returns a status code for each request that communicates information regarding the result. The `<http>` tag compares this value with the content of the `errorsbeginat` attribute, or with the default value of 400. If the status code provided by the Web server is smaller than the comparison value, then the access is successful.

9.7 CHECKING THE EXISTENCE OF PROPERTIES

The `<isset>` tag checks whether a property is set or not. It recognizes a single attribute, `property`, via which the name of the property to be checked must be communicated.

9.8 CHECKING FLAGS

The two flags, <istrue> and <isfalse>, allow testing of whether a string corresponds to the value for true or false. Here, the string always refers to the content of a property, since Ant offers no other possibility for dynamic introduction of values.

Ant evaluates several different strings as equivalent for true, or false. Thus, the strings "true", "yes", and "on" will be treated as symbols for true, and "false", "no", and "off", as symbols for false. These strings are synonyms. They can also be used for assigning values to attributes.

9.9 DETERMINING THE CURRENT OPERATING SYSTEM

The <os> tag makes it possible for you to determine just which operating system Ant is working under. Ant, itself, can indeed run entirely independently of the operating system, but sometimes system commands have to be called in order to start other programs. It is also conceivable that some files to be copied might be adapted depending on the operating system.

Ant expects four attributes in the <os> tag. Their names, as well as their range of possible values, are given in Table 9.7. For each attribute that is used, Ant tests whether its value corresponds to the current operating system. true will be returned only if all the attributes are evaluated successfully. By varying the number of attributes employed, you can adjust the fineness of the check.

TABLE 9.7 Attributes of the <os> Tag

Attribute	Description	Required
family	Name of the OS family (Windows, DOS, Mac, Unix, Netware, OS/2, Win9x, Z/os).	No
name	Name of the specific OS.	No
arch	Architecture.	No
version	Version.	No

A prespecified set of values exists only for the `family` attribute. All other values must be known. Only rarely in practical applications, of course, will there be a need for a more precise distinction than as to the operating system family. Some of the environmental variables of the system provide a clue here. The following example introduces one such set of values:

```
<condition property="o">
  <os family="Windows"
      name="Windows NT"
      version="4.0"
      arch="x86"/>
</condition>
```

9.10 CHECKING SOCKET CONNECTION

With the `<socket>` tag, you can check for the existence of TCP/IP listeners at a specified port of the chosen server. For this, you have to furnish the `server` attribute with the name or the IP address of the server, as well as the `port` attribute with the number of the port to be tested.

9.11 CHECKING THE UP-TO-DATENESS OF FILES

The `<uptodate>` command is one of those commands that can exist both within `<condition>`, as an embedded tag, and as a fully independent command. The tag checks whether one or more target files is current. A file is taken to be current (i.e., up-to-date) if it is newer than the source file.

Depending on the application, some of the attributes listed in Table 9.8 cannot be used as independent commands or as subtags. Thus, the `property` and `value` attributes will be effective only if `<uptodate>` is not used as a subtag. These attributes define the property that will be set in the successful (positive) case, as well as the value to be set, if necessary, in the property.

The definition of the two shared files is independent of the form of the application. Here there are two possibilities: you can first name the source and target files using the `srcfile` and `targetfile` attributes. You can also use an embedded tag

TABLE 9.8 Attributes of the `<uptodate>` Tag

Attribute	Description	Required
`property`	The name of the property to be created.	When used as an independent tag: Yes
`value`	The value to be assigned to the property.	No
`srcfile`	The source file.	Yes, if no embedded `<srcfiles>` tag is used
`targetfile`	The target file whose up-to-dateness is to be checked.	Yes, if no mapper is used

for specifying the source files. This has the name `<srcfiles>` here, but is entirely equivalent to the `<fileset>` tag. You can also construct the name of the target files with the aid of a mapper. (See Section 6.4.) You can even mix the two variants. It is entirely possible to specify the set of source files using an embedded `<srcfiles>` tag, and check these against a single target file that has been specified by the `targetfile` attribute. This may be appropriate for the target file, in connection with an archive, in which multiple source files are packed. Then the archive must always be brought up to date if at least one of the source files is newer than the archive.

A few examples will clarify the use of the `<uptodate>` tag in more detail. The first example just evaluates two precisely named files. These will be set by the attribute of the `<uptodate>` tag prescribed for the purpose:

```
<condition property="a">
 <uptodate srcfile   =  "example.java">
          targetfile = "example.class"/>
</condition>
```

In the second example, multiple source files are compared with a target file. The set of all XML files in a directory tree forms the comparison criterion for a Zip file. The Zip file can be defined in the `targetfile` attribute, while the embedded `<srcfiles>` tag must be used for selecting the source files:

```
<condition property="b">
  <uptodate targetfile = "examples.zip">
    <srcfiles   dir=   ".">
```

```
          <include name=".">
       </srcfiles>
      </uptodate>
    </condition>
```

The last example illustrates the use of a mapper. Here, a test will be made of whether all the classes in the subdirectory `classes` are up-to-date, or if at least one of the Java files has been modified since the pertinent class was made available:

```
<condition property="c">
  <uptodate>

    <srcfiles   dir=".">
       <include name="src/**/*.java"/>
    </srcfiles>

     <mapper type="glob"
             from="src*.java"
             to="classes*.class"/>
  </uptodate>
</condition>
```

In order to be able to activate the simplest possible mapper, the `dir` attribute in the `<srcfiles>` tag must point to a directory that contains both the source directory for the Java file and the directory `classes`.

9.12 LOGICAL OPERATORS

The subtags described thus far evaluate elementary conditions. Exactly one tag of this kind can exist within the `<condition>` tag. Other tags, however, make it possible to combine these conditions in logical expressions and, thereby, create complex instructions. The `<and>` and `<or>` tags accept an arbitrary number of all the available check tags whose results are then AND or OR coupled. In addition, the result of a single check tag, can be inverted using the `<not>` tag. The following segment from a listing illustrates the use of the logical operations:

```
<condition property="a">
  <and>
```

```
        <isset property="p1"/>
        <contains string="${p2} " substring="23"/>
        <not>
          <isset property="p3"/>
        </not>
      </and>
    </condition>
Chapter 9     14
```

10 Communication

A nt communicates in run time with the user. This occurs when Ant sends a sequence of status information to the console. On the other hand, Ant can request input from the user as it runs. The various processes are very pragmatic, and this, unfortunately, makes a general summary somewhat difficult.

The communications initiated by Ant can be partitioned into several domains. First, Ant automatically creates log output for the console. These log outputs cannot be influenced by commands inside the build files. Certainly, it is possible to activate so-called *listeners* and *loggers* which provide for additional processing of the log information, e.g., for entering in a file or sending by mail. The conventional listener writes the output to the console.

The second method of communication uses selected commands in order to deliberately create additional output within a build file. The output generated in this way appears in log data streams, but will also be processed by listeners and loggers.

A third possibility consists of editing the log outputs inside a build file and writing them to a file specified in the script. This possibility exists in parallel with the use of loggers and listeners, and is independent of them. Certainly, the same data stream is employed.

Last, but not least, Ant can also request input from the user. Here, also, with the aid of various input handlers, it is possible to read from the console or from a file. This offers you the possibilities either of working interactively with a build file, or of providing input values through a file without having to change the build file.

This section has a somewhat different structure from those of the previous ones. First, the commands that can be used for generating outputs will be described. This is followed immediately by a description of the input commands. It concludes with some remarks on the use of alternative loggers and input handlers.

10.1 OUTPUTS TO THE CONSOLE

The <echo> command enables the output of text to the console or into a file. In this way, the explicit file output is independent of any possible output handlers and can also be rerouted easily.

The information to be output will be noted either in the message attribute or between two <echo> tags. The latter variant permits the output of arbitrarily long texts, which may include line feeds. The syntax of this command also allows both variants to be used simultaneously.

When writing down the text inside the body of the text of the command, you must watch out for a possible line feed after the opening <echo> tag in the output, since that conflicts with XML conventions.

```
<project name="bsp1001" default="main" basedir=".">
  <target name="main">
    <echo message="Echo examples"/>
    <echo>Multiline text,
no spaces at the beginning.</echo>
      <echo>
Actually only one line, but with a line feed at the
beginning</echo>
    </target>
</project>
```

The three commands generate the following output:

```
[echo] Echo examples
[echo] Multiline text,
[echo] no spaces at the beginning.
[echo]
[echo] Actually only one line, but with a line feed at the
       beginning
```

Obviously, a property replacement takes place, so that you can also output the content of properties with the <echo> tag.

In order to reroute the output into a file, you have to enter the file name (with path specification, if necessary) into the file attribute. The value of the optional append attribute then determines whether an already existing file is to be overwritten, or the text in this case is to be appended to the end of the file. Table 10.1 summarizes all the attributes of this command.

TABLE 10.1 Attributes of the `<echo>` Command

Attribute	Description	Default	Required
message	The text to be output.		No
file	File into which the output is to go.		No
append	Append text to a file?	false	No
level	Text will only be output if Ant is running in at least the specified mode. Possible values are: error, warning, info, verbose, and debug.	warning	No

The operation of the `level` attribute is of interest for debugging and development support. Driven by some options in the command line, Ant can create outputs of different sizes. With the value of `level`, you set which `<echo>` outputs are to appear with which output variant. Create a build file with the following commands as a test of these attributes:

```
<project name="bsp1002" default="main" basedir=".">
  <target name="main">
    <echo message="error" level="error"/>
    <echo message="debug" level="debug"/>
    <echo message="info" level="info"/>
    <echo message="verbose" level="verbose"/>
    <echo message="warning" level="warning"/>
  </target>
</project>
```

Execute these files in sequence with different options:

- Ant -f bsp1002.xml -quiet
- Ant -f bsp1002.xml
- Ant -f bsp1002.xml -verbose
- Ant -f bsp1002.xml -debug

More outputs appear with each call. Table 10.2 again illustrates the relationship among the command line options and the value of `level`.

TABLE 10.2 Effect of the Different Level Specifications

Command line	error	warning	info	verbose	debug
-quiet	X	X			
No input	X	X	X		
-verbose	X	X	X	X	
-debug	X	X	X	X	X

10.2 OUTPUT OF FILE CONTENT TO THE CONSOLE

It may be desirable to deliver the content of files to the console for output of help texts, or for checking the operation of build files. This can be done with the aid of the <concat> command. This command cannot, however, be used to connect multiple files with one another. A somewhat detailed description of this is given in the section on modifying text files. At this point, only the output to the console will be described.

For this, you use the <concat> command without attributes. The file(s) to be output must be specified using embedded <fileset> or <filelist> tags. As these commands operate relative to a root directory that must always be specified, any previously specified complete file names must be broken up into a path specification and the file name.

The following simple example outputs the text of the current build file to the console. For this, the <basename> tag must be used in order to save the file name of the current build file. The build.name system property contains the complete path and not just the file name, as such.

```
<project name="bsp1003" default="main" basedir=".">
  <target name="main">
    <basename file="${ant.file}" property="this.name"/>
    <concat>
      <fileset dir="." includes="${this.name}"/>
    </concat>
  </target>
</project>
```

In similar fashion, it is possible to list the content of all XML files in a directory:

```
<project name="bsp1004" default="main" basedir=".">
  <target name="main">
    <concat>
      <fileset dir="."
               includes="*.xml"
               casesensitive="false"/>
    </concat>
  </target>
</project>
```

10.3 OUTPUT TO LOG FILES

The `<record>` command makes it possible to record the log outputs for selected commands directly in a file. The name of the file will be communicated to the command through the `name` attribute. This name is also the identifier for the recorder. Calling the `<record>` command with the attribute

```
action="start"
```

starts the rerouting of all subsequent log outputs to a file. Calling `<record>` with

```
action="stop"
```

will terminate the recording. Outputs to the console continue in parallel with recoding in a file from then on. As Table 10.3 shows, the command has several other attributes.

TABLE 10.3 Attributes of the `<record>` Command

Attribute	Description	Default	Required
name	Name of the file for deposit of the log information.		Yes
action	Start or stop recording? The possible values are: start and stop.		No
append	Append if the log file already exists?	yes	No
emacsmode	Remove the task name from the log outputs?	false	No
loglevel	Record at which log level? Possible values are: error, warn, info, verbose, and debug.	warn	No

If the record is repeatedly started and stopped, the append attribute controls whether the output data are overwritten with a new start, or the recorder is to append the new output to the end of the file.

The attribute

```
emacsmode="true"
```

can be used to remove the task name from the log output. By assigning a value to the loglevel attribute, one can limit the output to log outputs that correspond at least to the specified log level.

Some of the attributes, e.g., emacsmode and loglevel, can also be changed after the recorder has been started. For this, the <record> command is executed anew. Of course, besides the obligatory name attribute, only those attributes whose values are to be changed will be specified. Here is an example:

```
<project name="bsp1005" default="main" basedir=".">
   <target name="main">
    <record name="log.txt" action="start"/>
    <copy todir="backup" overwrite="true">
      <fileset dir="." includes="*.xml"/>
    </copy>

    <record name="log.txt" emacsmode="true" loglevel="debug"/>

    <copy todir="backup" overwrite="true">
      <fileset dir="../Kapitel09" includes="*.xml"/>
    </copy>

    <record name="log.txt" action="stop"/>

   </target>
</project>
```

There are two <copy> commands within the Ant file. The overwrite attribute in the two <copy> tags makes sure that something will be copied in every case. These tags will be used here for the sake of simplicity, in order to create some log output. These outputs will be recorded in the log.txt file by a recorder. The recorder will first be created and started by the command:

```
<record name="log.txt" actions="start"/>
```

After the first `<copy>` command, the settings of the two attributes, `emacsmode` and `loglevel`, must be changed. This is done by the command:

```
<record name="log.txt" emacsmode="true" loglevel="debug"/>
```

The name of the recorder (identical with the name of the log file) must be specified in every case. Then the attributes to be changed will be itemized. The values of all other attributes remain unchanged. The recorder also runs with the newly set characteristics, until it is stopped by the command:

```
<record name="log.txt" actions="stop"/>
```

New characteristics can be set as often as desired. A new log level can also be set using

```
<record name="log.txt" loglevel="info"/>
```

without engaging `emacsmode`.

10.4 CREATING BUILD ERRORS

The `<fail>` command induces a build error and interrupts the processing of the build file. It recognizes only three optional attributes (See Table 10.4). Informational text can be passed on using the `message` attribute and will appear at the console. `<fail>` is one of the few commands that processes both of the attributes `if` and `unless`. If a value is set for the `if` attribute, then this will be regarded as the name of a property. The build is interrupted only if such a property exists. When the `unless` attribute is used, on the other hand, an interrupt occurs only if the property does not exist.

TABLE 10.4 Attributes of the `<fail>` Tag

Attribute	Description	Required
message	Text for informing the user.	No
if	Interrupt only if the property exists.	No
unless	Interrupt only if the property does not exist.	No

The two attributes can be used together. In that case they will be AND coupled. This means that the build will only be broken if the property specified by if exists and the unless property does not exist.

10.5 READING FROM THE CONSOLE

With the <input> tag, an Ant file can read values from the input during run time. One possible example is branching into different processing branches in accordance with a user input.

The <input> command recognizes three attributes, all of which are optional. In practice, it is rarely possible to dispense with all three.

In the simplest conceivable form, without attributes, the <input> tag only waits until the Enter key is touched. No information is sent to the user in this case. The following example does function, but is not all that helpful in practice:

```
<project name="bsp1006" default="main" basedir=".">
  <target name="main">
    <input/>
  </target>
</project>
```

The disadvantage of this first variant is that the user of Ant is not informed further that he should react and what he has to enter. With the message attribute, you can output an explanatory text. You can, however, also omit this attribute and place the text between the opening and closing <input> tags. In this way, you can even output multiline texts. Here are two simple examples of this:

```
<project name="bsp1007" default="main" basedir=".">
  <target name="main">
    <input message="Further with &lt;ET&gt;"/>
    <input>Again &lt;ET&gt; for continuing</input>
  </target>
</project>
```

If Ant has to read-in and further process a value, this value must be entered in a property. Thus, you give a name to the property to be created using the addproperty attribute. The corresponding property may not yet exist when the <input> tag is

called, since the content of properties cannot be changed later. Here it also makes good sense to output an explanatory text.

```
<project name="bsp1008" default="main" basedir=".">
  <target name="main">
    <input addproperty="input.1"
           message="Input arbitrary text:"/>
    <echo message="${input.1}"/>
  </target>
</project>
```

If you would like to read the input later from a property file, the value of the message attribute serves as a key, which will be sought in the property file.

If the value to be entered must correspond to a prescribed range of values, this can be tested by the <input> tag. For this, you have to enter a list, separated by commas, in the validargs attribute. Ant presents this list to the console during runtime, so the user is informed about the allowed values.

```
<project name="bsp1009" default="main" basedir=".">
  <target name="main">
    <input addproperty="input.2"
           message="Erase old classes in advance?"
           validargs="Y,y,N,n"/>
    <echo message="${input.2}"/>
  </target>
</project>
```

In conclusion, Table 10.5 shows you the applicable attributes of the <input> tag.

TABLE 10.5 Attributes of the <input> Tag

Attribute	Description	Required
addproperty	Name of the property to be made available.	No
message	Advisory text; to be output to the console.	No
validargs	List with values that are accepted as valid input. Values separated by commas. Upper/lower case taken into account.	No

10.6 SEND MAIL

Mail with arbitrary content can be sent out from a build file. This feature should not be confused with the sending of log output by mail (using the mail logger). The `<mail>` tag described here is an Ant task, like all others, and operates independently of any disposition of the in- and output.

The `<mail>` tag has a series of attributes that are listed in Table 10.6. Use of this tag is, despite the number of attributes, not complicated.

TABLE 10.6 Attributes of the `<mail>` Tag

Attribute	Description	Default	Required
mailhost	Host name of the SMTP server.	localhost	No
mailport	TCP port of the SMTP server.	25	No
from	Sender's e-mail address.		Either attribute or embedded `<from>` tag
tolist	List of recipients, separated by commas.		At least one of three recipient attributes for embedded tags
cclist	List of recipients of copies.		
bcclist	List of BCC recipients.		
subject	Subject (heading) of the e-mail.		No
message	The message to be sent.		message or messagefile attributes or embedded `<message>` tag
messagefile	The file containing the message to be sent.		
messagemimetype	Mime type.	text/plain	No
files	Name of the files which are to be sent as attachments. Separated by commas.		No

(continues)

TABLE 10.6 Attributes of the `<mail>` Tag (*continued*)

Attribute	Description	Default	Required
failonerror	Issue build error if problems arise in sending the mail.	true	No
includefilenames	Include file names in the mail.	false	No
encoding	Which encoding should be used? Possible values: mime, uu, plain, and auto.	auto	No

The `<mail>` command expects many of the available values either in attributes or in embedded tags. It is, therefore, somewhat difficult to provide a survey of which attributes or tags should be used.

An indispensable technical prerequisite for sending mail is a mail server. In order for Ant to find this, the `mailhost` and `mailport` attributes must be set to the correct values. The default settings are not usually correct, so at least the mail server must always be specified.

An important part of an e-mail is the sender entry. This can come from the `from` attribute or the embedded `<from>` tag. The `<from>` tag enters the sender in the `name` attribute. As only one sender entry can be used, it is usually more transparent to enter it in the `from` attribute than to use the embedded tag. Regardless of how, an e-mail must contain a sender entry. It is recommended that a valid mail address be used, lest possible error information from the mail server gets lost.

Another indispensable element of an e-mail is the definition of at least one recipient. The `<mail>` command recognizes many different possibilities for defining a recipient. At least one of these must be used. As is well known, the mail protocol distinguishes between the main recipient, the open corecipients (cc), and the hidden corecipients (bcc), of a mail message. Attributes or subtags are available for all three groups of recipients. The subtags (`<to>`, `<cc>`, and `<bcc>`) are equipped with the obligatory `address` attribute for accepting a recipient entry. There can be many of these tags within the `<mail>` tag for each case. This allows for a clear notation for multiple recipients.

The `tolist`, `cclist`, and `bcclist` attributes can also be used for noting the recipients. These attributes accept a list with addresses, separated by commas.

Certainly, it is not recommended that this feature be used, as it can produce very opaque source text.

Now to the content of the mail itself: The subject attribute accepts the title of the e-mail. This attribute cannot be replaced by a subtag. It is optional, as you can send mail without a title, but this is not advised in practice.

Different variants are available for defining the message itself. The message attribute is only appropriate for very short messages. The <message> subtag is better suited, as multiline text can also be entered using it. The message is normally noted as the text body for the tag. In the <message> tag you can, of course, also use the src attribute to provide the name of a file that contains the mail text. In order to read the text of a mail message from a file, you can also employ the messagefile attribute in the <mail> tag. In both methods for using a file, property placeholders in the text are replaced by the current value of the properties.

Last but not least, a mail message can be provided using attachments. You note the name of the corresponding files in the files attribute. If several names are to be noted, they are separated by commas. It is more transparent, as well as clearly more practical to use one or more embedded <fileset> tags. In this way, the results of a build process can also be sent by mail.

You will have to adapt the following example fragments to any actual system environment. They merely offer a few illustrations of the syntax for the mail command.

The first example sends a mail message to the recipient with the mail address developer@ourcompany.de and a copy to boss@ourcompany.de. The file ourproject.jar will be made available for the mail message:

```
<mail from="build@ourcompany.de"
      subject="Build successful"
      mailhost="hermes"
      files="ourproject.jar">
  <message>Build successful </message>
  <to address="developer@ourcompany.de"/>
  <cc address="boss@ourcompany.de"/>
</mail>
```

The second example is addressed to all the recipients whose names are entered in the developers property. The addresses must be separated from one another by commas. All the log files of the build will be attached to the mail message.

```
<mail from="build@ourcompany.de"
      subject="Build failed"
```

```
        mailhost="hermes.ourcompany.de"
        message="Build failed"
        tolist="${developers}">
    <fileset dir="../logs">
      <include name="*.log">
    </fileset>
  </mail>
```

10.7 DISPOSITION OF STANDARD IN- AND OUTPUT

The concept of *disposition* does not describe the true situation correctly. Ant does not communicate directly with the environment, but gains access to the environment through certain classes. This concerns both the output of log information and the interactive input of data during a run.

Which classes specifically will be used can be configured. There are default settings with standard classes. Ant provides some optional classes, as well. These classes can also implement supplementary functionality with respect to in- and output. In addition, you can write your own classes and insert them into Ant.

10.7.1 Concepts

Several fundamental objects are of significance in connection with the in- and output of data. A *listener* can recognize and process the following events:

- Beginning and end of the build
- Beginning and end of the execution of a target
- Beginning and end of the processing of a task (commands)
- Explicitly created messages

A *logger* extends the possibilities of a listener. It has the following additional characteristics:

- Evaluating the log level
- Disposition of the output to the console or to a file
- Remove task designations

Loggers and listeners are entered in the command line when Ant is called. The options -logger and -listener exist for this purpose. These options expect the

name of a Java class as a parameter. Some of these classes are already available in Ant installation packets. Others can be self-programmed when needed.

Loggers extend listeners functionally, but also in an entirely concrete fashion at the level of Java programming. Loggers are the successors of the listener class and implement their interface. A logger can, therefore, also be inserted as a listener and its additional properties will, of course, be lost.

Ant recognizes several command line options which have an influence on the output of log information. These options are evaluated by the various loggers. If a log level is also set by the command line option, all log information will thenceforth be created within the build file. First they will be filtered through the logger. That means, as well, that listeners regularly receive and pass on all log information.

Another element is the *input handler*. Ant reads-in files with such a handler. The standard handler for the input reads from the console. Other handlers can be set with the -inputhandler command line option.

10.7.2 Listeners

Listeners regularly receive all log output, and the command line options will first be evaluated for log level or formatting later. Among the available optional classes for Ant there is only one real listener. That is the Log4j listener. This listener forwards all log output to the Log4j packet. This packet involves an open source project that provides extensive mechanisms for logging and evaluation of log messages.

In order to be able to use these listeners, several preliminaries must be satisfied:

- Log4j must be correctly installed and administered.
- During running, a reference to the Log4j jar-file must be contained in the class path.
- A Java system variable must point to a Log4j configuration file.

Correct use of the listener, therefore, requires some knowledge of another open source product, which cannot be provided here for reasons of space.

The listener will be put to use by entering the following in the command line:

```
ant -listener org.apache.tools.ant.listener.Log4jListener . . .
```

10.7.3 Loggers

Loggers can take over some other functions. In particular, they evaluate the various command line options. (See Table 10.7.)

TABLE 10.7 Command Options for Log Information

Option	Description
`-quiet, -q`	Minimum log information (log-level `warn`).
`-verbose, -v`	Extensive log information (log-level `verbose`).
`-debug`	Extensive log information (Log-level `debug`).
`No entry`	Normal log information (Log-level `info`).
`-emacs`	Remove task names.
`-logfile <file>, -1 <file>`	Output to log file.

At present there are four optional loggers besides the default logger. You can get their names and functions from Table 10.8.

TABLE 10.8 Loggers for Ant

Name	Description	Class
Default Logger	Standard logger for output to the console	`org.apache.tools.ant.DefaultLogger`
NoBanner Logger	Suppresses the output of empty target log information	`org.apache.tools.ant.NoBannerLogger`
Mail Logger	Sends the output of the default logger as mail	`org.apache.tools.ant.MailLogger`
AnsiColor Logger	Output to the console, with color text	`org.apache.tools.ant.AnsiColorLogger`
XML Logger	Output log information in XML form	`org.apache.tools.ant.XmlLogger`

A logger is integrated using the `-logger` command line option followed by the complete class name of the logger. Only one logger can ever be activated.

Loggers can also be installed as listeners, as they are the successors to this class. But this is actually appropriate only rarely.

For correct operation, the loggers sometimes require additional information which differs from logger to logger. The loggers will, therefore, be described separately. The following build file can serve as a test object:

```
<project name="bsp1010" default="main" basedir=".">
  <target name="main" depends="dummy">
    <echo message="error"   level="error"/>
    <echo message="warning" level="warning"/>
    <echo message="info"    level="info"/>
    <echo message="verbose" level="verbose"/>
    <echo message="debug"   level="debug"/>
  </target>
  <target name="dummy"/>
</project>
```

This file contains some <echo> commands by which log notices will be created with different log levels. In addition, it contains a target dummy, which contains no commands, so it creates no log notices.

Default Logger

The default logger reroutes the log output directly to the console. As this log is conventionally employed, activation by command line is superfluous. The logger yields the log information normally to the console. The -logfile command line option can be used to force rerouting into an arbitrary file. In this case, there is no output to the console. Notices that are created by the <input> tag are then also not visible, and this may lead to inexplicable interruption of processing.

This logger is quite well-suited to testing the different command line options in Table 10.8. Thus, calling

```
ant -f bsp1010.xml bzw.
ant -logger org.apache.tools.ant.DefaultLogger -f bsp1010.xml
```

will produce the following output at the console:

```
dummy:
main:
      [echo] error
      [echo] warning
      [echo] info
```

NoBanner Logger

This logger resembles the default logger. The only difference is that log outputs announcing the start of a target are suppressed if this target creates no further log outputs. Calling

```
ant -logger org.apache.tools.ant.NoBannerLogger -f bsp1010.xml
```

thereby creates an output in which the output of the target name dummy is absent:

```
main:
        [echo] error
        [echo] warning
        [echo] info
```

XML Logger

The XML logger makes an XML file available from the log information. This is somewhat more comprehensive, since more information is put into the file in comparison to the default logger. The output of this logger appears at the console, unless a log file is prescribed by the -logfile command line attribute.

The logger ties-in the reference to an XSL file in the generated output. Conventionally, log.xsl is used. This prescription can be overwritten by setting the Java property ant.XmlLogger.stylesheet.uri. Inasmuch as this property is created without a value, the referencing of a style sheet in the XML file is omitted. An Ant call with XML logger might look this way:

```
ant -logger org.apache.tools.ant.XmlLogger \$\
-Dant.Xml.Logger.stylesheet.uri=mystyle.xsl \$\
-logfile log.xml \$\
-f bsp1010.xml
```

The XML logger can also be installed as a listener. In this case, it writes the output into the customarily-provided file log.xml. This name can be overwritten by setting the system property XmlLogger.file.

In order to use the XML logger as a listener, the following form must be called:

```
ant -listener org.apache.tools.ant.XmlLogger \$\
-f bsp1010.xml
```

If a listener is activated, this changes nothing in the setup of a logger. From that point on, the default logger operates in parallel to the listener, and this leads to the output of the log information to the console.

ANSI Color Logger

The color logger also operates like the default logger, in that it also writes to the console. Of course, the individual lines will be indicated in color in accordance with the log level. Escape sequences in the output data stream cause color changes. This logger does not operate in Windows NT systems and the operating systems derived from it (Windows 2000). In other Windows systems, an ANSI.SYS driver must be loaded in order to ensure a correct display.

The color allocations can be changed if necessary. To do this, a file with the new color assignments must first be provided. The entries in this file have the form

```
AnsiColorLogger.<Level>_COLOR=mode;foreground;background
```

Five values come into play for the level: ERROR, WARNING, INFO, VERBOSE, or DEBUG (uppercase required). Mode and color are coded numerically. The background specification can be omitted. The allocations are listed in Table 10.9 and Table 10.10.

TABLE 10.9 Values for the Display Mode

Mode	Description
0	Reset to standard values.
1	Light or bold.
2	Shadow.
3	Underlined.
5	Left.
7	Inverted.
8	Hidden.

TABLE 10.10 Codes for colors

Color	Code for foreground	Code for background
Black	30	40
Red	31	41
Green	32	42
Yellow	33	43
Blue	34	44
Magenta	35	45
Cyan	36	46
White	37	47

A file might look like this:

```
AnsiColorLogger.ERROR_COLOR=2;31
AnsiColorLogger.WARNING_COLOR=2;33
AnsiColorLogger.INFO_COLOR=0;37
AnsiColorLogger.VERBOSE_COLOR=0;34
AnsiColorLogger.DEBUG_COLOR=0;36
```

Last, but not least, you must provide Ant with the name of the file with the changed color allocations. This is done using the Java system property `ant.logger.defaults`. This property is to be passed on to the JVM. A notation in the Ant command line, therefore, is useless. On the contrary, the property must be assigned in the system variable `ANT_OPTS`, whose content will be used as a parameter for the Java call in the Ant start files. This can be done using a command at the console:

```
set ANT_OPTS=%ANT_OPTS%  -Dant.logger.defaults=ansi.col
```

Mail Logger

The mail logger works like the default logger. It allows for the same command line attributes with respect to the log level, formatting, and rerouting to file. In addition, it mails the log output. All information required for sending must be passed on to the mail logger through Java system properties. These properties are described in Table 10.11.

TABLE 10.11 Java Properties for the Mail Logger

Property	Description	Default	Required
MailLogger.properties. file	File name for properties.		No
MailLogger.mailhost	Name of mail server.	localhost	No
MailLogger.from	Sender of the mail.		Yes
MailLogger.failure. notify	Should mail be sent if the build is interrupted?	true	No
MailLogger.failure. subject	Title for error mail.	Build failure	No
MailLogger.failure. to	Addresses to which error mail is to be sent (separated by commas).		Yes, if error mail is to be sent
MailLogger.success. notify	Should mail be sent after a successful build?	true	No
MailLogger.success. subject	Title for success mail.	Build success	No
MailLogger.success. to	Addresses to which the success mail will be sent (separated by commas).		Yes, if success mail is to be sent

There are two possibilities for transferring the properties to the JVM. First, you can, as already described for the color logger, enter all the properties in the system variable ANT_OPTS. This consumes a relatively large amount of time. The second possibility is to make a property file available, and merely insert a reference to this file in ANT_OPTS. For this, you use the property MailLogger.properties.file.

A property file for the mail logger might look like this:

```
MailLogger.mailhost=hermes
MailLogger.from=ant.tool@abcxyz.de
MailLogger.failure.to=developers@abcxyz.de
MailLogger.success.to=ant.@abcxyz.de
```

A build file is then called (in Windows) as follows, when the mail logger is in use:

```
set ANT_OPTS%ANT_OPTS%  -DMailLogger.properties.file=antmail.cfg
ant -f bsp1010.xml -logger
org.apache.tools.ant.listener.MailLogger
```

10.8 INPUT HANDLER

Ant needs the input handler in order to be able to read interactive input. In the current version there are two different input handlers, the *default input handler* and the *property file input handler*. While the first always reads input from the console and can, therefore, accept input from the user, the second handler obtains any values from a property file. In this way, a build file can be processed in a batch job.

The input handler must be set by the `-inputhandler` command line option in an Ant call. Without explicit selection of an input handler, Ant always uses the default handler.

When the *property file handler* is used, the name of the property file must also, of course, be passed on to Ant. This is done through an assignment to the `ant.input.properties` Java property. This is not an Ant property that can be used inside the build file, but a property of the JVM. Hence, properties of this type cannot be defined using the `-D` option in an Ant call. Rather, they must be included in the call of the Java runtime environment. This is most simply done by settings in the `ANT_OPTS` environment variables. This is illustrated by the following commands for a Windows console.

First, you have to provide a property file manually. In this example, this file cannot be created inside the build file, as it must already be available when Ant starts. In this example, it has the name `my1011.properties`. It should have the following content:

```
sourcedir=/project/src
targetdir=/classes
Build.Mode=internal
```

In the build file, you can select the entries in the property file using corresponding values in the `message` attribute in the `<input>` tag. The written entries must correspond exactly to those in the property file and upper and lower cases are distinguished.

```
<project name="bsp1011" default="main" basedir=".">
  <target name="main">
   <input message="Build.Mode" addproperty="build.mode"/>
   <input message="sourcedir" addproperty="dir.source"/>
   <input message="targetdir" addproperty="dir.target"/>
   <echo message="source: ${dir.source}"/>
   <echo message="target  : ${dir.target}"/>
   <echo message="mode   : ${build.mode}"/>
  </target>
</project>
```

The environmental variable ANT_OPTS must be set before Ant is called:

```
set ANT_OPTS=-Dant.input.properties=my1011.properties
```

Finally, you can call Ant in order to execute the build file. Here, of course, you must also use the *property file input handler*, in order to have access to the property file:

```
ant -buildfile bsp1011.xml -inputhandler
org.apache.tools.ant.input.PropertyFileInputHandler
```

Without the alternative input handler, Ant will request that the three values be input to the console.

11 Source Code Control Systems

Since software is predominantly developed by teams, the source code must be administered by appropriate tools. Important tasks for these tools include the handling of concurrent access and the updating of changes, as well as ensuring the protection of data. One of the prerequisites for a successful build is the availability of the current source code. Thus, Ant can gain access to many of the common source code administration systems. These systems are based on different concepts, so Ant cannot create a transparent interface. On the contrary, each of these systems will have its own set of commands.

Here we shall describe the use of CVS and MS source safe as typical of these systems. The focus will be on the Ant commands, rather than on the underlying philosophy of the two systems.

11.1 CVS

CVS is an open source project that is also quite widespread. Many development environments have an inbuilt CVS connection from the very beginning. Of course, during communication with CVS, Ant is directed to an external program. This program forms the core of a CVS client, which is installed in the local computer or must be accessible through a network. This client exists for different operating system platforms. An important requirement is that Ant be able to start the external program. It must be capable of being run on the current operating system, and be contained in the search path for programs (the environmental variable PATH). If necessary, the Ant start file must be adapted accordingly. The record in the class path is definitely not sufficient, as the CVS client is not a Java program.

Ant offers a few commands, most of which merely represent a wrapper over the external program. All instructions will be converted into command line parameters and passed on to the CVS client.

The CVS system is usually set up so that an authentication is required. Thus, prior to actual work with CVS, the registration must succeed. As any interactions must generally be avoided during work with Ant, the access data must be entered in the script or an external file. There are two possibilities for this.

The `<cvspass>` command prepares a password file from a few parameters. Its name is defined in the optional `passfile` parameter. It can be chosen freely. If no file name is given, this command creates the file `.cvspass` in the home directory of the current user. This file must be tied in to other CVS commands for authentication. The two other parameters are `cvsroot` and `password`. The content of `cvsroot` provides the complete registration, which consists of the user name, server address, and target directory. The format is prescribed by CVS and is independent of Ant. The following segment from a listing illustrates the use of this command:

```
<cvspass
  cvsroot=":pserver:berndm@cvsserver.firma.de:/usr/cvsroot"
  password="password"
  passfile="pfile"
/>
```

The command just described expects the password in the script. It can be hard-coded there, or be transferred as a parameter, when the Ant file is called. The `<input>` tag can also be used if necessary.

The second possibility is to create a password file. This involves the use of a special CVS command set. All these commands are executed using the generic tag `<cvs>`. Here the specific command is selected using the `command` attribute. The remaining attributes depend on the specific CVS command and cannot be tested by Ant.

The CVS command `login` also provides a password file, but interrogates the password interactively during the run at the console. No indications of the required input show up! Any such indication must be output separately using the `<echo>` tag. This command also provides for individually presetting the file name. The `.cvsroot` file in the home directory again serves as a default:

```
<cvs
  command="login"
  cvsroot=":pserver:berndm@cvsserver.firma.de:/usr/cvsroot"
```

```
    passfile="pfile"
/>
```

All the other commands are called following the same pattern. The actual command (e.g., checkout, update, submit) is noted in the command attribute. If this attribute is lacking, CVS automatically performs a checkout. A successful authentication, however, requires the passfile attribute every time, unless the default setting is used. All other attributes depend on the current command. Here the CVS documentation can be consulted, if needed.

```
<cvs
    command="checkout"
    cvsroot="${cvsroot}"
    package="factory"
    dest=${path.abs.src}"
    passfile="pfile"
/>
```

Table 11.1 lists at least the available attributes.

TABLE 11.1 Attributes of the <cvs> Tag

Attribute	Description	Default	Required
command	The CVS command to be executed.	checkout	No
compression	Compress during transfer.	false	No
compressionlevel	Degree of compression (1-9).	false	No
cvsroot	CVSROOT variable.		No
cvsrsh	CVS_RSH variable.		No
dest	Destination (target) directory.	Current working directory	No
package	Name of the packet to be checked.		No
tag	Name of the tag to be checked.		No

(continues)

TABLE 11.1 Attributes of the `<cvs>` Tag (*continued*)

Attribute	Description	Default	Required
date	Use the most up-to-date version up to the current date.		No
quiet	Suppress the output of information.	false	No
noexec	Just test, modify no files.	false	No
output	File name for info-log output.		No
error	File name for error output.		No
append	Append output to file? The alternative is to overwrite.	false	No
port	Port for the CVS server.	2401	No
passfile	Password file.	~/cvspass	No
failonerror	Interrupt build on error.	false	No

The CVS client involves a command line program which can be navigated over a multiplicity of different parameters. Not all the parameters can be set using the attributes of the `<cvs>` tag. For the sake of greater freedom of movement in calling external commands, you can insert arbitrary values in the command line with the embedded `<commandline>` tag. The `<commandline>` tag combines multiple `<argument>` subtags, and generates a complete command line out of their values. The syntax of the `<argument>` subtag is identical with that of the `<arg>` tag. You can find a further description of this tag in Section 14.3.

Besides the `<cvs>` tag, with which essentially all the crucial tasks during a build can be executed, Ant provides the `<cvschangelog>` and `<cvstagdiff>` tags, with which different evaluations can be provided.

11.2 MICROSOFT'S VISUAL SOURCE SAFE

Microsoft also provides a server for source code administration. It is known as *Visual Source Safe* (VSS). It differs substantially from CVS, both in its basic principles, and in its tie-in to Ant.

A significant limitation is that both the server and the client are only available for Windows platforms. Since a local client also must be on hand with this application, the tie to MS Source Safe can only be put into operation on Windows platforms. As with CVS, the client must be started by Ant. To be sure, it is not necessary to include the storage site in the system path. That can, rather, be passed on as an attribute with all VSS commands. A greater difference lies in the availability of separate Ant commands for each VSS function. There is also a difference that is made clear by the close dovetailing of the various MS products with the operating system: with an appropriate server configuration, the VSS client can transfer the current user data to the server. This makes a new authentication unnecessary under certain circumstances.

Here also, a description of the Ant commands alone, without knowledge of the VSS, is insufficient. Hence, the following descriptions provide a bit of insight into the functionality of the VSS, in addition to the description of the tags.

The most elementary task in the course of a build is to provide the source files. In VSS language, this function is referred to as "get latest version" or simply, "get." It reads the specified files from the server and furnishes them, as write protected and unprocessable files, in the local file system. The corresponding tag is named `<vssget>`. The list of attributes is quite long (See Table 11.2), but these are relatively simple.

TABLE 11.2 Attributes of the `<vssget>` Tag

Attribute	Description	Default	Required
vsspath	Name of the project to be read (root path from which it is to be read).		Yes
localpath	Local root directory for placing the read files.	Working directory from the VSS	No
recursive	Recursively process the directory branch in VSS.	false	No
writable	Eliminate write protection of the local files.	false	No
version	Number of the version to be read.		No
date	Date of the file version to be read.		No

(continues)

TABLE 11.2 Attributes of the `<vssget>` Tag (*continued*)

Attribute	Description	Default	Required
label	Name of the label whose state is to be read.		No
quiet	Suppress log output.	off	No
autoresponse	Automatically generated response to query from the server.		No
ssdir	Directory of the VSS client (`ss.exe`).		No
serverpath	Directory of the `srssafe.ini` file.		No
login	Name and password, separated by a comma.		No

The only required attribute is `vsspath`. This attribute contains the name or the path of the project to be read. You can also read arbitrary subprojects separately using the corresponding paths; individual files can likewise be selected. All other entries are optional. Certainly, the `localpath` attribute should be used as a precaution. This attribute is occupied by the name of the path through which the files and directories to be read are placed. In this way the placement site is specified uniquely. If the corresponding input is not kept in Source Safe, the local directory will be used as a placement site. This is, most likely, not desired. If the target files are not empty, all the files to be overwritten must be write protected. This sounds paradoxical; certainly, Source Safe assumes, on the basis of the missing write protection, that this file is to be processed and, as a precaution, interrupts the read procedure. All the read-in files are normally provided with write protection. The flag `writable` can be used to eliminate the write protection. That is appropriate, if the source texts of the files are to be modified (with the removal of comments, adding build numbers, etc.). In order to have all the subdirectories of a project read, you have to set the `recursive` flag to `true`.

In the standard setup, the latest version of the files is read. An older version can be selected using the attributes `version`, `date`, or `label`. The `<vssget>` tag always accepts only one of these attributes. You can suppress the log outputs of the tag by setting the attribute `quiet` to `true`.

Three other system-related attributes are important in practical operations. They can also be found with other VSS tags. With the ssdir attribute, you can define the path to the VSS command line client (program ss.exe). That is helpful if this path is not contained in the system path. The login attribute accepts the user name and password, since an explicit authorization is generally required. Finally, the serverpath attribute can indicate the directory containing the INI file of the VSS.

After a successful build it is appropriate to *label* the current state. In this way, the current state of all files in the project will be simultaneously and reproducibly frozen. The tag needed for this is <vsslabel>. It is provided with some of the attributes that have already been described, but also with some new ones (see Table 11.3). Specific to this command are the attributes label and comment. With them you preset the name of a label or a comment.

TABLE 11.3 Attributes of the <vsslabel> Tag

Attribute	Description	Required
vsspath	Name of the project to be labeled (root path from which it is to be labeled).	Yes
label	Name of the label.	Yes
version	Version which is to be labeled.	No
comment	Comment.	No
autoresponse	Automatically-generated response to server query.	No
ssdir	Directory of the VSS client (ss.exe).	No
serverpath	Directory of the srssafe.ini file.	No
login	Name and password, separated by a comma.	No

If files must be processed, they must be checked out on the VSS server. The server reserves these files exclusively for the user who is checked, until he checks them again. Concurrent write procedures are, accordingly, excluded. This scheme is necessary, since VSS cannot automatically compensate for parallel changes. For this reason, however, it is also possible for the first time to manage files other than pure text files.

The <vsscheckout> tag is used for checking files. Its attributes can be seen in Table 11.4. These attributes essentially correspond to those for the <vssget> tag.

The major differences are that the files to be checked out are automatically set to modifiable, and that an interlock memo is entered in the Source Safe server.

TABLE 11.4 Attributes of the `<vsscheckout>` Tag

Attribute	Description	Default	Required
vsspath	Name of the project to be checked out (root path from which it is to be read).		Yes
localpath	Local root directory to put the read files into.		No
writable	Eliminate write protection for the local files.	true	No
recursive	Recursive processing of directory tree in VSS.		No
version	Version number to be read.		No
date	Date of the file version to be read.		No
label	Name of the label whose state is to be read.		No
ssdir	Directory of the VSS client (`ss.exe`).		No
serverpath	Directory of the `srssafe.ini` file.		No
login	Name and password, separated by a comma.		No

After successful processing, the files will be checked in again using the `<vsscheckin>` tag. Here, also, the attributes offer little that is new (See Table 11.5).

TABLE 11.5 Attributes of the `<vsscheckin>` Tag

Attribute	Description	Required
vsspath	Name of the project whose files are to be checked in.	Yes
localpath	Local root directory to put the read files in.	No
writable	Let local files be modifiable.	No
recursive	Process the directory tree in the VSS recursively.	No
comment	Comment.	No

(continues)

TABLE 11.5 Attributes of the `<vsscheckin>` Tag (*continued*)

Attribute	Description	Required
autoresponse	Automatically-generated response to server query.	No
ssdir	Directory of the VSS client (`ss.exe`).	No
serverpath	Directory of the `srssafe.ini` file.	No
login	Name and password, separated by a comma.	No

You will find a somewhat more comprehensive example of using the VSS commands among the examples in Chapter 15.

12 Compiling

The Java SDK includes several compilers which must be used at different points of the build process. The Java compiler javac, itself, is naturally of central importance. When client-server applications are required, the RMI compiler comes into use. Besides these two compilers, there are other programs, either in the standard SDK, or in the packages associated with various extensions, e.g., javah for generating header files, or jspc for compiling JSP pages. Ant provides appropriate tasks for many of these compilers or generators.

12.1 JAVAC

The <javac> task fulfills the essential core task of a build tool. It compiles the java source files. It has one peculiarity compared to the other, previously mentioned, tasks. The Java compiler of the installed JDK will, of course, be used for compiling. Ant does not have a Java compiler of its own. Thus, the <javac> command uses an external application. Therefore, some qualitatively new requirements arise, which are embodied in additional attributes.

The attributes of the <javac> task can be roughly divided into three groups: the first group consists of the file- and path-related attributes. These establish which files are to be compiled and where the created class files are to be put, which class path to apply, etc. The inputs will initially be processed internally by Ant and passed on to the compiler in processed form. Attributes from this group must almost always be used in order to make meaningful use of the <javac> command.

The second group includes attributes to make the tags work together with the build file. These include, for example, inputs regarding behavior during compiler errors, or the output of log information. Some of these attributes are interpreted by Ant, others are passed on to the compiler.

The last group of attributes includes technical settings that extend directly to the compiler. The Java compiler can be started with various options. Depending on the platform, there are also various compilers. The options in this group do not change the number of files to be compiled, but only influence the type and manner of the compiling procedure.

The following discussion treats these groups separately. This does not represent a value judgment, but merely allows for a better summary.

First, some comments on file selection: one important element in a call of the `<javac>` tag is the list of files to be compiled. The `<javac>` tag accepts different variants for entering these. As the tag implicitly resembles a `<fileset>` tag, all the variants resemble the latter tag.

The definition of a source root directory by the `srcdir` attribute, or an embedded `<src>` tag, is absolutely necessary. This attribute corresponds to the `dir` attribute of a fileset. Unless other limitations arise, all Java files will be compiled into this directory. The value of this attribute is used by Ant to construct a list with the files to be compiled. This list is passed on to the Java compiler as an argument. The value for the `sourcepath` attribute is generated from the name of the root directory at the same time. This attribute is passed on unchanged to the Java compiler, which expects an attribute of the same name. Normally, it is not necessary to use the `sourcepath` attribute in an Ant script.

As a supplement to the root directory, you can accept or include files explicitly in the selection using the options known from fileset. The `includes`, `includesfile`, `excludes`, and `excludesfile` attributes are available for this purpose. In addition, you can use the corresponding embedded tags for file selection.

As all the other attributes are optional, a correct call of the `<javac>` command might look like this:

```
<javac srcdir="${pf.path.abs.src}"/>
```

Of course, this call works correctly only when certain boundary conditions are satisfied, especially that the class path is set correctly outside Ant in the system environment. In practice, additional inputs will be required here for various reasons.

Another important, even if optional, adjustment involves the target directory. Normally, the compiled classes will be put in a separate directory tree. `<javac>` has the `destdir` attribute for specifying the root of this tree. Without this attribute, the Java compiler puts the `class` files in the source path. The destination directory must already exist; it will not be created by the `<javac>` command. A nonexistent target directory causes a build error.

At this point, some advice on the correct configuration of the root directories and file names or patterns is necessary. The `<javac>` command analyzes source and target files, and only compiles those files which are more up-to-date than the class files that may exist. This selection can speed up the compiling of large projects considerably. Such a comparison requires that the `<javac>` command be able to find out exactly which files belong together. For this, it compares the complete relative path names below the root directory for sources and target.

In the target directory, the structure is produced by the package structure of the Java classes. In order for identical relative path names to emerge now, an adequate directory structure must also exist in the source directory. In addition, the values for `srcdir` and the selection pattern must have been prescribed correctly. The following examples should elucidate the problem.

ON THE CD

Let an arbitrary project directory (`project1` on the CD-ROM) be given, which must serve as root directory for all the files in the project. It is defined in the listings by the Ant property `root`. The directories `src` and `classes` should exist under this directory. The file `AntExample.java`, which is to be translated, should be in the directory `src`. This file is not a component of a package, as the following segment from the listing of the Java file shows:

```
import java.awt.*;
import java.awt.event.*;
public class AntExample extends Frame  implements ActionListener {
    public AntExample(String title) {
.<\q>.<\q>.
```

The following target should be used for compiling the file:

```
<project name="bsp1201" default="main" basedir=".">
  <property name="root" value="./project1"/>

  <target name="main">
    <javac srcdir="${root}/src"
           destdir="${root}/classes"/>
  </target>
</project>
```

The file `AntExample.classes` arises out of the file `AntExample.java` and is put directly into the target directory `classes`. Thus, both the source and the target files appear directly under the directories designated as target and destination

directories in the target. In a subsequent compiling, Ant can order the files uniquely one after another and check whether a new compiling is actually necessary or not.

Problems can arise if the Java file must be a component of a package, as the following example clarifies. You can find the file on the CD-ROM in the subdirectory project2:

```
package myPackage;
import java.awt.*;
import java.awt.event.*;
public class AntExample extends Frame  implements ActionListener {
    public AntExample(String title) {
.<\q>.<\q>.
```

If the file also lies immediately in the src directory, it can be compiled without problems using the following example:

```
<project name="bsp1202" default="main" basedir=".">
  <property name="root" value="./project2"/>

  <target name="main">
    <javac srcdir="${root}/src"
           destdir="${root}/classes"/>
  </target>
</project>
```

Certainly, the resulting class file is not put directly into the classes directory. On the contrary, the compiler creates a subdirectory myPackage into which it puts the class. The file name relative to the root directory is now myPackage/AntExample.class. The names for the source and target files are now different, so that the up-to-dateness of the target file can no longer be tested by the <javac> tag. Only when a subdirectory myPackage is also placed in the source directory, and the Java file is put there, is an up-to-dateness test again possible.

Even with a correct directory structure (see the subdirectory project3 on the CD-ROM), however, errors are possible. For the case in which only one package exists, or only one is to be compiled, the idea of keeping the package name directly in the srcdir attribute suggests itself:

```
<project name="bsp1203" default="main" basedir=".">
  <property name="root" value="./project3"/>
```

```
      <target name="main">
        <javac srcdir="${root}/src/myPackage"
           destdir="${root}/classes"/>
      </target>
    </project>
```

Certainly, the relationships are then the same as in the second example. The path name of the source file is determined only relative to the value of the srcdir attribute, whereby, in turn, the name of the package is lost. In this case it is right to leave the srcdir attribute unchanged, and instead select the package to be compiled via the <include> tag:

```
    <project name="bsp1204" default="main" basedir=".">
      <property name="root" value="./project3"/>

      <target name="main">
        <javac srcdir="${root}/src"
               destdir="${root}/classes">
          <include name="myPackage/**"/>
        </javac>
      </target>
    </project>
```

The next, most indispensable attribute in practice is classpath or classpathref. If external Java packets are to be used in the application to be compiled, these have to be itemized in the class path in order for the Java compiler to find them.

The Ant library, and the standard libraries for the Java environment, are automatically tied into the class path. If this is not desired (e.g., during cross-compiling), this behavior can be cut off using two attributes (includeantruntime and includejavaruntime).

In the rarest of cases, the class path has to be set by the attribute of the same name, since it customarily consists of numerous elements, and entering it in an attribute leads to an unintelligible instruction. In addition, the class path is often required in multiple statements. Thus, it is recommended that the class path be defined once and used subsequently by reference. The definition can be made outside the target using the <path> tag, and inside the <javac> command using the <classpath> tag. Both of these tags provide for the allocation of an ID by which access to the class path is possible later in the classpathref attribute. The following fragment of an actual project illustrates this:

```
<path id="classpath">
  <pathelement path="${classpath}" />
  <pathelement location="${pf.path.build}/classes" />
  <pathelement location="${pf.path.extClasses}/servlet.jar" />
  <pathelement location="${pf.path.extClasses}/infobus.jar" />
</path>
.<\q>.<\q>.

<target name="-ff_comp">
  <javac srcdir="${pf.path.src}"
         destdir="${pf.path.build}/classes"
         includes="ff/**"
         excludes="ff/addon/plugins"
    <classpath refid="classpath"/>
  </javac>
</target>
```

Inside the `<javac>` command, however, multiple procedures for defining the class path can be used simultaneously. Thus, it is possible to tie in a class path that is available over the whole project, using the `classpathref` attribute and, inside the `<javac>` tag, to add other elements using the `<classpath>` subtag.

The attributes for selecting the files to be compiled are summarized in Table 12.1.

Some further attributes control the combined operation of the `<javac>` tasks and the Ant environment, as well as the extent of the log outputs (see Table 12.2). Aside from the `failonerror` and `listfiles` attributes, all these attributes depend on the command line options of the compiler. The corresponding values will simply be passed on by Ant. All these attributes are optional, and have no effect on the class files that are created.

TABLE 12.1 `<javac>` Attributes for File Selection

Attribute	Description	Default	Required
srcdir	Root directory for Java sources. The value is used by Ant.		Yes, except when an embedded `<src>` tag exists.
destdir	Target directory for class files.		No

(continues)

TABLE 12.1 `<javac>` Attributes for File Selection (*continued*)

Attribute	Description	Default	Required
includes	List of all files to be compiled. Patterns are possible. Individual values separated by commas.	`**/*.java`	No
includesfile	Name of a file containing the files to be compiled.		No
excludes	List of the files that are not to be compiled. Separated by commas. Patterns are possible.		No
excludesfile	Name of a file containing the files that are not to be compiled.		No
classpath	The class path.		No
sourcepath	The root directory for the source files. The value is passed on to the compiler.	Value of `srcdir`	No
includeantruntime	Should the Ant runtime libraries be tied into the class path?	yes	No
includejavaruntime	Should the standard JVM libraries be tied into the class path?	yes	No
classpathref	Reference to a class path.		No
sourcepathref	Reference to a source path.		No

TABLE 12.2 Attributes for Communicating with the Environment

Attribute	Description	Default	Required
`failonerror`	Should the build be continued if compiler errors occur?	`True`	No
`listfiles`	List the names of all compiled files?	`No`	No
`nowarn`	Show compiler warnings?	`off`	No
`debug`	Create class files with debugging information?	`off` (corresponds to the command line option `-g:none`)	No
`debuglevel`	Debug level. Possible values: `none` or a comma-separated list of the values: `lines`, `vars`, or `source`. The setting works only if the value of `debug=on`.	None	No
`deprecation`	Output deprecation information.	`off`	No
`verbose`	Generate detailed compiler outputs.		No

In the standard case, the `<javac>` command announces only the number of files to be compiled. For more precise evaluations or for checking selection patterns, it may be helpful to list the names of the files to be processed. This happens with the setting

```
listfiles=true
```

The `failonerror` attribute makes it possible to control whether the entire build should be interrupted for a compiler error or not. If `failonerror` is set to `true`, the entire build interrupts when it encounters an error during compiling. This makes it possible to program various cleanup processes or to protect log files. There are, of course, no simple ways to establish whether the build was successful, since the Ant tasks generally do not set any status variables or return codes. A solution to this problem requires the use of the `<update>` tag. The following example clarifies this solution:

```
<project name="bsp1205" default="main" basedir=".">
  <property name="root" value="./project3"/>

  <path id="classpath">
    <pathelement path="${classpath}" />
    <pathelement location="${root}/classes" />
  </path>

  <target name="main" depends="-comp, -message"></target>

  <target name="-comp">
    <javac srcdir="${root}/src"
           destdir="${root}/classes"
           failonerror="false">
      <classpath refid="classpath"/>
      <include name="myPackage/**"/>
    </javac>

    <uptodate property="build.status" value="Build o.k.">
      <srcfiles dir="${root}">
        <include name="src/**/*.java"/>
      </srcfiles>
      <mapper type = "glob"
              from = "src*.java"
              to   = "classes*.class"/>
    </uptodate>
  </target>

  <target name="-message" depends="-messageOK, -messageFailed"/>

  <target name="-messageOK" if="build.status">
    <echo message="Build O.K."/>
  </target>

  <target name="-messageFailed" unless="build.status">
    <echo message="Build failed"/>
  </target>

</project>
```

A package is compiled in the build file. By setting the `failonerror` attribute, the build file runs through completely, even if an error is encountered during compiling.

By means of the `-message` target, as a proxy for other actions, an announcement should be issued about the current state of the build.

The success of the build can only be ascertained indirectly from the state of the target files. Within the `-comp` target, the `<uptodate>` tag checks whether all the target files are current or not. If they are current, this can be regarded as an indication of a successful build. If they are not, then an error has evidently occurred.

Because the `<uptodate>` property constitutes the needed status-indicator property only if the test condition is satisfied, two subtargets are called in the `-message` target, whose execution is mutually coupled to the existence or nonexistence of the property.

The possibly confusing log outputs can be suppressed by Ant using the `-q` command line option. In the end, Ant always reports a successful execution of all targets when the build file has been completely processed. Thus, whether the build only ran because the interruption owing to the `failonerror` attribute was suppressed, plays no role here.

For testing the build file, you have to modify the source code in the example so that an error is produced. Then the `-messageFailed` target will create a corresponding error message.

Besides the attributes which are evaluated by Ant, there are some others which correspond mainly to the command line attributes of the Java compiler (See Table 12.3). These attributes are mainly used to set technical adjustments and parameters for cross-compiling. Since parameters that are not Ant-specific are involved, they will not be discussed in detail here. Only those attributes which affect the processing operation of the Java compiler are worth mentioning. The compiler itself is a Java application which can, therefore, be executed directly by Ant through Java mechanisms. The roundabout way, via a command line or an operating system call for starting an external program can, therefore, be dropped. With the attribute

```
fork=yes
```

you can, however, force this form of call as an external application. In this case, you can prescribe the path to the program that is to be called using the `executable` attribute. This attribute is optional. If you don't use it, the compiler of the currently-installed JDK being used by Ant will be employed. The compiler runs subsequently in a proper Java environment.

TABLE 12.3 Technical Attributes for the `<javac>` Compiler

Attribute	Description	Default	Required
fork	Start the Java compiler as an external program.	no	No
executable	Path to the compiler, if `fork=yes`.		No
memoryinitialsize	Minimum initial memory when the compiler runs as an external application.		No
memorymaximumsize	Maximum initial memory when the computer runs in external mode.		No
encoding	Coding of the source files.		No
optimize	Turn on optimization?	off	No
depend	Turn on dependency tracking?	off	No
source	Value of the `-source` command line parameter.		No
target	Compiling for a special JDK version.		No
compiler	Name of the compiler to be used.	Content of the `build.compiler` property	No
bootclasspath	Boot class path for cross compiling.		No
bootclasspathref	Reference to boot class path.		No
extdirs	Directory of the extensions to be employed.		No

Starting the compiler as an external application makes sense particularly when very large projects must be compiled. Sometimes the standard available memory is insufficient in that case. Ant or the Java compiler will then interrupt owing to lack

of memory. It is mostly not worth the bother to reserve as much memory for Ant as the compiler may need later, thereby dispossessing other applications. An external call can be used to temporarily request more memory from the system. This is done using the `memoryinitialize` and `memorymaximumsize` attributes. The values of both attributes will be passed on to the Java runtime environment. Within the Sun-JVM, the attributes correspond to the `-Xms` and `-Xmx` command line operations.

12.2 RMI COMPILING

Java applications are also being installed in the client server area to an increasing extent. Along the way, the RMI protocol is used for communication among the components. This communication interface is supported by Java. For classes which participate in this form of communication, additional objects, the so-called *stubs* and *skeletons*, do have to be generated. The basis for generating them is not the Java sources, but the corresponding class files. They are evaluated by the RMI compiler `rmic`, which then creates two additional class files in each case. The names of these files are obtained by appending the strings `_Stub` and `_Skel` to the original file names. The name specification `.classes` remains unchanged.

The RMI compiler is a component of the JDK. It, again, involves a Java application, so it can be started without problems from within Ant.

The simple method for calling it contrasts with the very complex operational mode of the RMI compiler, which is manifested in a large number of command line parameters. It makes little sense to describe the tasks and operation of these parameters in detail here, as they represent merely a portion of the topic of RMI. Here, as for the Java compiler, just the call from Ant will be discussed, and not the precise operational mode of the RMI.

The task `<rmic>` exists in Ant for calling the RMI compiler. The most important problem for the programmer is the selection of the files to be processed. Like the `<javac>` tag, the `<rmic>` tag has an inbuilt fileset command available. This permits file selection with all the attributes and subtags for the `<fileset>` tag that have already been described. The only exception is the `base` attribute of the `<rmic>` tag. It corresponds to the `dir` attribute of filesets, and again specifies the root directory for the data selection. Reference to the fileset is explicitly included in the `includesfile` attribute. Given the special character of the RMI compiler process, this attribute is required relatively often.

To the extent that only one file is to be handled by the RMI compiler, the corresponding class can be noted in the classname attribute of the <rmic> tag. Thus, the simplest conceivable call for the command has the form:

```
<rmic base="${root}/classes" classname="myPackage.Server" />
```

This example also illustrates a distinctive feature of the use of this attribute. The name of the class to be processed is specified in the package notation, and not as a normal file name. The components of the name are separated by a period, and the file name specification class is dropped. This holds, of course, only for this attribute. The other attributes and tags for file selection work with the conventional file and path names. The files that are provided are otherwise put in the same directory as the output files; shifting them to other directories normally makes no sense.

First, a few comments on the syntax of the command. The available attributes are listed in Table 12.4.

TABLE 12.4 Attributes of the <rmic> Tag

Attribute	Description	Default	Required
base	Root directory for the file selection.		Yes
classname	Name of a single class to be handled.		No
sourcebase	Shifts the generated help files to the root directory (corresponds to the command line attribute -keepgenerated or -keep).		No
stubversion	Specifying the JDK version for which stubs are to be generated.		No
classpath	The class path during compiling.		No
classpathref	Reference to the class path.		No
includes	Comma- or space-separated list with selection patterns. For all selected files, an RMI compilation is performed.		No

(continues)

TABLE 12.4 Attributes of the `<rmic>` Tag (*continued*)

Attribute	Description	Default	Required
includesfile	Name of a file with selection patterns.		No
excludes	List of the files excluded from the selection. Accepts a selection pattern with comma or space separators.		No
excludesfile	Name of a file with selection patterns. The files selected in this way will be removed from the selection list.		No
defaultexcludes	Take default-excludes into account?	yes	No
verify	Check whether the classes are remotely implemented?	false	No
iiop	Generate portable stubs (RMI/IIOP).		No
iiopopts	Additional arguments for iiop.		No
idl	Generate an interface description in IDL format.		No
idlopts	Additional arguments for idl.		No
debug	Create debugging information (corresponds to the -g command line option).	false	No
includeantruntime	Include runtime libraries from Ant in the class path.	yes	No
includejavaruntime	Include runtime libraries from the JVM in the class path.	no	No
extdirs	Path to installed extensions.		No
compiler	The compiler to be used (if it should be different from the standard).	Content of the build.rmic	No

Besides the many attributes, a few embedded tags are also available. These tags are in addition to the embedded tags which <rmic> has inherited from the <fileset> command. First there is, again, the <classpath> tag, which makes all additionally-required classes available during compiling. Beyond that, you can define them, or the path to the installed Java extensions, using the <extdirs> tag, in case the corresponding attribute is not sufficient for this.

As the RMI compiler has relatively many, partially implementation-dependent command line attributes available, these can also be transferred directly to the compiler. For this, the <compilerarg> subtag is available. It corresponds essentially to the <arg> tag, which will be described in more detail in connection with the calling of system commands in Section 14.2. The only extension of the <compilerarg> tag is the additional attribute compiler. This attribute can be used to establish for which specific implementation of the RMI compiler the corresponding attribute should be effective.

Now to consider some aspects of the practical use of the <rmic> tag. Normally, RMI compiling is only required for relatively few files in a project. These files can be scattered over the entire project. Thus, it is sometimes difficult to assemble the list of files to be compiled, or to transfer it to the <rmic> tag. A truly generic solution is not possible for every project, since RMI classes are not equipped with any special criterion by which they might be traced easily and securely using Ant techniques. Some possibilities will be presented below, but none of them is really perfect. All variants can be combined with one another throughout, in order to attain an optimum with respect to generality, security, and maintainability.

It is simplest to maintain the list with the RMI classes manually in a separate text file. This file can be tied into the <rmic> tag using the includesfile attribute. The following segment comes from an actual build file:

```
<rmic base          = "${pf.path.abs.build}/classes"
      includesfile  = "${basedir}/rmifiles.txt"
      verify        ="true"
      classpathref  = "classpath"/>
```

This variant is relatively simple to program. Certainly, it requires some writing effort to maintain the external file. This can be done by the developer himself. Forgetfulness leads to errors, which first show up in a practical test of the application and, thereby, force a new build with subsequent deployment or new installation. In mature projects, where new classes seldom arrive, this method is quite acceptable. For early development stages, however, somewhat more automatic operation is definitely to be desired.

There are other ways for file selection than those inherited from fileset. It makes sense to use these only if the need for RMI compiling can be inferred from the file name. Should this be the case, the `<rmic>` tag can very easily be assembled and used, at least as far as the file selection is concerned. A simple `<include>` tag or an `includes` attribute is adequate in that case:

```
<rmic base="${root}/classes"
    <include name= "**/*RMI*.class"
</rmic>
```

The effort required for this procedure is relatively minor, and, in most cases, the allowance for the naming convention is quite good. The share of errors or forgetfulness is smaller than when a separate list is maintained. Certainly, on practical grounds, file names cannot be conferred as flexibly as might be necessary here. Meanwhile, Design Patterns, which produce their own naming conventions, will be used a lot in the Java ambience. If, for example, one uses the Factory sketch pattern, then the implementation `CustomizingTableFactoryImpl.java` belongs to the `CustomizingTableFactory.java` interface. Naturally, only the implementation of the interface has to be RMI-capable, not the interface itself. Appending additional symbols to the class names will, however, disturb the taxonomy of file names.

Another possibility for file selection is offered by the fact that RMI-capable classes are often derived from quite specific classes of the JDK, e.g., by `java.rmi.server.UnicastRemoteObject`. Since the names of the superclasses also survive in a compiled class file, selection by a string search becomes possible. This can be done with a selector:

```
<rmic base="${root}/classes"
    <contains text= "UnicastRemoteObject"/>
</rmic>
```

But this variant is not entirely without problems, either. It can certainly also happen that a class derived from `UnicastRemoteObject`, serves as a superclass for other, likewise RMI-capable, classes. But then the string used in a search pattern is not contained in it, so that the file selection must be extended to a search pattern or a list with file names. One way out might be to put a project-dependent string as an identifier in the classes which must be RMI compiled. Since the pattern search occurs in the classes and not in the source files, this string must, of course, exist as a Java object; a comment is not sufficient. This procedure is dependent on the dili-

gence of the programmer. In addition, the string search naturally consumes more time than a pattern search over file names or even tying-in a text file.

A significantly more extravagant variant relies on an analysis of the source files. A small Java program, which can be called from Ant, provides a text file with the names of all files for the RMI compiler run. This program can search through the source code for various identifiers and, if necessary, take the mechanism of inheritance into account. Compared to the variants described above, here the increase in ease is clearly less than the effort.

Some of the variants described above can be used together in a command. You have, however, to take note of some of the characteristics of the `<fileset>` tag. Thus, pattern-based selections and selection according to file properties (with selectors) are, in general, AND coupled. Hence, the interesting combination of the `includesfile` attribute and a selector (e.g., `<contains>`) usually does not yield the desired result. If a mixed choice in terms of characteristics and patterns is desired, in general only selectors should be inserted and explicitly OR coupled. For pattern searches, the generally-known special selector `<filename>` is available. The following example shows a segment from an actual Ant file:

```
<rmic base="${pf.path.abs.build}/classes"
      verify="true"
      classpathref="classpath"
  <or>
    <contains text="UnicastRemoteObject"/>
    <filename name="ff/il/internal/usermgmt/provider/*.class"/>
  <or>
</rmic>
```

12.3 COMPILING JAVA SERVER PAGES

One often-used variety of Java file is JSP files. These are almost essential for the production of Java-based Web applications. Here we are actually concerned with HTML files with embedded Java code. In a two-stage process, these files are first converted into pure Java code using an extension of the Web server, the JSP engine, and then compiled. This process proceeds automatically. It will always be triggered if the JSP file is more up-to-date (younger) than the pertinent Java class. It is especially disadvantageous that this compilation is triggered by the JSP engine, so that

it first occurs when the JSP page is used for the first time. When there are incompatibilities between the Java code in the JSP page and the other classes (e.g., with objects provided by a server application), a runtime Java exception results. Problems of this sort can be safeguarded against by compiling JSP pages just before installation on the Web server. Also, if the Web server sometimes compiles these pages again, at least the syntactic correctness of the JSP pages can be ensured by a previous compilation.

The JSP compiler, which is called by the <jspc> tag, only provides Java files from the JSP files. Thus, it does not really compile and cannot recognize syntactic problems which can arise when external classes are used. For that purpose, a real Java compilation must be included.

With both Java and RMI compilers, Ant calls an external program for conversion of a JSP page. That, however, is not part of the standard JDK, but belongs to the installation packet of the *Tomcat* servlet engine. In order to be able to call the JSP compiler, you have to tie a few jar archives into the class path. The names of the archives depend on the Tomcat version and the current JVM. For version 3.2.4 under JDK 1.4, they are jasper.jar, servlet.jar, and webserver.jar, while for Tomcat 4.x, they are jasper.jar and jasper-runtime.jar. Whether the archives belong to a complete Tomcat installation, or are merely copied on the build computer does not, therefore, matter.

The list of attributes for the <jspc> tag in Table 12.5 is comprehensive.

TABLE 12.5 Attributes of the <jspc> Tag

Attribute	Description	Default	Required
destdir	Root directory for the generated files.		Yes
srcdir	Root directory for the Source files.		Yes
package	Name of the package for the generated Java files.		No
classpath	Class path.		No
classpathref	Reference to the class path.		No
failonerror	Interrupt the build because of error.	yes	No
verbose	A number that specifies the extent of the log outputs.	0	No

(continues)

TABLE 12.5 Attributes of the `<jspc>` Tag (*continued*)

Attribute	Description	Default	Required
uribase	Basis for relative URLs.		No
uriroot	The root directory for URLs.		No
mapped	Separate allocation for output of each HTML row.	false	No
compiler	Name of the JSP compiler.		No
ieplugin	Class ID for the Internet Explorer Java plugin.		No

Entries for the source and target directories are absolutely necessary. The selection of specific files takes place, if necessary, using embedded tags, which correspond to those of a fileset. As do the `<javac>` and `<rmic>` tags, the `<jspc>` tag inherits all characteristics of the fileset.

If necessary, a compiler, other than the standard one of the Tomcat engine, can be used by employing the `compiler` attribute. A class path entry is required if the JSP compiler is not available in the standard class path of the system.

The two parameters `uribase` and `uriroot` affect the relative and absolute URLs generated in the JSP pages. These entries are necessary only if the JSP files are ready to be compiled finally on the Web server and not only as a test for a syntax check.

The generated Java files can contain a package entry. This can be set in the `package` attribute. This entry overwrites the standard package entry provided by the `<jspc>` command. The generated Java files are put under `destdir`, always subject to the package name.

As regards the evaluation of the directory structures of source and target directories and the package name, JSP compilers differ substantially from other compilers. Here it is to be noted that the compilers are external programs and do not belong to the Ant package. The specific behavior, therefore, varies among the different Tomcat versions. Thus, the compiler belonging to Tomcat 3.2 does not take the path under the source directory into account. The first found source file (regardless of the subdirectory from which it comes) is put immediately into the target directory. For files in and under the first directory that is found, the structure will be correctly copied. For other directory branches, however, the JSP compiler generates a package name which results from the absolute path name of the JSP

files. When a package name is entered, all subdirectories are ignored, and all the generated Java files are put in one and the same directory. Files with the same name will thereby be overwritten.

Correct compiling and distribution of JSP pages is, therefore, not without problems. It is clearly simpler to deliver the class files with tests, in order to exclude syntax errors.

The following listing shows a slightly modified segment from a productive Ant file. It illustrates the use of the `<jspc>` command in a rather pragmatic fashion:

```
<path id="tomcatlibs">
  <fileset dir="${path.abs.tomcat.lib}">
    <include name= "**/*.jar"/>
  </fileset>
</path>

<target name="checkjap">
  <mkdir dir="${path.build}/jsptmp"/>

  <jspc srcdir="${path.src}/myprj/jsp"
        destdir="{path.build}/jsptmp"
        classpathref="classpath" >
  <include name= "*.jsp"/>
  <classpath refid="tomcatlibs"/>
  </jspc>

  <javac classpathref="classpath"
         srcdir="${path.build}/jsptmp"
         destdir="${path.build}/jsptmp"/>
  <include name= "**/*.java"/>
  <classpath refid="tomcatlibs"/>
  </javac>

    <delete includeemptydirs="true"
            dir="${path.build}/jsptmp"/>
</target>
```

After the JSP compiler is called, and after the final compiling of the Java files generated by it, some classes of the servlet engine must be available. For this reason, a path element with the ID tomcat-libs is first provided. All jar files in the lib-directory of the servlet engine will be included by fileset. Indeed, not all will be needed, but on the other hand, this procedure is very simple.

Compiling proceeds only to locate syntax errors. The generated files will definitely not be needed further and can be erased. A temporary directory has to be used. This is provided at the beginning of the proper target and is erased again at the end, thus ensuring that the build directory is completely empty.

The call for the JSP compiler follows immediately. The source and target directories are defined by the corresponding attributes. Likewise, a class path valid for the entire project is referenced by the `classpathref` attribute. The definition of this path is not included in the example. Within the tag an embedded `<classpath>` tag is then used to append the path defined at the beginning of the example to the current class path. This setting has no lasting effect, but is only valid for calling the JSP compiler.

The files to be processed are selected using a simple `<include>` tag; `<jspc>` ultimately inherits all the characteristics of a fileset. After processing of this tag, the generated Java files stand ready in the directory `${path.build}/jsptmp`. These can then be compiled by an equally simple call. As a precaution, the extended class path must be passed on to the Java compiler, since some packages from the servlet library are tied into the JSP pages, or more precisely, into the Java files generated from them. Complete collection of all jar files is not, indeed, necessary here, but they should not be in the way.

If errors occur during creation of the Java files or, finally, as they are compiled, this causes interruption of the build. On the other hand, if all the files have been correctly processed, the temporary files, including the directories, can be erased. The build then proceeds entirely normally.

12.4 GENERATING JAVADOC

Detailed documentation is essential, especially during program development by teams, but also for later evaluation of the application. For essentially technically oriented components, *Javadoc*, which is generated directly from the source text, usually comes into action. It can be tied into many development environments, even as online help. Providing a Javadoc is, therefore, an elementary component of a build

The Javadoc command is, indeed, not a compiler in the narrow sense, but this command does generate, from the original data, a set of new files with an entirely different functionality. This command likewise belongs to the standard JDK. It has considerably more command-line parameters than the compiler of the packet itself. Many of these parameters are available only for specific versions of the JDK. Thus,

correct use of these Javadoc commands requires extensive knowledge and, perhaps, a bit of preliminary work. Hence, at this point, only the use of the Ant task which is called by the external Javadoc command will be described. Only a selection of the most important attributes and subtags can be mentioned here. You can find details on external Javadoc commands in the standard Java documentation.

Table 12.6 contains a selection of the most important attributes.

TABLE 12.6 The Most Important Attributes of the `<javadoc>` Tasks

Attribute	Description	Required
sourcepath	Root directory for the file selection.	At least one of the three source* attributes or definition by embedded tags (see Text)
sourcepathref	Reference to a path definition, which serves as a root for the file selection.	Yes, if no doclet has been defined. (The attribute is not contained in this table.)
sourcefiles	List of source files, separated by commas.	No
destdir	Target directory.	No
maxmemory	Maximum value for the main memory to be made available to the JVM.	No
packagenames	List of the packages to be processed. A final pattern symbol is possible.	No
classpath	Class path as direct value.	No
classpathref	Reference to a class path definition.	No
failonerror	End build if an error occurs.	No
excludepackagenames	Comma-separated list of the packages not to be processed.	No
defaultexcludes	Include a list of the default exclude pattern.	No

As with almost all commands, for <javadoc>, as well, the files to be processed must be selected. Several possibilities are available for doing this beyond the conventional fileset-based variant. In addition, it is natural to name a target directory. The destdir attribute serves this purpose.

The simplest way of specifying source files is to enumerate the individual Java files. This can be done in the sourcefiles attribute. Multiple file names are possible. They have to be separated by commas. In addition, you can employ conventional pattern symbols which will also be accepted at the command line level. Of course, the current version of Ant (1.5.1) accepts no spaces in this attribute, either within file names, or as a separator between them.

```
<javadoc
  sourcefiles = "${path.abs.src}/factory/server/Constants.java"
  destdir     = "${path.abs.doc}"
  classpathref= "classpath"/>
```

Correct path names must be contained in the sourcefiles attribute. In this case, that means either absolute paths or relative paths referring to the working directory of the build file. The sourcepath attribute of the <javadoc> tag does not work in this case. Note that, with this attribute, selecting files by pattern symbols does not correspond to the capabilities of a fileset. In particular, there is no recursive search. In order to write a Javadoc for a complete (sub-) package, the packagenames attribute should be used. It contains the list of packages which are to be handled by Javadoc. In addition, the package writing style is to be used. A final pattern symbol can be used. This attribute only works correctly in combination with a sourcepath attribute:

```
<javadoc  sourcepath   = "${path.abs.src}"
          packagenames = "ff.il.*"
          destdir      = "${path.abs.root}/javadoc"
          classpathref = "classpath"/>
```

If necessary, you can also avoid processing specified packages using the excludepackagenames attribute.

Both attributes can be replaced by an equivalent subtag. An embedded <fileset> tag can work instead of the sourcefiles attribute. Ant automatically provides the pattern **/*.java for all path settings to be used in the fileset. Thus, you can limit yourself to noting the directory names and, thereby, select complete packages for Javadoc generation. Of course, you could also select individual files and do

a generation run only for them. The root directory for the data selection is executed in the fileset with this variant; a `sourcepath` attribute is not required in the Javadoc command. The following command will generate the Javadoc for all Java files in the source code directory `factory/server`:

```
<javadoc  destdir="${path.abs.doc}"
          classpathref ="classpath"/>
   <fileset dir=${path.abs.src}">
     <include name="factory/server"/>
   </fileset>
</javadoc>
```

Certainly, the `packagenames` attribute rarely has to be used. The corresponding subtag is `<package>`. The attribute `name` is available to it, and it accepts a package name or a pattern in each case. Here also a root directory must be prescribed using the `sourcepath` attribute or the `<sourcepath>` tag. If multiple separate packages have to be named, this tag must be written down several times:

```
<javadoc  sourcepath  = "${path.abs.src}"
          destdir     = "${path.abs.doc}"
          classpathref = "classpath"/>
   <package name="ff.il.*"/>
   <package name="ff.admin.*"/>
</javadoc>
```

Besides the tags described thus far, there is yet another one which combines the characteristics of the fileset with those of the `<package>` tag. This refers to the `<packageset>` tag. This tag is a variant of a dirset. The syntax is similar to that of a fileset. A root directory is specified using a `dir` attribute, while other attributes or embedded tags (e.g., `<include>`) define a selection. This consists, not of individual files, but merely of directories. Ant now generates the Javadoc for all Java files in the selected directories.

As long as the file selection is done using embedded tags, the `excludepackagenames` attribute of the Javadoc command is ineffective. If exclusion of packages is required, then the `<excludepackage>` subtag is necessary.

Besides the tags and attributes for file selection, the `maxmemory` attribute must be mentioned in any case. The external Javadoc command is started in a Java Virtual Machine of its own. For this JVM, the maximum available main memory can be in-

fluenced by this attribute. In extensive projects, in the absence of additional main memory, Javadoc breaks off with an `OutOfMemory` exception. A number is expected for the value of the attribute. It can be followed by the letters `k` or `m` representing the units `kbyte` or `mbyte`.

13 ¦ Archives

After a project is compiled, all of the required classes are indeed available, but they are often collected into archives so they can be passed on and installed easily. For that reason, Ant supports construction of the common archive types. Zip, jar, tar, and war archives are conventionally supported. These archives can both be created and unpacked.

The archives are directly supported by Ant; no supplementary packages are required.

13.1 ZIP ARCHIVES

The zip format is the ubiquitous classic. It originated, above all, in the desire to compress files and, thereby, save space in data storage media. Although jar archives are more important in the Java environment, the zip format cannot be ignored. The number of attributes means that a multiplicity of functions is provided through the <zip> tag (See Table 13.1).

TABLE 13.1 Attributes of the <zip> Command

Attribute	Description	Default	Required
destfile	Name of the zip file to be created.		Yes
basedir	Root directory for file selection.		No
compress	Compress the archive.	true	No
encoding	Symbol encoding.		No
			(continues)

TABLE 13.1 Attributes of the `<zip>` Command (*continued*)

Attribute	Description	Default	Required
filesonly	Consider only files.	false	No
includes	List of the files to be included, separated by commas.		No
includesfile	Name of a file, with the files to be included.		No
excludes	List of the files not to be included in the archive, separated by commas.		No
excludesfile	File, with a list of the files to be excluded.		No
defaultexcludes	Account for default excludes.	yes	No
update	Bring archive up-to-date if it already exists. The alternative is completely new creation.	no	No
whenempty	Behavior when no files are suitable. Possible values are: `fail`, `skip`, and `create`.	skip	No
duplicate	Behavior when duplicates of files are found. Possible values are: `add`, `preserve`, and `fail`.	add	No

With the attributes and subtags, you have to distinguish between those which are appropriate for file selection and those which are appropriate for archive creation, as such. Because of the peculiarities of data selection, some details of the archiving functions, themselves, should first be pointed out.

Although zip has come to be known mostly because of its compression function, it does combine two functions. Multiple files can be packed into an archive and this archive can additionally be compressed. The compression function is conventionally activated, but it can be shut off using the attribute:

```
compress="false"
```

This saves some time.

The update attribute controls the behavior of the tag if the target file already exists. If this attribute has the value true, then an existing archive will only be brought

to the most recent state. Only those source files which have been changed will be added anew to the archive. The value `false`, on the other hand, ensures that the archive file will first be erased and then completely rebuilt.

When an archive is being created, it may happen that no source files exist. Perhaps class files are to be archived which were not even created because of a compilation error, or were not created in this build run because of a special setting. The `whenempty` attribute establishes what should happen in this case. The value `fail` ensures interruption of the build, `skip` continues the build without creating an archive, and `create` creates an empty archive.

Depending on the type of file selection, a file may be included in an archive more than once, or many files with identical names may be selected. In this case, as well, the behavior of the zip command can be adapted as required using an attribute. The attribute to be used in this case, `duplicate`, recognizes three values: `add`, `fail`, and `preserve`. When `add` is used, the duplicates will be appended to the archive. All the files exist simultaneously in the archive. Problems show up first during unpacking. Unless they are packed separately in different directories, only the last of the files with the same name will survive. A value `fail` causes a build error to appear when duplicates are appended, while `preserve` ensures that the duplicates are ignored. Anyhow, in the last case, Ant generates a log output.

With regard to file selection, the `<zip>` tag makes its functions available in a very pragmatic way, which requires some caution in its use.

Unlike some other tags, the `<zip>` tag inherits all the characteristics of a fileset, but additionally accepts the `<fileset>` tag as an embedded tag. Newer versions of Ant reject the implicit use of the fileset characteristics as out-of-date (deprecated). Thus, these versions should not be used any more for new projects. The use of separate filesets is, moreover, more flexible, so only these variants will be described here.

Within the `<zip>` tag, multiple independent filesets can be defined. Each fileset puts the files it selects into the archive. Thus, for each file, the path entry corresponding to the relative path for the file under the root directory of the fileset, is recorded. This offers the advantage that files from different source directories can be included in the archive, but only the relative paths under the corresponding source directory appear in the path entries within the archive. The following example illustrates this behavior:

```
<project name="bsp1301" default="main" basedir=".">

  <target name="main">
    <zip destfile="antexamples.zip">
```

```
            <fileset dir=".">
              <include name="**/*.*"/>
              <exclude name="**/*zip"/>
            </fileset>
            <fileset dir="../Chapter08">
              <include name="**/*.xml"/>
            </fileset>
        </zip>
      </target>
    </project>
```

The zip command creates the archive `antexamples.zip`. Additional attributes are omitted here for reasons of clarity. The files to be included in this archive are provided by two filesets. The first reads all files from the current directory (except a possible zip archive). The second provides the archive with all XML files from another directory. After the archive is unpacked, all files will appear in a single common directory.

One practical application for this procedure is mixing property or resource files in an archive. In this way, the variant with multiple filesets saves possible copying and, thereby, speeds up the build.

Within the `<zip>` tag, there is a modification of the fileset subtag, along with the original fileset. This is the `<zipfileset>` tag. Besides the `fileset` attribute, this tag recognizes three other attributes, which are listed in Table 13.2.

TABLE 13.2 Additional Attributes of the `<zipfileset>` Tag

Attribute	Description
fullpath	Sets a new name, including the path, for a single file within the archive.
prefix	Additional path entry, which is placed in front of the actual path in the archive.
src	Replaces the `dir` attribute. Denotes a zip file in which the file selection takes place.

The `src` attribute replaces the `dir` attribute. With its help, a zip archive is defined as the source for the file selection instead of the root directory. The files indi-

cated by the known subtags will be erased from the archive and written in the new archive.

The two attributes `fullpath` and `prefix` affect the names or paths under which the files are to be placed in the archive. `prefix` can be used to prescribe a path which is placed in front of the actual path in the archive. During unpacking, therefore, the file will be unpacked into a directory other than the one from which it was read. This attribute is helpful if the structure of an archive must deviate from that of the actual file system. It occasionally saves having to create a 1:1-form for the later archive.

The `fullpath` attribute can only be used if just one file is to be selected by the `<zipfileset>` tag. In this case, the attribute can be used to set an entirely new name (path included) for this file. The `fullpath` and `prefix` attributes are, naturally, mutually exclusive.

If many existing zip archives must be packed into a new archive, this can be done using appropriately many `<zipfileset>` tags. Of course, the use of the `<zipgroupfileset>` tag is more elegant and somewhat more convenient. In terms of its syntax, it corresponds to the conventional fileset. But only zip archives should be selected by the selection subtag. These will be unpacked and appended to the new archive. Selecting other files does not lead to a syntax error, although, to be sure, these are not taken into account during the creation of the new archive.

13.2 JAR ARCHIVES

Jar archives are similar to zip archives. Archives of this type are used almost without exception for combining the many individual class files of a Java application into a large file. This task is supported by a few additional pieces of information which can be stored in a Jar file. The `<jar>` tag corresponds more or less to the `<zip>` tag, but has a few special attributes. The selection of the files which are to be included in a jar archive proceeds in a manner similar to that for the `<zip>` tag. The jar task inherits all characteristics from the `<fileset>` tag, and accepts embedded filesets, as well. Thus, there is no need to go into more detail on this topic. The focus of this section is primarily on the differences from the `<zip>` tag.

Table 13.3 lists the attributes of the `<jar>` tag.

TABLE 13.3 Attributes of the `<jar>` Tag

Attribute	Description	Default	Required
destfile	The name of the archive file to be created.		Yes
basedir	Root directory for the file selection.		No
compress	Compress the archive.	true	No
encoding	Symbol encoding.	UTF8	No
filesonly	Consider only files.	false	No
includes	List of the files to be included, separated by commas.		No
includesfile	Name of a file, with the files to be included.		No
excludes	List of the files not to be included in the archive, separated by commas.		No
excludesfile	File, with a list of the files to be excluded.		No
defaultexcludes	Consider default excludes.	yes	No
update	Bring archive up to date if it already exists. The alternative is a completely new creation.	no	No
whenempty	Behavior when no files match. Possible values are: fail, skip, and create.	skip	No
duplicate	Behavior when duplicates of files are found. Possible values are: add, preserve, and fail.	add	No
manifest	The name of a manifest file to be tied-in.		No
index	Create class index for the archive.	false	No

Only the two attributes `manifest` and `index` are new. Since a jar file is mainly used in order to combine class files from a Java application, additional index information in a jar file can speed up access to the individual classes. This function is normally shut off and must be activated using:

```
index="true"
```

Since Version 1.3, in fact, Java has been able to make use of an index in the jar file.

A jar file can contain a so-called *manifest*. This is a file with various specifications for use. A manifest can be created manually as a separate file (usually with the name `manifest.mf`), or using the manifest task. You include the file in the jar archive using the `manifest` attribute. A manifest is automatically placed in the `META_INF` path.

The two subtags which go beyond the zip command also refer to meta information for a jar file. The `<metainf>` tag provides a version of fileset. All the files specified in this tag are put in the `META_INF` path in the archive.

Besides the `manifest` attribute, there is a `<manifest>` tag. It can be used either as an independent tag or as a subtag within the `<jar>` command. You can create a manifest file with an independent `<manifest>` tag. On the other hand, if you use the tag as a subtag, you insert the manifest information directly, without a detour via a file, into the jar archive. When it is used as a subtag, the two attributes `file` and `mode` of the `<manifest>` tag are ignored.

13.3 WAR ARCHIVES

A war archive (Web application archive) is an archive whose inner structure is suited to the requirements of a Web application. Some additional attributes make it possible to include files in predefined subdirectories of the archive. These tasks can be performed by the zip or jar tasks, as well, by using the `prefix` and `fullpath` attributes. Use of the war task saves some writing, and is also easy to maintain because of the expressive attributes and tag names.

The type and method of file selection for the `<war>` tag correspond to those for the zip and jar tasks. Some of the other attributes for `<zip>` and `<jar>` are, of course, missing. Table 13.4 is a complete listing of the available attributes.

TABLE 13.4 Attributes of the `<war>` Tag

Attribute	Description	Default	Required
destfile	The name of the archive file to be created.		Yes
basedir	Root directory for the file selection.		No
compress	Compress the archive.	true	No

(continues)

TABLE 13.4 Attributes of the `<war>` Tag (*continued*)

Attribute	Description	Default	Required
encoding	Symbol encoding.	UTF8	No
filesonly	Consider only files.	false	No
update	Bring archive up to date if it already exists. The alternative is a completely new creation.	no	No
includes	List of the files to be included, separated by commas.		No
includesfile	Name of a file, with the files to be included.		No
excludes	List of the files not to be included in the archive, separated by commas.		No
excludesfile	File, with a list of the files to be excluded.		No
defaultexcludes	Consider default excludes.	yes	No
webxml	Name of the file, with the deployment descriptor.		Only if update=false
manifest	The name of a manifest file to be tied-in.		No

Only the webxml attribute is actually new here. This attribute names a file which is put in the WEB-INF directory as web.xml. This file contains deployment information for a Web server.

The subtags serve mainly for putting files in special directories. They represent variants of the <filesets> tag. The <lib> subtag puts all the selected files in the WEB-INF/lib directory, as the <classes> tag puts them in the WEB-INF/classes directory. With the <webinf> tag, the files are put directly in the WEB-INF directory, while <metainf>, which is already known from the <jar> tag, fills the META-INF directory.

All the other subtags (<fileset>, <zipfileset>, ...) are naturally applicable from here on.

13.4 TAR ARCHIVES

The home of the tar archive is the Unix world. There they are the standard archive format. Since Ant must work with overlapping platforms, it naturally has to be able to process this format, as well. Given the history of its development, the `<tar>` tag naturally recognizes a slightly different syntax than the other three tags.

There are almost no differences with respect to file selection. The `<tar>` command inherited some characteristics of filesets, so it recognizes the common attributes such as `includes`. Table 13.5 shows you the applicable attributes.

TABLE 13.5 Attributes of the `<tar>` Tag

Attribute	Description	Default	Required
destfile	The name of the archive file to be created.		Yes
basedir	Root directory for the file selection.		No
includes	List of the files to be included, separated by commas.		No
includesfile	Name of a file, with the files to be included.		No
excludes	List of the files not to be included in the archive, separated by commas.		No
excludesfile	File, with a list of the files to be excluded.		No
defaultexcludes	Consider default excludes.	yes	No
longfile	Behavior with long file names (>100 characters). Possible values are `fail`, `truncate`, `omit`, `warn`, and `gnu`.	warn	No
compression	Compression method. Possible values: `none`, `gzip`, and `bzip2`.	none	No

The two attributes `longfile` and `compression` constitute the difference from the other archive commands. Tar archives are not intended from the start for compressing the contents. The functions of archiving and compression are separated from the beginning in the Unix world, not the least for reasons of performance. Of course, the `<tar>` command supports two compression techniques, which can be activated by the `compression` attribute, if needed. In the standard setup, the command

operates without compression. When unpacking tar archives, the appropriate method must, of course, be specified (See Section 13.6).

The `longfile` attribute is considerably more important than the compression attribute. The standard variant of the Unix tar command can only process path specifications with a length of up to 100 characters. Modern versions of the command do not recognize this limit. For reasons of compatibility, however, under certain circumstances, this limitation must be taken into account. Thus, the `longfile` attribute recognizes some setups which prevent putting long file or path names in the archive. The value `fail` provides for a build error if such a file is recognized. With `omit`, the file can be skipped; it is then not included in the archive. Finally, the value `truncate` provides for automatic shortening of the file name. All these values prevent the formation of incompatible archives, although at the price of missing files or false file names. You can create archives with correct contents using the settings `gnu` and `warn`. Both variants use the Gnu-tar version, which can create files with long names. Archives of this sort can, of course, then only be unpacked using this same version of the tar command. The difference between the two settings for the `longfile` attribute is merely that `warn` passes a notice on to the console, while `gnu` does not.

In addition to the attributes and subtags for file selection inherited from fileset, the `<tar>` tag recognizes another embedded tag. Instead of the `<fileset>` tag, which is possible in the other archive tasks, here the `<tarfileset>` tag has to be used. This tag operates like the `<fileset>` tag, and recognizes all its attributes and functions. Of course, it also has some other attributes which apply to other characteristics of Unix operating systems. Table 13.6 also lists attributes that are available to the conventional fileset.

TABLE 13.6 Attributes of the `<tarfileset>` Tag

Attribute	Description	Default	Required
mode	Unix access rights as a 3-digit octal number.		No
username	User name for the files to be provided.		No
group	Group name for the files to be provided.		No

(continues)

TABLE 13.6 Attributes of the `<tarfileset>` Tag (*continued*)

Attribute	Description	Default	Required
prefix	Additional prefix for the path specification.		No
fullpath	Alternative path for the files to be provided.		No
preserveleadingslashes	Retain leading "/" symbols in path names.	false	No

The first three attributes set the access mode, the user, and the group for the files to be provided. These are conventional inputs for Unix.

The file names can be provided with a prefix using the `prefix` attribute. The operational mode corresponds to that of the attribute with the same name for the `<zipfileset>` tag. With this attribute, directory structures can be constructed in the archive which do not have to actually exist during running. Likewise, the `fullpath` attribute is known from `<zipfileset>`. It can only be used under certain conditions. It cannot be applied simultaneously with the `prefix` attribute, and can only be used if exactly one file is selected in the `<tarfileset>` command. It makes it possible to set the name of a file to be included in the archive freely and without reference to the name of the source file.

The last attribute of the `<tarfileset>` command controls whether a leading "/" character in the path name should be retained. Since absolute paths can rapidly lead to problems during unpacking of archives, these characters are usually suppressed.

13.5 MANIFEST INFORMATION

When Java software is provided in the form of an archive, in some cases the JVM requires additional information. This can also be contained in so-called *manifest files* in the archive. A file of this sort can be generated manually and tied into the archive with special tags. It is also possible to create the manifest file with a special Ant command, or to modify an existing file.

Detailed knowledge of manifest files is closely related to the Java development as such, and is not Ant specific. Here you will find only a description of the Ant tags without any extensive information on manifest.

The <manifest> tag has only two attributes (See Table 13.7). They determine the name of the manifest file and the update mode. Either a manifest file can be created completely anew, or the manifest command merely produces changes in an existing file.

TABLE 13.7 Attributes of the <manifest> Tag

Attribute	Description	Default	Required
file	Name of the manifest file.		Yes
mode	Modify or replace the manifest file. Possible values: update and replace.	replace	No

The work, as such, is carried out by embedded tags. Attributes are put into a manifest file. If necessary, this can be partitioned by so-called *sections*. Attributes are created by the <attribute> tag. It possesses the two mandatory attributes name and value, which determine the name and the value of the attribute.

If a section must be applied, you use the <section> tag. This tag recognizes only one mandatory attribute, name, with which the name of the section can be set. Attributes which must be assigned to the manifest file of a section have to be defined inside a <section> tag.

The following example creates a new manifest file:

```
<manifest file="MANIFEST.MF" mode="replace">
  <attribute name="Main-Class" value="NTUserImporter"/>
  <attribute name="DLL" value="ntuser.dll"/>
</manifest>
```

The following file results. Two attributes will be automatically made available by Ant:

```
Manifest-Version: 1.0
Created-By: Apache Ant 1.5
Main-Class: NTUserImporter
DLL: ntuser.dll
```

13.6 UNPACKING ARCHIVES

Archives can not only be created, but also unpacked. Often unpacking is one of the first steps in a build, if source files from remote sources are supplied in the form of a zip archive. Each archive format has its own unpack command, although the syntax for all four commands (`<unzip>`, `<unjar>`, `<unwar>`, and `<untar>`) is identical. They can thus be described together.

Table 13.8 lists the four attributes of the commands.

TABLE 13.8 Attributes of the Unpack Commands

Attribute	Description	Default	Required
arc	The archive to be unpacked.		Yes, if no embedded filesets exist
dest	Target directory for the extracted files.		Yes
overwrite	Overwrite mode.	true	No
compression	Compression mode for `<untar>`. Possible values are: none, gzip, and bzip2.	none	No

The archive to be unpacked is either named in the src attribute or defined with the aid of an embedded fileset. In the latter case, multiple archives can even be named and packed using a single command.

In any case, a target directory into which the archive is unpacked must be communicated to the unpack commands. The path structure within an archive is found once more under this working directory. If the working directory does not yet exist, it is created.

The following target will unpack the file with the examples for this book (see Section 15.1, as well) into a separate directory:

```
<unzip dest="antexamples" src="antexamples.zip"/>
```

It is also possible to define a patternset within the unpack commands. During unpacking of the archive, only those files will be considered whose names correspond

to one of the patternsets. The following target makes use of a patternset in order to extract only readme files from the archive with the examples:

```
<unzip dest="antexamples" src="antexamples.zip"/>
  <patternset includes="readme*" />
</unzip>
```

13.7 SEPARATE COMPRESSION AND DECOMPRESSION

In the Unix world, the two tasks of archiving and compression are separated. That is also evident for the tar command, for example. For compression and decompression of arbitrary individual files, additional procedures are, therefore, available. These are the command pairs <gzip> and <gunzip> or <bzip> and <bunzip2>. The two commands compress using different procedures.

The syntax of the commands is conceptually simple. The two compression commands recognize the attributes src and zipfile, with which you enter the names of the source and target files. In giving out the names, it should be kept in mind that the decompression commands expect files that bear a correct file ending suitable for the compression procedure. The endings are .gz or .bz2. The following example illustrates the gzip command:

```
<gzip src="ff.tar"  zipfile="ff.tar.gz"/>
```

The decompression commands always require setting of the src attribute with the name of the compressed file. Without further input, this file will be decompressed with the name of the target file taken from the source file. Thus, only the ending .bz or .bz2 will be removed. The target file is put in the current directory.

Optionally, during decompression, you can use the dest attribute to specify an alternative name for the target file, (path included), or just the name of a directory in which the target file is to be put under its original name. The directories that are used must already exist.

The following commands illustrate all the variants for defining the target file:

```
<gunzip src="ff.tar.gz" />
<gunzip src="ff.tar.gz"  dest="gg.tar" />
<gunzip src="ff.tar.gz"  dest="install" />
<gunzip src="ff.tar.gz"  dest="install/hh.tar" />
```

Let a compressed file with the name `ff.tar.gz` be given. The first command decompresses this file, in the course of which the target file receives the name `ff.tar`. The second command uses the name `gg.tar` for the target file instead.

The third command presumes that a directory named `install` exists. The `<gunzip>` command then puts the target file `ff.tar` into this directory. The fourth and last command again writes the target file into the directory `install`, but assigns another file name, `hh.tar`.

14 External Applications

From time to time, external applications must be called, especially in connection with testing and installation tasks. Sometimes this is necessary before the actual compiling, e.g., when source text generators are brought into use. Ant can execute Java classes as well as system commands.

14.1 CALLING JAVA APPLICATIONS

It may be necessary to call external applications during the build. Some of the various tasks (e.g., `<javac>`), moreover, represent an implicit calling of other Java applications. It may also be necessary to launch a Java program from within Ant for a function test of the written application. Ant has the command `<java>` for this purpose. Its attributes (See Table 14.1) are mainly technical in nature because of its system-related function.

TABLE 14.1 Attributes of the `<java>` Command

Attribute	Description	Default	Required
classname	Name of the class to be executed.		Either `jar` or `classname`
jar	Name of a jar archive. A main class must be specified in its manifest. (`fork=true` is required.)		No
classpath	The required class path.		No
classpathref	Reference to a class path.		No

(continues)

TABLE 14.1 Attributes of the `<java>` Command (*continued*)

Attribute	Description	Default	Required
fork	Start the JVM separately.	false	No
jvm	Command for starting the JVM. Only works for fork=true.	java	No
maxmemory	Maximum main memory for JVM. Only works for fork=true.		No
dir	Directory for JVM start. Only works for fork=true.		No
failonerror	Interrupt the build when an error occurs.	false	No
output	Output of console output to file.		No
append	If console output is to file, then append the output to an existing file.	false	No
newenvironment	Transfer old environmental variables to the new JVM. Only works for fork=true.	false	No
timeout	Stop the external application after a prescribed time.		No

The command is relatively easy to use in the standard case. Essentially, you have to transfer only the name of the class to be started (in package notation) in the `classname` attribute. In most cases, it will also be necessary to set the correct class path. For this, the attributes `classpath` and `classpathref`, as well as the embedded tag `<classpath>`, are available. Insofar as the called class accepts parameters, these can be defined using the `<arg>` subtag. The classes can also be contained in an archive, as long as this is made accessible via an appropriate class path.

Java offers the additional possibility of starting a jar file directly. In this case, however, the jar archive must contain a manifest file which contains a main class entry. This entry must refer to the class which is to be started. If this form of call is desired, the `jar` attribute must be employed. Furthermore, a class can only be executed from a jar file in a separate JVM. To do this, at least the `fork` attribute has to be set to the value `true`.

The following two examples demonstrate the calling of a Java application. For the sake of completeness, the examples include the compiling or creation of the jar file. The first example illustrates the start of the application in the -run target using a direct call of a single class:

```
<project name="bsp1401" default="main" basedir=".">
  <property name="dir.src"   value="./source"/>
  <property name="dir.build" value="./classes"/>

  <path id = "classpath">
    <pathelement path = "${classpath}" />
    <pathelement location = "${dir.build}" />
  </path>

  <target name="main" depends="-prepare, -compile, -run"/>

  <target name="-run">
    <java classname="myExample.AliveExample"
          classpathref="classpath" />
  </target>

  <target name="-prepare">
    <mkdir dir="${dir.build}"/>
    <delete>
      <fileset dir="${dir.build}" includes="**/*.*"/>
    </delete>
  </target>

  <target name="-compile">
    <javac classpathref = "classpath"
           destdir      = "${dir.build}"
           srcdir       = "${dir.src}"
           includes     = "**/*.java" />
  </target>
</project>
```

The example of starting a jar file is somewhat more extravagant. In order to make it more understandable, the listing also shows the creation of the archive, including the manifest file:

```
<project name="bsp1402" default="main" basedir=".">
  <property name="dir.src"   value="./source"/>
```

```xml
<property name="dir.build" value="./classes"/>
<property name="dir.lib" value="./lib"/>

<path id = "classpath">
  <pathelement path = "${classpath}" />
  <pathelement location = "${dir.build}" />
</path>

<target name="main"
        depends="-prepare,
                 -compile,
                 -makejar,
                 -runjar"/>

<target name="-runjar">
  <java jar="${dir.lib}/myExample.jar"
        fork="true" />
</target>

<target name="-makejar">
  <jar destfile="${dir.lib}/myExample.jar">
    <fileset dir="${dir.build}">
      <include name="**/*.class"/>
    </fileset>
    <manifest>
      <attribute name="Main-Class"
                 value="myExample.AliveExample"
      />
    </manifest>
  </jar>
</target>

<target name="-prepare">
  <mkdir dir="${dir.build}"/>
  <mkdir dir="${dir.lib}"/>
  <delete>
    <fileset dir="${dir.build}" includes="**/*.*"/>
    <fileset dir="${dir.lib}" includes="**/*.*"/>
  </delete>
</target>

<target name="-compile">
  <javac classpathref = "classpath"
```

```
              destdir    = "${dir.build}"
              srcdir     = "${dir.src}"
              includes   = "**/*.java" />
      </target>
   </project>
```

The `<java>` tag is, again, very simple. But it can be understood only after an examination of the creation of the jar file. Within the `<jar>` tag, manifest information is generated using the `<manifest>` tag, that serves as the basis of the manifest file in the jar archive. Only an entry for the `Main-Class` attribute is accepted in this manifest. The name of the class to be executed serves as a value. When the jar file is called, it is exactly this file which will be executed. Since a jar file can be called only via a separate JVM, the `fork` attribute also has to be employed in the `<java>` tag.

For various reasons, it may be necessary or sensible to start a second JVM. First, as just shown, it is necessary for starting a jar file. Another reason may be that modified environmental variables are required for execution of the application. For example, you can set the allotted memory, environmental variables, and system properties using attributes and subtags.

Besides the attributes, the `<java>` tag also recognizes several embedded tags. Some of these only work if a second JVM is started, using the `fork` attribute. First, however, to the generally valid subtags: the `<classpath>` tag has already been mentioned. It enables the definition of a class path with the commands for file and path selection. If parameters are to be transferred to a Java application which is to be called, this can be done using the `<arg>` command. This tag will be discussed in detail in Section 14.3 on command line calls.

If, besides the command line parameters, system properties also have to be specified for the JVM, the `<sysproperty>` tag is helpful. This tag recognizes four different attributes. You establish the name of the property with `key`. Values are assigned using one of the attributes `value`, `path`, or `file`. `value` assigns a value directly. With `path` you can establish path specifications consisting of multiple elements. These can contain semicolons or colons as separators between the elements; Ant replaces this character with the value appropriate to the current platform. The `file` attribute, on the other hand, can contain a file name which will be supplemented by Ant with the absolute path for this file. These entries will work for the JVM which executes the external classes.

Two of the subtags only work if a separate JVM is started. These are `<jvmarg>` and `<env>`. With `<jvmarg>` you transfer command line options to the JVM which is

to be started. The syntax for these tags corresponds to that for <arg>. You can define environmental variables which will work for the second JVM using <env>.

14.2 EXTERNAL PROGRAMS AND SHELL COMMANDS

Besides Java applications, any external application can be executed from inside Ant. Ant has two commands, <exec> and <apply>, available for this. The two commands differ in their complexity. The <exec> tag can supply the program to be executed only with relatively simple and, primarily, static parameters. The <apply> tag, on the other hand, permits the inclusion of file lists, to which the external command is applied. In this way, a <mapper> tag and special subtags can be used for dynamically creating the names of output files.

These two tags are especially significant in the following cases:

- execution of operating system dependent functions, e.g., setting file attributes
- calling compilers which are not directly supported by Ant

One peculiarity is to be kept in mind when using these two commands: neither <apply> nor <exec> start a shell (error interpreter) which then executes the desired command. Rather, they use operating system calls, to which they transfer the names of commands. At the same time, an executable program must be involved. Many instructions, which customarily are issued in the command line, however, are not executable programs by commands within the interpreter. As an example, only DIR shows up in Windows or SET, in Unix. If such instructions must be executed, a suitable shell, to which the instruction to be executed is transferred as an argument, must first be started.

Both when starting a suitable shell, and when calling other commands, the tag is to be configured specifically for an operating system or a group of operating systems. Here the attribute os is available for the two Ant commands. It sets the operating system for which the command is to be executed. If you don't use this attribute, the command will always be executed. As a test, Ant compares the name of the current operating system (contained in the os.name property) with the content of the os attribute. If the string from os.name is contained in os, the command is executed, otherwise not. The current version of Ant (1.5.1) seems to carry out this test by means of a simple string search. This means that the name of all permitted

operating systems can be noted in the os attribute without special separators. If, for
example, the current operating system is Windows 2000, then the os.name property
contains the string "Windows 2000". In order for <apply> or <exec> to be executed,
this string must appear in the os attribute, if it is to be used at all. In this sense,

```
os="Windows_NTWindows 2000Unix"
```

is also correct.

It is not possible in this way to specify an operating system group in the os at-
tribute, e.g., all Windows versions, by the keyword "Windows." On the contrary,
you have to enumerate all the versions in the os attribute, or write complex pro-
grams employing the <condition> command.

Note, also, that Ant sets the names of the operating systems under its own
rules, and does not transfer the content of similarly-constituted system variables of
the operating system. In order to be able to specify the names correctly, in every
destination platform you have to determine the correct value of os.name by calling

```
<echo message="${os.name} "/>
```

After these preliminary remarks, which hold for both commands, we can now
describe them concretely. The simplest of the two commands is <exec>. It executes a
system command, to which a simple, static (at the time of the call) list of command-
line parameters is transferred. It has a relatively long list of attributes, but only a few
of these have to be used in practice. (See Table 14.2.)

The conventional call of a command is relatively simple. Only the executable
attribute is absolutely required. It contains the name of the system command to be
called. If command line arguments must be imparted to this command, the <arg>
subtag is used. Since this tag, like <env>, can be used for both <exec> and <apply>,
these two subtags will be described in more detail in a separate section, 14.3.

The simplest conceivable call uses only the executable attribute. Thus, for ex-
ample, the command

```
<exec executable="notepad.exe" />
```

is sufficient to start an editor. With this command, of course, there must be a re-
striction to specific operating systems:

```
<project name="bsp1403" default="main" basedir=".">
  <target name="main">
```

```
        <exec executable="notepad.exe"
              os=" Windows NT Windows 2000"/>
    </target>
</project>
```

If the editor is to be started for processing just one file, it can be passed on as a command line argument. The `<arg>` subtag is used for this purpose. For example, a log file could be registered in the editor or newly created:

```
<project name="bsp1404" default="main" basedir=".">
  <target name="main">
    <exec executable="notepad.exe"
          os="Windows NT Windows 2000">
      <arg line="build.log"/>
    </exec>
  </target>
</project>
```

If interpreter instructions are to be executed, the appropriate shell is started with the instruction as a command line parameter. The DIR command must be executed by Windows in the following way:

```
<project name="bsp1405" default="main" basedir=".">
  <target name="main">
    <exec executable="cmd"
          os="Windows NT Windows 2000">
      <arg line="/c dir"/>
    </exec>
  </target>
</project>
```

A simple listing at the console makes little sense. You can use the output or outputproperty attributes to direct the console outputs from the called application to a file or a property:

```
<project name="bsp1406" default="main" basedir=".">
  <target name="main">
    <exec executable="cmd"
          os="Windows NT Windows 2000"
          outputproperty="p.dir">
      <arg line="/c dir"/>
```

```
    </exec>
    <echo message="${p.dir}"/>
  </target>
</project>
```

This opens up the possibility of further processing the results of an external application in an Ant application. When the output is diverted to a file, the append attribute can be used to establish whether a file of the same name that should be overwritten, or whether the output should be appended to the end of this file.

In the examples shown up to here, the called command runs in the current working directory. This can be changed using the dir attribute:

```
<project name="bsp1407" default="main" basedir=".">
  <target name="main">
    <exec executable="cmd"
          dir="c:\"
          os="Windows NT Windows 2000" >
      <arg line="/c dir"/>
    </exec>
  </target>
</project>
```

Environmental variables occasionally have to be set or changed for correct execution of external commands. The <env> subtag serves this purpose. The syntax of this command will be discussed in more detail in Section 14.3. Here we merely give an example which can also illustrate the operation of the newenvironment attribute. This attribute works to provide the called command with only the newly defined environmental variables:

```
<project name="bsp1408" default="main" basedir=".">
  <target name="main">
    <exec executable="cmd.exe"
          newenvironment="true"
          os="Windows NT Windows 2000Unix">
      <arg line="/c set"/>
      <env key="NEW_PARAM" value="new value"/>
    </exec>
  </target>
</project>
```

In the example, the Windows shell parameter SET is executed with no other parameters, in order to indicate the current state of the environmental variables. Beyond that, a new environmental variable is added using the <env> tag. The list of environmental variables is very short. Besides those already defined, it contains only a few variables that are rigidly prescribed by the system. This changes if either the newenvironment attribute is set to false or the <env> tag is removed. In the first case, the existing environment is extended by the new entry and passed on to the system command. In the second, the old environment is passed on, and the newenvironment attribute only comes into operation if new environmental parameters are defined.

Table 14.2 summarizes all the attributes of the <exec> command.

TABLE 14.2 Attributes of the <exec> Command

Attribute	Description	Default	Required
executable	The program to be executed (without command-line arguments).		Yes
dir	The working directory for the command.		No
os	List of operating systems under which the command is to be executed. See the text!		No
output	Put output of the command into the specified file.		No
append	Append the output of the command to the output file if this already exists. The alternative is to overwrite.	false	No
outputproperty	Name of a property into which the output of the command is put.		No
resultproperty	Property for the return code of the external command. Only of significance for failonerror=false.		No
timeout	Interrupt after passage of the specified time (unit: milliseconds).		No
failonerror	Interrupt the build if the external command announces an error.	false	No

(continues)

TABLE 14.2 Attributes of the <exec> Command (*continued*)

Attribute	Description	Default	Required
failifexecution-fails	Interrupt the build if the external program cannot be started.	true	No
newenvironment	If new environmental variables are defined, do not pass on the old environment.	false	No
vmlauncher	Execution of the command using special features of the JVM.	true	No

The second command in this group is <apply>. Its task is primarily to apply a system command to multiple files, which are selected by a fileset. The principal structure of the command and its attributes (see Table 14.3) resemble those of the <exec> command. The system command to be executed, is defined by the executable attribute, and you can establish a working directory with dir. It is possible to redirect the output from the called command or to allow execution only for specified operating systems.

TABLE 14.3 Attributes of the <apply> Command

Attribute	Description	Default	Required
executable	The program to be executed (without command line arguments).		Yes
dest	The working directory for writing the processed files.		Yes, if a mapper is used
dir	The working directory for the command.		No
relative	Constrain relative path names.	false	No
os	List of operating systems under which the command is to be executed. See the text!		No

(continues)

TABLE 14.3 Attributes of the `<apply>` Command (*continued*)

Attribute	Description	Default	Required
output	Put output of the command into the specified file.		No
append	Append the output of the command to the output file if this already exists. The alternative is to overwrite.		No
outputproperty	Name of a property into which the output of the command is put.		No
resultproperty	Property for the return code of the external command. Only of significance for `failonerror=false`.		No
timeout	Interrupt after passage of the specified time (unit: `milliseconds`).		No
failonerror	Interrupt the build if the external command announces an error.	false	No
failifexecution-fails	Interrupt the build if the external program cannot be started.	true	No
skipemptyfilesets	Do not execute the command if no source files are selected, or the target files are more up-to-date.	false	No
parallel	Immediately transfer all source files to the command.	false	No
type	Establishes whether only files, only directories, or both, are transferred to the external command. Range of values: `file`, `dir`, and `both`.	file	No
newenvironment	If new environmental variables are defined, do not pass on the old environment.	false	No
vmlauncher	Execution of the command using special features of the JVM.	true	No

This command first accepts the <arg> and <env> subtags, which establish the command line parameters and environmental variables. These tags are optional. In any case, however, a fileset must be contained in order to specify the source files. Normally the external command is called repeatedly by Ant. For this, each of the selected files will be passed on to the external command as a parameter, one after the other, depending on its name. The following example simply uses a shell command in order to remove the write-protection on all XML files in the current directory, and to set the archive attribute. A subsequent DIR command makes the changes evident.

```
<project name="bsp1409" default="main" basedir=".">
  <target name="main">
    <apply executable="cmd.exe"
           os="Windows NT Windows 2000" >
      <arg line="/c attrib -r +a"/>
      <fileset dir="." includes="*.xml"/>
    </apply>

    <exec executable="cmd.exe"
          os="Windows NT Windows 2000Unix">
      <arg line="/c attrib"/>
    </exec>
  </target>
</project>
```

The advantage of this command is that a fileset permits a much more flexible choice of files than the operating system's customary selection mechanism.

Sometimes commands expect more complex parameters, so that Ant cannot simply append the name of the source file to the end of the command line. If necessary, the name of the target file must also be specified. The <apply> command, therefore, recognizes other subtags which have an influence on the structure of the command line parameters. Ant assembles the command lines from the contents of the <arg> command. It can give several, which enter the final command line in the order of their appearance. The two placeholders

```
<srcfile/>
```

and

```
<targetfile/>
```

can stand between these two tags. Ant then appends the name of the source file or the name of the target file to the corresponding place in the command line. If the name of the target file must be input explicitly, then you can use a mapper in order to create it. In this case, the name of the target directory must be prescribed using the dest attribute of the <apply> tag.

The use of the external copy command in Windows should serve as an example. Files are to be copied into another directory and, at the same time, renamed. The same functionality could be obtained more simply and independently of platform by Ant using the <copy> tag, but it is perfectly suited for illustrating the characteristics of the <apply> tag:

```
<project name="bsp1410" default="main" basedir=".">
  <target name="main" depends="prepare">
    <apply executable="cmd.exe"
           os="Windows NT Windows 2000"
           dest="backup">
      <arg line="/c copy"/>
      <srcfile/>
      <targetfile/>
      <fileset dir=".">
        <include name="*.xml"/>
      </fileset>
      <mapper type="glob" from="*.xml" to="*.bak"/>
    </apply>
  </target>

  <target name="prepare">
    <mkdir dir="backup"/>
  </target>
</project>
```

The attributes of the <apply> tag and the first <arg> subtag start the command interpreter of the system and call its copy instruction. The files to be copied are selected by the fileset. Since the target files should get another name, a mapper also has to be used in order to change the file endings to BAK. The characteristics of the <apply> tag also require that a target directory must be specified if a mapper exists. The dest attribute serves this purpose.

The name of the source and target files must each be transferred to the Windows copy command in the command line. Thus, in the example, the placeholders <srcfile/> and <targetfile/> are appended to the <arg> tag. Ant replaces the first

placeholder by the name of the source file selected by the fileset, and the second placeholder by the file name created by the mapper.

14.3 SETTING COMMAND LINE ARGUMENTS AND ENVIRONMENTAL VARIABLES

The two commands `<apply>` and `<exec>` can call external applications and shell commands. This requires that both commands have an influence on the structure of the command line and be able to set appropriate environmental variables. This is done using the two tags `<arg>` and `<env>`. Variants of these tags are also available in other commands which sometimes call external applications. An example is the `<java>` tag.

You establish the content of the command line, or more precisely, the additional elements to be transferred, using the `<arg>` tag. This tag recognizes four attributes, of which only one either can, or must, be used at a given time. Table 14.4 summarizes these four attributes.

TABLE 14.4 Attributes of the `<arg>` Tag

Attribute	Description
value	A single command line argument
file	File name; it will be converted by Ant into the absolute file name
path	Path specification containing a semicolon or a colon as separator. Ant converts the separator characters in accordance with the platform.
line	A list with command line arguments

This tag can be used repeatedly. The single values appear in the order of their definition in the command line.

The `line` attribute allows you to define the entire command line all at once. You will find examples of this in the preceding section.

With the `value` attribute, on the other hand, you define a single command line element at a time. Even if the actual style of the original document states otherwise, there are problems with the use of spaces. This attribute is necessary if path names

or path specifications have to be appended to the command line using the other two attributes (`file` and `path`).

You transfer a file name to the `file` attribute. As is known, within Ant, relative file names are set relative to the current working directory. Naturally, an external application does not recognize this directory. Ant, therefore, converts the file name of the `file` attribute into an absolute file name if necessary. In this way, the external application can identify the desired file without any uncertainty.

The `path` attribute, on the other hand, ensures that a path list will be produced with separators appropriate to the target platform. This includes both the separator characters within a path (/ or \) and the separators between multiple paths (; or :).

The last two attributes also come into action in the `<env>` tag. This tag defines the environmental variables for calling an external command. Thus, use of the `key` attribute is absolutely necessary. With this attribute, you define the names of the environmental variables to be applied. Their values are specified using one of the three attributes `value`, `file`, or `path`. With `value` you assign the value directly, while the other two operate in the same way as described for the `<arg>` tag.

15 Examples

This section presents some examples that illustrate a number of Ant commands in a practical context. Compiling is not the focus here. The strengths of Ant lie not in calling a compiler, but in carrying out the overall build process, including preliminary and follow-up tasks.

15.1 LOADING AND UNPACKING THE EXAMPLES FROM THE WEB

ON THE CD

The examples in this book are, of course, contained in the enclosed CD-ROM. But the most up-to-date version is also available at my home page. You can use the following script to download these examples to your computer without difficulty:

```
<project name="bsp1501" default="main" basedir=".">
  <property name="zipfile" value="antexamples.zip" />
  <target name="main">
    <input message="Input target directory:"
           addproperty="target"/>

    <mkdir dir="${target}"/>

    <get src="http://www.geocities.com/bernd_matzke/ant/${zipfile}"
         dest="${target}/${zipfile}"
         verbose="on"
         usetimestamp="true"
         ignoreerrors="true"/>

    <unzip dest="${target}"
           src="${target}/${zipfile}"
```

```
                               overwrite="true"/>

              <delete file="${target}/${zipfile}"/>
         </target>
    </project>
```

15.2 BRINGING THE BUILD NUMBER UP TO DATE

The task of this example is to enter a build number and the current build date in the source files for a larger application prior to compiling. The build number is incremented for every build, and is to be securely kept in the source code administration system. By this mechanism, the application should always have the correct build number available, in an about box or in the log messages.

Instructions such as the following exist in the important classes:

```
private final static String versionControl=
"Build $build.number$ from $build.date$";
```

These should be converted into

```
private final static String versionControl=
"Build 0056 of 11.11.2002  11:11";
```

First, a few thoughts on a possible solution for this problem: there are only two ways in Ant for doing simple calculations. One of these uses the `<buildnumber>` tag, while the other relies on the `<entry>` subtag of the `<propertyfile>` tag. The second variant is obviously more flexible, and also makes it possible to calculate the date if a suitable choice is made. Both tags work together with a property file. They cannot modify direct code in Java sources or define properties directly. If the information has to be kept until the next build, this file can be stored together with the sources, themselves, in the source code administration.

In order to change the content of a Java file, there are, again, two possibilities in principle. Some commands (`<replace>` and `<replaceregexp>`) execute the changes directly in the raw data file. Another variant involves changing the file content during copying. This way the raw data file remains unchanged and changes occur only in the copy. Which of the two procedures comes into action, depends on organizational, as well as technical, boundary conditions. In the case at hand, the decision was for the latter variant. The files to be processed are stored by a source code ad-

ministration system. They are read into a transfer directory by other components of the Ant application. Perhaps the build fails, and a few source files have to be supplied anew, out of the source code administration, following some modification by the developer. This may cause problems if the file in question also has to be processed externally by the build script. It is, therefore, advisable not to modify files in the transfer directory of a source code administration system.

Thus, the task involves several parts:

- read the old build information.
- calculate the new build information.
- rewrite the build information.
- bring the sources up to date.

There is a separate target for each sub-problem. All the targets belong logically together and are, therefore, put into a common build file. The execution is controlled by a main target, whose sole task is to call the four other targets.

The example works together with MS Visual Source Safe. Since the individual actions will be put into separate targets, the two targets could be changed relatively easily for source code administration.

Now to the script itself: for the sake of clarity, explanations are inserted between the instructions in the script. A complete build file without comments can be found on the CD-ROM.

ON THE CD

```
<project name="factory_buildinfo" default="main" basedir=".">
  <property file="ff.properties"
            prefix="pf"/>
```

A property file is loaded at the beginning of the build file. The prefix pf is put before each property name in order to give the properties unique names.

The property file contains the executed properties listed in Table 15.1.

TABLE 15.1 Content of the Property File for the Example

Property	Task
path.abs.vss	Absolute path to the program file of the MS Source Safe Client.
vss.project	Name of the project in Source Safe.

(continues)

TABLE 15.1 Content of the Property File for the Example (*continued*)

Property	Task
name.buildinfo	Name of the property file with the build number.
path.abs.src	Absolute path for the final version of the source files.
path.abs.srcvss	Transfer directory for communication with the source code administration.

The main target possesses no tasks of its own. It serves merely as an entry point and starts the four functional targets using the depends attribute:

```
<target name="main"
        depends="buildinfo_checkout,
                 buildinfo_update,
                 buildinfo_checkin,
                 modify_sourcefiles"/>
```

Providing the file with a build number and date is the task of the first independent target. It must read the file from the SCCS and ensure that it is writeable. In the present case, this is done by the checkout function of MS Source Safe. Most likely, other systems will require another procedure.

```
<target name="buildinfo_checkout">
  <vsscheckout
    ssdir="${pf.path.abs.vss}"
    vsspath="${pf.vss.project}/${pf.name.buildinfo}"
    localpath=${pf.path.abs.src}"
    recursive="false" />
</target>
```

If the file is ready, the entries for the properties build.number and build.date can be changed. This is done in each case using the <propertyfile> tag or its <entry> subtag. These cause a modification of a property entry in the given file in each case. The first subtag modifies an entry with the name build.num. The other attributes of the <entry> tag mean that a numerical value is involved, which will be written as the default value 0000 in the absence of a value. With each access (in-

cluding the initial installation), the value is incremented. The step size prescribed by Ant is 1. In addition, the value contains four digits and, if necessary, begins with leading zeroes.

```
<target name="buildinfo_update">
  <propertyfile
    file="${pf.path.abs.srcvss}/${pf.name.buildinfo}"
    comment="Build Information File - DO NOT CHANGE" >
    <entry  key="build.num"
            type="int"
            default="0000"
            operations="+"
            pattern="0000" />
```

The second value, the date, is always set anew, with a value always entered as the current date. The formatting is according to the German notation (day, month, year), with the current clock time appended:

```
    <entry  key="build.date"
            type="date"
            value="now"
            pattern="dd.MM.yyyy HH:mm" />
  </ propertyfile>
</target>
```

Once the property file has been brought up to date, it can be written back in the SCCS. The command also has no special features:

```
<target name="buildinfo_checkin">
  <vsscheckin
    ssdir="${pf.path.abs.vss}"
    vsspath="${pf.vss.project}/${pf.name.buildinfo}"
    localpath="${pf.path.abs.srcvss}"
    comment="Modified by automatic build" />
</target>
```

The actual work is done by the last tag. It must copy the source files into the proper work directory of the compiler and, thereby, replace the placeholders with the values that have just been calculated:

```
<target name="modify_sourcefiles">
```

For this, the property file must first be read-in. Although the properties have been modified by the script, they are first available in the script if they have been read-in explicitly:

```
<loadproperties
  srcfile="${pf.path.abs.srcvss}/${pf.name.buildinfo}"/>
```

Now the <copy> tag can be used. File selection can simply be stopped, since all the files are to be copied:

```
<copy todir="${pf.path.abs.src}">
  <fileset dir="${pf.path.abs.srcvss}"/>
```

Placeholders are replaced by so-called *filters*. The two required filters are assembled by a filterset, which also defines the initial and final characters in the placeholders:

```
<filterset begintoken="$" endtoken="$">
  <filter token="build.number"
          value="${build.num}" />
  <filter token="build.date"
          value="${build.date}" />
</filterset>
</target>
</project>
```

16 ▪ Tips

In working with Ant, the developer often comes across the same problems again and again. Frequently, the shift from a conventional programming language to Ant raises a few problems, since Ant is based on entirely different concepts. This chapter provides a few brief solutions which you can use as elements of your own applications. Besides the solutions presented here, an analysis of the problems should provide a deeper insight into the way Ant works.

16.1 CONDITIONAL EXECUTION OF TARGETS

Execution of a target can be made to depend on the existence or absence of a property. Of course, this property applies only to the execution of the current target and not to the targets called by depends. This is, in itself, logical, since in the scheme of Ant, no "subprograms" of the current target are defined by the depends attribute. Rather, these targets create the preconditions for the execution of the current target. Of course, situations often occur in which a whole series of related targets must be conditionally executed. In this case, a target which will ensure the conditional execution has to be inserted. This target then calls the real target using <ant> or <antcall>.

The following example illustrates this procedure. Compiling, along with a few preliminaries, must only be carried out if the property help does not exist. The tricky point is that various partial tasks might have to be activated by different parameters in the command line. All other activities should be suppressed by the help property and, instead, only help information will be displayed.

The -comp target provides for calling the compiler, just as the depends attribute provides for the execution of preliminary work. Should inspection of the properties take place via this target, then the prepare target would always be executed. Thus,

the inspection would be carried out by a second `comp` target whose only task is to start the `-comp` target via the `<antcall>` command.

```
<target name="comp"  unless="help">
  <antcall target="-comp"/>
</target>

<target name="-comp" depends="prepare">
...
</target>
```

16.2 SIMULATION OF IF AND ELSE

In its basic form, Ant does not recognize `if` or `else` instructions. These are, of course, available in extensions. But if these commands cannot or should not be used, it is possible to construct this functionality using three separate targets.

The example first shows two targets for the IF or ELSE branches. The execution is dependent in one case on the existence, and in the other on the nonexistence, of one and the same property. Inevitably, only one of the targets can be executed. The property must be written into the original program, e.g., with the `<condition>` tag. A third target, called `doit` here, calls both targets in a `depends` chain. Thus, both targets have a possibility of being executed. Of course, the premise is always satisfied only for one.

```
<target name="doit" depends="if_target, else_target" />
<target name="if_target" if="${condition_property}">
...
</target>
<target name="else_target" unless="${condition_property}">
...
</target>
```

This procedure can be extended. If the `doit` target also sets a third target at the beginning of the `depends` list (`check_condition`), the evaluation can also be tied into the condition:

```
<target name="doit"
        depends="check_condition, if_target, else_target" />
```

```
<target name="check_condition">
<!-- set condition_property somewhere here -->
</target>
<target name="if_target" if="${condition_property}">
...
</target>
<target name="else_target" unless="${condition_property}">
...
</target>
```

Note here that you have to call the tag for checking the condition unconditionally using the `depends` attribute. Otherwise, the property, which is created if necessary, would not have been visible. The two other tags can also be executed via the `<ant>` or `<antcall>` commands, so long as the transfer of the deciding property is thereby taken care of.

16.3 PARAMETER ECHO FROM SUBTARGETS

Not all target calls can be carried out with the help of the `depends` attribute. For widely varying reasons, the `<ant>` and `<antcall>` commands also come into use. In the meantime, a problem arises with targets called in this way, since they are executed in a separate process, so they cannot return any information to the calling target. In this way, at first it seems that the use of targets as "subprograms" is excluded. There is, however, a way out, although it is tricky and not very productive.

The `<echoproperties>` tag can generate correct property files from Ant properties. If a called target writes the desired echo parameters into a property file using this command, the calling target can read them in using the `<property>` command, so that correct Ant properties again result. The following example illustrates the procedure in principle:

```
<project name="bsp1601" default="main" basedir=".">
  <target name="main">
    <antcall  target="sub"/>
    <property file="sub.properties"/>
    <echo>${sub.p1}</echo>
  </target>
```

```
<target name="sub">
  <property name="sub.p1" value="Property from sub target"/>
  <echoproperties destfile="sub.properties" prefix="sub"/>
</target>
</project>
```

In practice, you should take note of a few points:

■ The `<echoproperties>` tag can limit the set of properties to be written using the `prefix` attribute. You have to equip all the return values with a standardized prefix, so that these properties can be selected deliberately. Perhaps other properties exist during running, which have been transferred from the called target (using the attribute `inheritall="true"`).

■ Because properties cannot be overwritten after they have been called once, the names must be unambiguously established. Here, also, the prefix can be used. The name of the called target is recommended, perhaps extended with the name of the build file. This would then truly be unambiguous.

■ The property file must be put in a temporary directory, which will be erased at the beginning of the build. This avoids undesired side effects that might occur as a result of reading out-of-date properties.

■ The created property file must be evaluated immediately after the target is called in order to clarify its logical connection with the target call.

■ This procedure should be used sparingly, as it is obscure and takes a lot of time.

16.4 PROPERTIES WITH DEFAULT VALUES

Some commands generate properties that depend on various conditions. If a condition is satisfied, the property is generated; otherwise it is undefined. Occasionally this behavior is not desired, as when a valid value is always assumed, or a default value must be assigned. Since properties can only be supplied once with a value, there are several tricks available: immediately after the task which is supposed to generate a property, this property is created again by the `<property>` command and set to the default value. Should the property already exist at this time, the command has no effect. Otherwise, the property is supplied with the default value.

You can also modify this procedure so that a property with the default value is created immediately after it is evaluated.

Note that, in some cases, only the existence of a property is decisive here, regardless of its value. For properties of this sort, of course, this procedure is inappropriate.

Here is an example which merely illustrates the principle:

```
<project name="bsp1602" default="main" basedir=".">
  <target name="main">
    <property name="prop"
      value="No definition in command line!"/>
    <echo>${prop}</echo>
  </target>
</project>
```

Should the prop property be defined when the script is called in the command line, its content will be passed on. If not, the <property> tag comes into action in the main target and assigns it a default text.

16.5 DELETING A NONEXISTENT DIRECTORY

When a delete command is executed for a nonexistent directory, a build error results. Constellations of this sort arise occasionally during preliminary work, e.g., when the target directory of the compiler is erased. It is, therefore, recommended that a root directory be established at once using <mkdir>, whether it already exists or not. Subsequently, the entire content of the directory is erased. Whether the root directory is erased, as well, or just its contents, is up to you.

Here is an example:

```
<mkdir dir="build/classes"/>
<delete includeemptydirs="true">
  <fileset dir="build/classes" defaultexcludes="false">
    <include name="**/*"/>
  </fileset>
</delete>
```

16.6 ELEMENTS OUTSIDE A TARGET

A number of objects can be defined outside targets. At the same time, no command is executed. The elements can, however, be used later in commands by reference. This kind of storage allows transparent maintenance of the elements, since they can be put into a central site. In addition, the time spent in writing is reduced by multiple use. Table 16.1 lists these tags and explains their functions.

TABLE 16.1 Tags that Can Exist at the Upper Level

Element	Function	Described in Chapter
classfileset	Definition of the class path.	
description	Output of a descriptive text for the current build file.	4
direst	List, with patterns for directory selection.	6.2
extension	Defines a Java extension.	
extensionset	Set of multiple extensions.	
fileset	List, with patterns for file and directory selection.	6.1
filelist	List with files.	6.3
filterchain	Group of commands for manipulating file contents.	8.9
filterreader	Call for filters by complete class names. Serves primarily for calling self-programmed filters.	8.9
filterset	Filter for modification of file contents during copying.	8.3
libfileset	Special list with file names.	
mapper	Instructions for conversion of file names.	6.4
path	Path specification.	6.3
patternset	Pattern for file selection.	6.1.2
regexp	Instructions for manipulation of file contents.	8.8
selector	Instructions for selection of files by file characteristics.	6.1.5
substitution	Substitution pattern in regular expressions.	8.8
xmlcatalog	Grouping of DTDs or other files for XML applications.	

16.7 REFERENCES TO PATH ELEMENTS

Only the <path> tag can be used outside targets to create path specifications. A number of other tags with identical functionality exist, but they can only be used inside targets or tasks. The names of these tags indicate the special significance of the path defined in this way. One example is <classpath>. It is possible to indicate a general path element in this tag by use of the refid attribute.

An example:

```
<path id="classpath">
  <pathelement path=${classpath}" />
  <pathelement location=${root}/classes" />
</path>

<target name="-comp">
  <javac srcdir="${root}/src"
         destdir="${root}/classes"
         failonerror="false">
    <classpath refid="classpath"/>
    <include name="myPackage/**"/>
  </javac>
  . . .
```

17 Regular Expressions

Regular expressions are complex search patterns. As a rule, they are not supported by all Java versions. This support was first integrated into Java beginning with version 1.4. With the other versions, you have to install a supplementary package. Several different packages exist. The programmers of Ant recommend Jakarta Oro (see *http://jakarta.apache.org/oro/index.html*). This package is also contained in the enclosed CD-ROM. The syntax of regular expressions is consistent with that of the programming language Perl. A study of the extensive literature is recommended for complete familiarization with this topic.

ON THE CD

Besides documentation and the sources, the Jakarta Oro package contains only a single jar file (i.e., `jakarta-oro-2.0.6.jar`). In order to be able to use Oro in combination with Ant, this file must be tied into the class path before it is called by Ant. Since the start scripts for Ant automatically include all files in the `lib` directory of the Ant installation in the class path, it is sufficient to copy the Oro archive into this directory.

No further installation effort is required.

17.1 EXAMPLES OF REGULAR EXPRESSIONS

Regular expressions originate in the Unix world, but are, in the meantime, used across platforms by many applications. The following section explains the basic characteristics of regular expressions subject to the particular features of Ant.

You can try out the examples with the script printed below. It has been tested in Java 1.4 and Windows 2000. At the same time, no additional libraries for regular expressions have been installed. The script resembles the Unix command `grep` in its mode of operation. It outputs to the console all those lines of a file that in-

clude strings which match the search pattern. If no line satisfies the search criterion, an appropriate output also is produced. If you type in the example manually without using the files in the CD-ROM, you have to pay attention to the line feeds and spaces in the target prepare and, in particular, in the <echo> command. The last character in each line should, therefore, be followed immediately by a line break with no final spaces included.

```
<project name="bsp1701" default="main" basedir=".">
  <property name="file.name" value="regexp.txt"/>

  <target name="main" depends="prepare, grep">
    <property name="file.content"
              value="No appropriate lines '${re}' were found for
printing "/>
      <echo>${file.content}</echo>
  </target>

  <target name="grep">
    <loadfile srcfile="${file.name}" property="file.content">
      <filterchain>
        <linecontainsregexp>
        <regexp pattern="${re}"/>
        </linecontainsregexp>
      </filterchain>
    </loadfile>
  </target>

  <target name="prepare">
    <echo file="${file.name}">aaa
  abc
abx
   aaa
ac.d
quelltext.c  ijklmn
An empty line follows

An empty line was here before
bbxyc
      ayuuu
qqq
a.b
```

```
12345  that is the next to last line of the file text
xyz.c
      </echo>
    </target>
</project>
```

You can call the script using

```
ant -f ant211.xml -Dre="regular expression"
```

In the following, only the regular expressions will be noted, not the whole command lines.

The simplest form of regular expression consists of a simple string without special characters. In this case, exactly this string will be searched for. Thus,

```
uuu
```

finds all lines containing three letters u in succession at any point.

More flexibility is made possible by a few special characters. The two signs ^ and $, for example, represent the line start and line end. Depending on the platform and library, \n can be, or may have to be, used for the line end in some cases. Hence, the expression

```
^a
```

finds all characters a that appear at the beginning of a line.

```
c$
```

on the other hand, finds all c's at the end of a line. The correct notation is important here. Colloquially, the sequence ^a means "line start and then just the letter a," while c$ can be paraphrased as "the letter c followed by a line end."

The entry $c is syntactically false. It would mean that the letter c follows a line end, but this is impossible, since regular expressions are processed line-by-line. On the other hand,

```
^$
```

is correct. With it, you will find all spaces.

Regular expressions can include wild card symbols, as with file names at the command interpreter level. Of course, the symbols are different here. Thus, a period symbolizes exactly one arbitrary character. Consequently,

```
^a..$
```

finds all lines beginning with a that are exactly three characters long.

If a period is sought, the special meaning of the period as a wild card is eliminated by placing a backslash in front, i.e.,

```
^a\.
```

finds all character strings a. at the beginning of a line.

Sets can be indicated by enclosure in square brackets, e.g.,

```
a[bc]
```

finds the string "ab" or "ac". You can define larger ranges by specifying upper and lower limits:

```
a[b-x]
```

Placing ^ before a set means that all the characters that do not belong to the set will be recognized as valid characters, e.g.,

```
a[^b-x]
```

All strings consisting of two characters beginning with a and with a second character that does not lie in the range from b to x will be selected. The symbol ^ can also have different meanings in regular expressions, depending on their position.

A combination of both variants for specifying sets (single characters and ranges) is possible; e.g.,

```
a[abx-z]
```

Here the character combinations aa, ab, ax, ay, and az will be found. Naturally, spaces can be searched for, as well.

Spaces often occur in unspecified numbers at, for example, the beginning of a line. If a regular expression is to be valid as a search pattern with arbitrary repeti-

tion, the repetition can be indicated by *. Here the asterisk also stands for no entry at all!

The expression

```
^ *a
```

finds all strings beginning with an arbitrary number of spaces followed by an a. In this way, for example, spaces at the beginning of a line (but also in other places) can be skipped.

Other repetition characters include the + sign for one or more repetitions, as well as the question mark to represent an appearance of, at most, one time. While the preceding example also yields lines in which an a is in the first position, the condition for the following example is at least one leading space:

```
^ +a
```

The vertical slash (pipe) represents OR coupling of two regular expressions:

```
ab|xy
```

Other pattern symbols are available to simplify regular expressions. Thus, there are abbreviations for separators, all letters or numbers, as well as the corresponding negations. The following example lists all lines that contain numbers:

```
\d
```

Table 17.1 summarizes the regular expressions.

TABLE 17.1 Regular Expressions

Expression	Description
c	One letter c.
rr	Chaining two regular expressions.
^	Line start.
$	Line end.
.	An arbitrary symbol.

(continues)

TABLE 17.1 Regular Expressions (*continued*)

Expression	Description
\s	Cancel special meaning of s if it is a metacharacter.
r*	Arbitrary repetition of the expression r (including none).
r+	The expression r at least once.
r?	The expression r at most one time.
[ccc]	Set of characters.
[a-e]	Set of characters in the form from-to.
[^ccc]	All characters that do not belong to the specified set.
r)	Grouping of regular expressions.
\t	tab.
\d	An arbitrary number, identical to [0-9].
\D	An arbitrary character, but not a number, identical to [^0-9].
\s	A separator, identical with [\t\n\x0B\f\r].
\S	An arbitrary symbol that is not a separator. Corresponds to [^\s].
\w	An arbitrary letter or number, same as [a-zA-Z_0-9].
\W	A character that is neither letter nor number.

Finally, regular expressions can be enclosed in parentheses. They have no effect on the search function. Rather, parentheses separate regular expressions or the strings selected by them, from one another. Access can later be had to the selected characters using the expressions \1 to \9, for example, in order to insert them in other strings. With the placeholder \0, all the search results will be addressed together.

About the CD-ROM

The CD-ROM included with *Ant: The Java Build Tool in Practice* includes the Ant software and the code from the various examples found in the book.

CD-ROM FOLDERS

Examples: Contains all the code from examples in the book by chapter.

Software: Contains the Ant package and the Oro package for regular expressions. The installation process is described in the book.

OVERALL SYSTEM REQUIREMENTS

- Windows, Linux, Unix
- Pentium II Processor or greater
- CD-ROM drive
- Hard drive
- 64 MBs of RAM, minimum 128 recommended
- a Java Virtual Machine (1.3.1 or newer) must be installed
- a Tool to unzip or untar the Software packages
- a Text- or an XML-Editor for viewing and editing the examples. On Windows systems, often the file extension .xml is connected with the Internet Explorer. Change these connections or open the examples with the function "File | Open" in your editor.
- 30 MBs of hard drive space for Ant and the examples.

Index